JEREMY PAXMAN

The

VICTORIANS

Britain Through the Paintings of the Age

BOOKS

Published to accompany the BBC television series
The Victorians first broadcast on BBC One in 2009.
Executive producer: Basil Comely
Series producer: Julian Birkett

1 3 5 7 9 10 8 6 4 2

First published in 2009 by BBC Books, an imprint of Ebury Publishing
A Random House Group Company.
This edition published in 2010.

The Random House Group Limited Reg. No. 954009.
Addresses for companies within the Random House Group can be found at
www.randomhouse.co.uk

A CIP catalogue record for this book is available from the British Library

ISBN 978 1 846 07744 9

Editing and additional research: Neil Hegarty
Consultant: Rosemary Barrow

Commissioning editor: Albert DePetrillo
Project editor: Christopher Tinker
Copy-editor: Steve Tribe
Design: O'Leary & Cooper
Picture researcher: Sarah Hopper
Production: David Brimble

To buy books by your favourite authors and register for offers, visit www.rbooks.co.uk

Printed and bound in the UK by CPI Cox & Wyman, Reading RG1 8EX.
Colour separations by XY Digital Ltd

The Random House Group Limited supports The Forest Stewardship Council (FSC),
the leading international forest certification organisation. All our titles that are
printed on Greenpeace approved FSC certified paper carry the FSC logo.
Our paper procurement policy can be found at www.rbooks.co.uk/environment

Contents

INTRODUCTION

IN MY CHILDHOOD IT was generally agreed that the adjective 'Victorian' meant stuffy, buttoned-up, gloomy, cold, mawkish, prudish and hypocritical. Victorians wore dark, uncomfortable clothes and had dark, uncomfortable values. They inhabited a world of smugness and draughty corridors. They shrouded the legs of pianos in case the turn of a piece of wood might trigger lascivious thoughts. If you were describing where someone lived (and the house where I spent many of my early years fits the bill) you might, without thinking about it very much, add the extra adjective: 'He lives in that grim Victorian house down the road.' No one disputed your right to make such a value judgement. To our eyes, the Victorian house *does* look grim, gothic and forbidding, designed less to welcome or comfort than to impress.

The curious thing about this prejudice was that a dislike of the taste of the Victorians ran alongside the painful recognition that the country they had created had enjoyed a much better standing in the world than the one in which the inhabitants of Cold War Britain spent their lives. We were like children railing against unfairness, screaming 'you'll be sorry'; it strikes me now that so much of this dislike was the consequence of this fatuous sense of perceived injustice. The Victorians had made our world, but we didn't feel much at home in it. We weren't quite sure what the new world would require (we're no more certain now) but we were quite confident that, whatever it was, it wouldn't involve the moral certainties and gothic curlicues of the Victorians.

It has been the odd destiny of the Victorians to have created modern Britain, only for modern Britain to sneer and spit at them. In reality, of course, the reputation of the age rises and falls not on its own intrinsic merits but on the tastes and prejudices of the point from which it is viewed. Our attitudes have yet to escape the long shadow cast by the superiority of the Bloomsbury set. As the cartoonist and nineteenth-century enthusiast Osbert Lancaster once observed of the Victorians, 'in the twenties they were deemed comic because they were good husbands, in the thirties they were thought shocking because they were bad employers.' By the 1960s, they were just an irrelevance.

And so an astonishing world began to vanish. Entire streets of terraced houses were bulldozed. Municipal buildings, public bath-houses and schools were laid to

waste. The General Post Office on St Martin's Le Grand, with its thousand radiant gas lamps, was demolished as early as 1912. The London Coal Exchange had a date with the wrecker's ball in the 1960s, swept away to allow for road-widening work in the City of London. With its central rotunda and towering dome, its 40,000-piece wooden floor inlaid in the shape of a mariner's compass, its tiers of balconies, dealers' offices, its wind dial to determine when the next shipment of coal might arrive, this, surely, was a building that might have belonged in Harry Potter's Diagon Alley. It was flattened. The same fate befell the grandest monument of the railway age, the magnificent classical-revival arch which greeted travellers at Euston station. The contractor charged with levelling the thing offered to find an alternative site for the arch, but, no, the government decreed it must be destroyed. The remorseful contractor commissioned a silver model of the arch and presented it to the president of the Victorian Society, who remarked that the gesture 'made him feel as if some man had murdered his wife and then presented him with her bust'.[1] The rubble of the arch, meanwhile, was tipped summarily into the bed of the River Lea. In this sort of atmosphere, the best that a conservationist might hope for was mere indifference, of the sort that befell the Midland Hotel, the spectacular building designed by George Gilbert Scott at St Pancras, with its clock tower, turrets, gables and pinnacles: what had once been the grandest hotel in the empire subsided over the decades under moss, decay and pigeon shit.

We flatter ourselves that we are less blinded by aesthetic prejudice today. The miracles of Victorian engineering – the Clifton and Forth Bridges, the Ribblehead Viaduct that carries the Settle to Carlisle railway line across the uplands of northern England, and many others like them – are now loved and appreciated; and those severe nineteenth-century houses appear today, curiously, a little less severe when advertised on glossy property websites. Victorian storytelling is, rightly, recognised as second-to-none, and the larger-than-life characters invented by Dickens, Gaskell, Trollope, Thackeray and the Brontë sisters provide perfect fodder for a succession of screen costume dramas. But the visual art of the Victorians has yet to be rescued from indifference. J.M.W. Turner may have painted the most popular picture in Britain (*The Fighting Temeraire, Tugged to Her Last Berth to be Broken Up, 1838* according to a 2005 poll by the National Gallery and BBC Radio 4), but between him and the Impressionists there is little to trouble the senses apart from the Pre-Raphaelites, and they are a decidedly acquired taste. In 1963, for example, you might have bought Frederic, Lord Leighton's *Flaming June* for £1,000. The art dealer Jeremy Maas – one of the very few enthusiasts for the period – did so; he was unable to find a single British gallery to take it on and eventually sold the painting to a private collector in Puerto Rico. Greater prosperity, a bigger, worldwide market and a general inflation of art prices means that when a Victorian painting comes on the market today the prices are better. But – the Pre-Raphaelites apart – many pictures of this era are still by no means highly sought-after.

It isn't difficult to see why they should have become so disregarded. Britain's second most popular painting, *The Hay Wain* by John Constable (not a Victorian: he died in 1837, the year that she took the throne), appeals to a sense of rural stability that feels absent from our frantic, deracinated present. *The Hay Wain* and similar paintings do not merely adorn the tops of old-fashioned chocolate boxes – they are themselves a kind of comfort food. Many of the pictures of the Victorians, in contrast, seem like a dose of bitter medicine. The painters are clearly on the lecture circuit: they are trying To Tell Us Something, and there is an uncomfortable sense that they expect us to damn well sit up and pay attention. We're much less comfortable being instructed to do that than being invited to wallow comfortably in some fictional bucolic bliss.

So, I know we are not supposed to like many of these paintings very much. In fact, F.W. Fairholt's *Dictionary of Terms in Art* of 1854 tells us that a good deal of Victorian art was not much more highly regarded at the time – in certain circles at any rate. Anecdotal paintings, he notes disapprovingly, were 'very reprehensible, although the most popular among the vulgar-minded patrons of Art'. Today, from a greater distance, the military ones appear to glorify battles we know nothing of, the moral tales seem to be trying to indoctrinate values we discarded long ago, and too many of the remainder appear cloyingly sentimental. And we might as well be frank and acknowledge that lots of them are simply not very good.

But there is another way of looking at these pictures. They tell us stories. As someone who has spent all his working life in the business of journalism, I am fascinated by them for that reason. In the days before the widespread use of photography, some of them were no more than attempts to create a visual record of what happened in an era of unprecedented change. After all, Britain may not have experienced the political revolutions which swept through much of continental Europe in the middle of the nineteenth century, but the long period of Victoria's reign witnessed revolutions in virtually every other field; nothing was the same at the end of this era as at its beginning. Where people lived, how they worked, what they did with their leisure time, even what they believed were all transformed, often out of all recognition. The artists of the period – people like William Frith, Elizabeth Butler, Ford Madox Brown and Edwin Landseer – helped the Victorians adjust to new realities, taught them to celebrate the places where they were now living, provided moral guidance and connected the whirling, noisy present to a suddenly distant ancestral past.

Often, the stage was set for formal presentations of Victorian life: a posed family scene, commissioned to show off one's wife and children, a comfortable drawing room complete with framed canvases and rosewood furniture, a display of material success for the gazing world. Such scenes are two-a-penny in Victorian painting: William Mulready's *An Interior Including a Portrait of John Sheepshanks at His Residence in Old Bond Street* (1832), painted just before Victoria came to the throne, is perfectly representative of the

genre. At other times, such artists as Richard Dadd – who wound up in Broadmoor – delved into their imaginations in order to explore other currents at work in Victorian Britain. Such painters as Henry Alexander Bowler reflected the doubts and fears that modernity was increasingly bringing in its wake; others, like Edward Burne-Jones, responded to these tremendous changes by looking back to a distant and ostensibly secure mythical past.

Not all of this art makes for comfortable viewing – for Victorian paintings do more than simply provide illustrations of the period, snapshots before such things were widely available. In the subjects the artists chose and the messages their patrons wanted to see communicated, they tell us about the condition of Victorian society. And, patrons or artists – Luke Fildes, for example, who would go on to become quite wealthy through his painting – with finely developed moral and political senses can show us how life was, not merely for the statesmen, mill-owners, divines and philosophers, but also for ordinary people and, frequently, for those at the bottom of the heap.

These subjects and concerns, however, were in the minority, for the main focus of the contemporary artist was the world of bourgeois Britain. In this sense, the art of the period was a faithful reflection of Victorian Britain itself, for this was the era in which the middle class rose into full cultural and economic dominance. The paintings echo the concerns of this class, its pleasures, its preoccupations, its loves, hatreds and fears. Some Victorian artists would become hugely prosperous by feeding the market: large

fortunes were being accumulated by industrialists and traders, large houses were being built to accommodate them – and large canvases were needed to decorate their new walls. The demand was there: fashionable painters certainly had no need to shiver in a garret, unless they especially wanted to do so. Instead, they could watch their trade build up, and in the fullness of time acquire large houses of their own. By the end of the century, some paintings were being sold for vast sums of money; even the most unlikely subjects could command high prices. So much so that, in 1881, *The Monarch of the Meadows,* a painting of cattle by T.S. ('Cow') Cooper was stolen from the London home of the wealthy glove manufacturer who had commissioned it, and ransomed. When Sir Lawrence Alma-Tadema was commissioned by a wealthy engineering contractor to paint *The Roses of Heliogabalus,* showing the Roman emperor Elagabalus attempting to suffocate his guests by showering them in petals, the artist could afford to have fresh roses sent every week from the south of France during the four months it took him to paint the canvas.

Alma-Tadema* (the unusual name was Dutch in origin – in art, as in everything else, Victorian Britain was a magnet for economic migrants) was one of many painters who liked to display their success conspicuously. Before Victoria's reign, metropolitan artists had tended to rub along among

* Alma-Tadema was in fact christened Lourens Tadema: the canny incorporation of Alma into his surname moved him to the front of art catalogues.

the artisans of Soho and Tottenham Court Road. As the vast new middle-class market gave them the opportunity to become middle class themselves, so they began to settle in smarter and more comfortable areas of London: Kensington, Holland Park and St John's Wood. Alma-Tadema had a house in St John's Wood elaborately decorated in the style of a Pompeian villa, dripping with opulence. These artists' houses were intended to serve as both studio and home. But they were also, frankly, for showing off. Frederic Leighton's house in Holland Park, complete with its astonishing Arab Hall, is perhaps the grandest of the residences which survive, but many others clustered nearby. Other artists in the area included George Frederic Watts, the son of a poor piano-maker; William Holman Hunt, whose father had been a warehouseman; the sculptor Hamo Thornycroft; the illustrator Marcus Stone; and now largely forgotten figures such as the professor of painting at the Royal Academy Val Prinsep and Scottish artist Colin Hunter.

As the public devoured their paintings, so they lapped up anything they could learn about the artists who produced them – and many of the successful nineteenth-century painters were happy to oblige, revelling in their fame. They opened their studios to the public, so their customers might gawk at the scene of a great man's work. For those who could not get to the artist's house, there were articles in magazines, and books with titles like *Artists at Home* (1884). Many of these artists were delighted to pose for photographs, the resulting festival of facial hair showing them in a variety of attitudes, most characteristically 'at work' in their studios,

perhaps in smoking jacket, palette in hand, perhaps sat in contemplative pose merely thinking Great Thoughts. A few, like the Pre-Raphaelite Henry Holiday, were willing to dress up (he is seen wearing medieval armour and dressed as a bishop). Pictures of others seem merely to be designed to demonstrate the well-fed affluence of men who knew their place in the world. Some calculatedly cultivated an image of slightly eccentric creativity in their photos, notable among them being G.F. Watts, whose well-trimmed beard and skullcap became instantly recognisable to large numbers.

Nowadays, of course, few of these figures are widely known – and this is in itself a reflection of the fact that so many of their paintings are largely unappreciated. *The Victorians* is an attempt to rediscover the lives of these artists, the work they created, and the society they represented in all its complexity and colour. The pictures herein are the core of the national art collection, commissioned and executed at the very time that city fathers across the land were beginning to build art galleries to show that the wealth of Britain was about more than dark satanic mills. If you spare the time to stop and examine them, there is no better way of coming to understand what life was like at the time when, with the aid of steam power and armed with the Bible, the British traversed the globe.

ONE
THE MOB IN THE PICTURE GALLERY

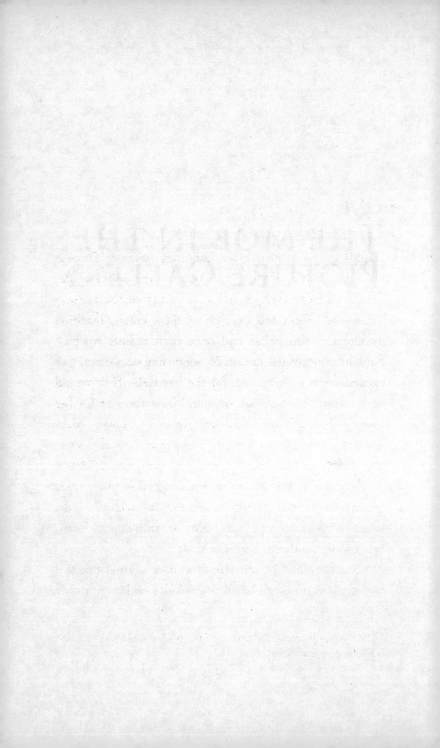

IN 1841, A BAPTIST missionary named Thomas Cook had a bright idea. Over the previous decade, he had observed the slow unrolling of the railway across the length and breadth of the country, reaching its tentacles into what had once been remote towns.* Now he conceived a notion of organising occasional day excursions at a cheap rate for the less well-off. It would be a means, he reasoned, of moral improvement for the lower orders, and it would enable these same lower orders to take advantage of a rapidly changing world. Cook, therefore, entered into negotiations with the Midland Railway Company to lay on special trains for private outings for temperance clubs and Sunday schools. Trips would be organised to places like Scarborough, Whitby, Blackpool, Southport and Ramsgate.

Saturday half-holidays had become normal practice in the 1860s and, combined with bank holidays (another

*The first railway in Britain, the Liverpool & Manchester, had been inaugurated in 1830.

Victorian invention), the once-unbelievable luxury, for the lowest-paid, of family holidays away from home had now become a possibility. In the process, life in a host of hitherto sleepy seaside towns would be transformed into boisterous resorts, as the summer season began to see crowds of city folk flocking to the beaches. Not everyone was happy to see such changes: after 162,000 people descended on Brighton beach on a single day, for example, residents of the town lobbied the railway companies to increase day return fares from London. They might as well have tried to turn back the tide.

In the summer of 1851, the artist William Powell Frith (1819–1909) followed the example of many of his fellow citizens and went down to Ramsgate for a seaside holiday. Frith had already carved out an artistic reputation in portraiture, but now he wanted to try something completely different. 'Weary of costume painting,' he would remember years later, 'I had determined to try my hand on modern life, with all the drawback of unpicturesque dress. The variety of character on Ramsgate Sands attracted me – all sorts and conditions of men and women were to be found there. Pretty groups of ladies … reading, idling, working and unconsciously forming themselves into very paintable compositions.' He was delighted, he recalled, to discover 'a theme capable of affording … the opportunity of showing an appreciation of the infinite variety of everyday life.'

In the next few years, Frith would try out various sketches and essays in oils and, in the midst of all that, he

was elected to membership of the Royal Academy on the strength of his earlier work. Rumours began to spread that he was engaged in the creation of something altogether new and modern, prompting one elderly Academician to note peevishly: 'This comes of electing fellows too hastily.' Frith himself, though, was doubtful that his new piece would meet much in the way of success, for his diary for 11 September 1853 reads: 'Will all this repay me in any way? I doubt it.'

The result emerged in 1854 as *Life at the Seaside (Ramsgate Sands)*, and at first it seemed that he had been right to despair of its prospects, for it was rejected by half a dozen patrons before eventually finding its way into the Royal Academy's summer show of that year. The picture includes some familiar sights – on the right, the donkeys and, in the background, the building that was to become the fish and chip shop, then known as the Pier Castle. There are also some unfamiliar ones – bathing machines to spare swimmers' blushes, a Punch and Judy Show and some performing animals. But the focus is the people. Surrounded by all the clunky paraphernalia of the Victorian seaside, they might look rather formal to us now, but only because they're – by our standards – so amazingly overdressed. But they were really a very ordinary lot, and it is this ordinariness that gives the painting its potency. A child paddles tentatively in the water, other children dig in the sand, and ladies read their newspapers. In the background are entertainers – minstrels, a boy with a mouth organ; donkeys peeping into the picture. It was real life, and understood by any spectator of the time – who had likely been to Ramsgate

or similar seaside towns in the not too distant past – *as* real life, reflecting the texture and facts of their own experience. Put this way, the painting was revolutionary.

And so, when the work was exhibited, the art world was duly appalled. One man described *Ramsgate Sands* as 'a tissue of vulgarity'. A fellow artist dismissed it as 'a piece of vulgar Cockney business unworthy of being represented even in an illustrated paper'. The offence was genuine and quite understandable, for the notion of portraying ordinary families on a beach, dressed drably and bathed in the unflattering glare of a summer sun, was new and wholly unwelcome. It must have been even more than usually gratifying to Frith, therefore, when *Ramsgate Sands* was voted picture of the year by the journal *Royal Academy Pictures* and was bought by Queen Victoria herself, who fell in love with this portrayal of a town where she had spent periods of her childhood.

This was Victorian Britain looking at itself in the mirror and – after a little guidance – deciding that it quite liked what it saw. More precisely, this was the middle class looking at itself. Ramsgate was a respectable town – unlike Margate further along the Kentish coast – and the crowd on the beach were got up in the latest bourgeois fashions. It is little wonder that viewers were pleased by the spectacle before them: it was presenting ordinary life as a worthy subject for art. The painting touched off a flood of imitations, including Abraham Solomon's *Brighton Front* (*c.*1860), William Hopkins and Edmund Havell's *Weston Sands* (1864), Charles Rossiter's *To Brighton and Back for 3s 6d* (1859), and David Cox's *Rhyl Sands* (*c.*1854).

Frith may have turned his gaze on life at the seaside, but, all around, people were looking at the country in a new way. Ever-increasing mobility within Britain inevitably led to an age of spectacle, of gazing – and this was mirrored and echoed by artists. The results were sometimes predictable, as in Daniel Alexander Williamson's *Coniston Old Man from Warton Crag* (c.1863), which paints a lusciously glowing – and entirely unpeopled – picturesque upland of the sort increasingly visible to day-trippers and travellers as they rattled past on the train. Such travel and such paintings played their part in a new kind of national exploration and appreciation of the country's landscapes, beauty and fragility, leading to – for example – the foundation of the National Trust in 1888.

There was, of course, a long tradition in British culture that looked dimly on any notion of industrial or urban encroachment. Fifty years before Victoria came to the throne, William Blake was meditating on England's 'dark, satanic mills';[1] thirty years earlier, Jane Austen was using the pages of *Emma* to paint an unflattering portrait of a then up-and-coming Birmingham ('I always say there is something direful in the sound').[2] And, well into Victoria's reign, John Ruskin was bewailing the state of Britain's landscape and its soul:

> For the sake of distinctness of conclusion, I will suppose your success absolute: that from shore to shore the whole of the island is to be

set as thick with chimneys as the masts stand in the docks of Liverpool: and there shall be no meadows in it; no trees; no gardens; only a little corn grown upon the housetops, reaped and threshed by steam: that you do not leave even room for roads, but travel either over the roofs of your mills, on viaducts; or under their floors, in tunnels: that, the smoke having rendered the light of the sun unserviceable, you work always by the light of your own gas: that no acre of English ground shall be without its shaft and its engine; and therefore, no spot of English ground left, on which it shall be possible to stand, without a definite and calculable chance of being blown off it, at any moment, into small pieces.[3]

George Cruikshank's sharp little cartoon of *London Going out of Town – or – the March of Bricks and Mortar!* (1829) is an early example of this school of thought, personalising the city as a flow of builders moving destructively through urban Islington towards the green and wooded heights of Hampstead far away. *Coniston Old Man from Warton Crag*, therefore, can just as well be seen as representative of a school of painting that preferred to gaze on what might have been, rather than what actually was.

And yet, the likes of a new and rapidly changing world were being fashioned on canvas just the same, as painters gazed upon landscapes increasingly shaped by

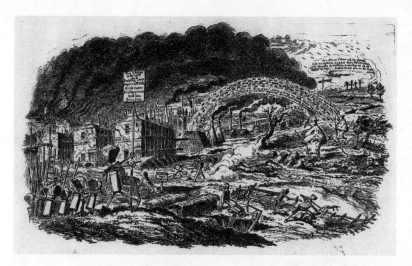

George Cruikshank, *London Going out of Town
– or – the March of Bricks and Mortar!*, 1829.

human hands, with viaducts, bridges and astonishing
feats of engineering. Turner's *Rain, Steam, and Speed*
(1844) is an early example of one such celebratory
painting, John Osborn Brown's view of the now vanished
Belah Viaduct (1869) another. One of the most famous
is Ford Madox Brown's remarkable and essentially
modern *An English Autumn Afternoon, Hampstead –
Scenery in 1853* (1852–1855). In this piece, the scene is
of a London suburbia spreading up the slopes of the hills
towards Hampstead; the views are not just of orchards
but of rooftops and back gardens too. Ruskin was not
amused. 'What,' he complained, 'made you take such a
very ugly subject? It was a pity for there was some nice

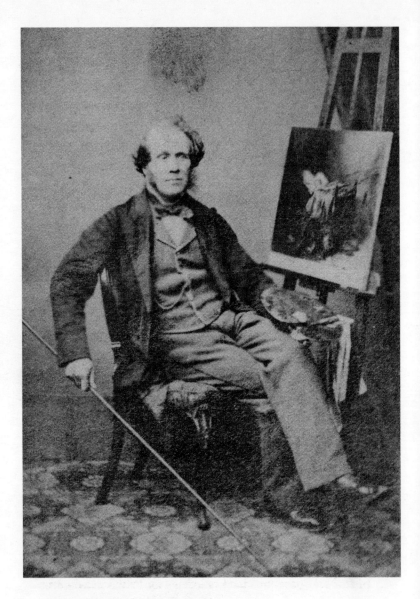

William Powell Frith photographed by
Maull & Polyblank in the mid-1860s.

painting in it.' Brown answered, tersely: 'Because it lay out of a back window.'[4] Frith himself, as he sat on the beach at Ramsgate, could not have put it better.

It was only a short step from realistically painting the world outside the city to celebrating the city in its natural habitat. Walter Greaves's *Hammersmith Bridge on Boat Race Day* (*c.*1862) is a case in point, capturing as it does the colour and excitement of a specifically urban scene. And Holman Hunt's *London Bridge on the Night of the Marriage of the Prince and Princess of Wales* (1863–1866) is another. All human life is here, it seems to say; 'the mob' has become the crowd – altogether less threatening. Hunt includes a scene of a criminal at work – not so much a threat, of course, as part of the rich tapestry of the Victorian city. And there's the reassuring presence of a policeman closing in on him.

The Derby Day

Certain painters, of course, were quicker to respond than others to changing preoccupations and interests – and once more Frith led the field. *The Derby Day*, which was first exhibited at the Royal Academy in 1858, was one of the most popular and successful paintings of its day. One of several densely packed paintings by Frith, it shows an enormous crowd gathered for the annual running of the Derby on Epsom Downs. By the time of Frith's visit to the

race, the event had become an unofficial public holiday – even parliament closed for the day.

Frith was intoxicated by what he called the 'kaleidoscopic aspect of the crowd'. His picture is a dense, exuberant tableau of over ninety individuals which celebrates the sheer spectacle of humanity. Pickpockets, prostitutes and tricksters jostle against aristocrats, children and politicians. The Derby was an occasion – one of the very few in the Victorian calendar – when all classes, from the grandest to the criminal, rubbed up against each other. Not that all was unadulterated equality: the toffs would tour the encampments of Irish gypsies and other itinerants before the races began, viewing their inmates as a novel species in a nineteenth-century version of a Bedlam tour; the *Illustrated London News* reported shrilly on the sight of the upper classes prepared 'positively to hob and nob with those palpably inferior to them in station'. But Derby Day was the closest Victorian Britain could come to abandonment – as one French visitor tartly put it, it provided 'an outlet for a year of repression' – and it was this that attracted Frith.

He had first attended the Derby in 1856 with his friend, the painter Augustus Egg, and he has left behind an account of his intoxicating day. Not that it began all that well, for Frith came within inches of being conned by a bogus vicar before the sun had risen far in the sky:

> So convinced was I that I could find the pea under
> the thimble, that I was on the point of backing my

guess rather heavily, when I was stopped by Egg, whose interference was resented by a clerical-looking personage, in language much opposed to what would have been anticipated from one of his cloth.

'You,' said Egg, addressing the divine, 'you are a confederate, you know; my friend is not to be taken in.'

'Look here,' said the clergyman, 'don't you call names, and don't call *me* names, or I shall knock your d---d head off.'

'Will you?' said Egg, his courage rising as he saw 2 policemen approaching. 'Then I call the lot of you – the Quaker there, no more a Quaker than I am, and that fellow that thinks he looks like a farmer – you are a parcel of thieves!'

'So they are, sir,' said a meek-looking lad who joined us; 'they have cleaned me out.'

'Now move off; clear out of this!' said the police; and the gang walked away, the clergyman turning & extending his arms in the act of blessing me and Egg.

Frith called the spectacle on Epsom Downs 'Modern Life with a vengeance', and set about turning his experience into the definitive painting of this national festival. 'The acrobats,' he later wrote, 'with every variety of performance, the nigger minstrels, Gipsy fortune-telling, to say nothing of carriages filled with pretty women,

together with the sporting element... the more I considered the kaleidoscopic aspect of the crowd on Epsom Downs, the more firm became my resolve to reproduce it.' A lady friend told him that it would be an impossible task to get all the bustle of the races onto a single canvas – but Frith was a man who liked a challenge. In January of the following year, he began the work that would take him fifteen months to complete. In his *Reminiscences*, published years later, he looked back on the period and noted confidently: 'On the 20th January (1857) my diary says: "first day's work on 'Race-course'; a long journey, but I go to it with a good heart, and if I live, doubt not a triumphant issue."'

The painting was commissioned by amateur artist Jacob Bell, whose Quaker background may have prevented him gambling on the horses, but did not inhibit his enjoyment of the spectacle of humanity *en fête*. The heir to a pharmaceutical fortune (as in John Bell and Croyden, the Wigmore Street chemists), he did not achieve the artistic ambitions he nurtured for himself, but he enabled the creation of one of the most celebrated Victorian paintings of all. He also, thanks to what Frith described as an 'extensive acquaintance, especially among the female sex', supplied many of the models. 'I had but to name the points required,' Frith would later remember, 'and an example was produced. "What is it to be this time?" he would say. "Fair or dark, long nose or short nose, Roman or aquiline, tall figure or small? Give your orders." ... I owe every female figure in the "Derby Day", except two or three, to the foraging of my employer.'

To create as accurate a portrayal as possible, Frith and the art dealer Ernest Gambart (the other sponsor – he had bought the reproduction rights) sent a photographer to take pictures of the Epsom grandstand. It was the first time that photography had been used in the planning and creation of a prominent painting. Frith hired a jockey to stand in the stirrups on a wooden horse in his studio ('I grieve to say,' he noted later, 'that my little jockey friend was soon after killed by a fall from his horse in France'), persuaded a pair of acrobats from the Drury Lane pantomime to pose for him and engaged a series of models to stand or sit in attitudes which seemed appropriate to the stories he wished to tell.

The crowd is overwhelming. At the left of the painting (and strategically situated just outside the tent of the Reform Club, ho-ho) is the 'thimble-rigger' himself: the con-man with the table for the unwinnable game in which a ball or pea is hidden under one of three tumblers, and participants (like Frith himself) removed of money by thinking they know where it is. The thimble-riggers sneer at the pale-faced, top-hatted victim while the crowd urges a perspiring policeman to intervene; the policeman passes his hand through his hair distractedly, as if saying he's powerless to do so. Immediately to the right of the table is a flash young man who has had his pockets emptied, while to the left a country bumpkin in a milking smock is held back from losing *his* money by his girlfriend. Between them stands the thimble-rigger's accomplice, brandishing a fistful of notes he seems to have won, to

entice further victims. The figure in the red fez is Frith's friend, the fairy painter Richard Dadd. Pushed back into the middle ground is the supposed main business of the day, the track and its races.

In the central foreground, meanwhile, is a group of gypsies. Behind them, a troupe of tumblers performs in front of a carriage full of toffs. A young boy drops some coins into a hat; a picnic is spread on the grass, distracting a young boy from his business of turning somersaults for payment; and a group of pickpocketing urchins works the crowd, focusing on a pair of tall-hatted German visitors. On the right of the picture, another carriage holds a young woman, not a girlfriend this time but an unhappy-looking mistress, the property of a repellent-looking young man who leans back, smoking a cheroot. The murderer John Thurtell can be identified in the midst of the throng, clad in green and clutching a banknote. It is absurdly, unrealistically, crammed, of course, a crowded, swirling impression of a day at the races rather than a snapshot. The juxtapositions are not false, merely heightened, which is what gives the painting its force. More than anything, it is like a successful soap opera, a celebration.

Frith did well with his paintings. For *The Derby Day*, he earned £1,500 from Jacob Bell, the same amount from selling the engraving rights, and another £750 from exhibitions. This was art for the new urban world, and the new urban world loved it. When the painting was displayed in the Royal Academy's crowded premises

on Trafalgar Square in the spring of 1858, the crowds had to be held back by a specially installed stout iron rail and an even stouter policeman; one account spoke of 'people smelling the picture like bloodhounds'. Even Queen Victoria and her husband, when they came to the Academy several days later, told the artist how much they liked the scene. Albert, characteristically, offered advice about how the painting might have been improved, which Frith appears to have accepted with good grace – although as his *Reminiscences* demonstrate, he wasn't afraid of blowing his own trumpet:

> When the Queen came into the large room, instead of, as she invariably did, looking at the pictures in order according to the catalogue, she went at once to mine; and after a while sent for me and complimented me in the highest and grandest manner. She said it was 'a wonderful work', and much more that modesty prevents my repeating ... It was on this occasion that the Prince Consort surprised me exceedingly by his intimate knowledge of what I may call *the conduct of* a picture. He told me why I had done certain things, and how, if a certain change had been made, my object would have been assisted. How the masses of light and shade might be more evenly balanced, and how some parts of the picture might receive still more completion. I put many of the Prince's

suggestions to the proof after the close of the Exhibition, and I improved my picture in every instance. There were several little Princes and Princesses in the Royal party; and I remember one little boy saying, the moment he looked at the picture: 'Oh, mamma, I never saw so many people together before!'

The unveiling was followed by five lucrative years in which the painting was displayed around the world, from Paris to America to the Australian goldfields to Vienna – where Frith, to his great satisfaction, was elected a member of the Austrian Academy on the strength of his painting's reception. In 1865, *The Derby Day* was brought to the National Gallery. It hangs today in Tate Britain and remains one of the gallery's most popular paintings.

The Railway Station

The audiences to whom *The Derby Day* and *Ramsgate Sands* were first exhibited greeted the paintings enthusiastically because they could read them like a book. To be sure, they caused ructions too: F.W. Fairholt was not the only contemporary commentator who disapproved of a 'reprehensible' school of painting that could inflame the vulgar mob. A review of the International Exhibition of 1862 in the *Art Journal*, however, sheds a rather different

light on this thread of 'anecdotal painting'. According to the triumphant reviewer, narrative painting of everyday life could be seen as 'emphatically English':

> And it is English, moreover, because we in England are daily making to ourselves a contemporary history ... because, unlike the nations enjoying long-established stagnation, Britain is a land of action and of progress, trade, commerce, growing wealth, steadfast yet ever changing liberty ... because in this actual present hour we act heroically, suffer manfully, and do those deeds which, in pictures and by poems, deserve to be recorded.

Nor was it merely the British critics who offered words of nationalistic praise; at the Paris Exhibition of 1855, the French too were delighted by the detail, colour and freshness evident in the painting emerging from the other side of the Channel.

The Derby Day, of course, springs directly from the emergence of the Victorian city, a new monster that contained all manner of humanity within it. In the faces of the Derby crowd the spectator reads the different social origins, moral character and final destiny of the individual within the mass. The conventional assumption that Victorian society was one in which you were likely to die in the social group in which you had been born is not true, as the upward social mobility of many of the artists (and much of the burgeoning middle class) demonstrates. But it

was certainly the case that much of the middle class itself believed that the key to a stable society was for everyone and everything to have its place. And yet, in Frith's famous painting, these normal class divisions have collapsed. Pictures like these celebrated a new social reality.

It was not always thus. Early reactions to these sprawling, noisy, smelly places had been fearful. *The Derby Day* and *Ramsgate Sands,* however, show the urban masses as something to enjoy. In another Frith picture, *The Railway Station* (1862) which shows a bustling crowd beneath the arching roof of Paddington Station, this message is even more explicit. Again, there was huge public interest in the painting, and much discussion at the time of what was shown happening; and again, the painting bustles with energy, showing massed humanity as something to be savoured rather than feared.

In this painting, Frith paints himself and his family – or rather, one of his families – into the narrative. A fond mother, modelled on his wife Isabella Frith, clad in fashionable paisley shawl and off-the-brow bonnet, is bidding farewell to her younger son, who is clutching a new cricket bat; her elder son, about to escort his brother to boarding school for the first time, looks on, with his father's hand protectively on his shoulder. This affluent Victorian family scene is cut, however, with other influences: on the right of the painting, two policemen arrest a bankrupt or forger as he attempts to join his wife on the train; these gentlemen were based on celebrated detectives of the time, both of whom posed for Frith. (He found them admirable models

in that they were used to 'standing on the watch, hour after hour, in the practice of their profession, waiting for a thief or a murderer'.) A bridal party next to them provides a clean moral contrast; a scarlet-coated foreigner, modelled on a Venetian employed to provide Italian lessons to the daughters of one of Frith's families, argues with a cabby; a family rushes into the side of the painting, late for the train; an elderly lady stands guiltily, caught in the act of smuggling her Maltese terrier into a compartment; and a bonneted lady at Frith's elbow may or may not be a representation of his young ward, Mary Alford. Nor were Frith and his assorted relatives alone in being featured in the painting. The art dealer Louis Victor Flatow, who commissioned the painting (and paid a generous £4,500 for it: a record at the time), insisted on being included: he's the small, rotund gentleman busy in conversation with the train driver.

In the aftermath of *The Derby Day*'s success, Frith was on a roll. Nor did he necessarily have to stick with the Royal Academy, where pictures competed for space in a crowded display, since *The Railway Station* was instead exhibited at Flatow's own gallery on the Haymarket in the spring of 1862. Frith's *Reminiscences* are once again unctuous with satisfaction: 'A great success. I find that 21,150 people paid for admission in 7 weeks, and the subscription for the engraving was surprising and satisfactory.' *The Railway Station* also toured extensively, before settling down at last at the new Royal Holloway College in Surrey.

At this point in his career, with success following success, Frith was one of the most popular of Victorian

artists. The Queen's personal patronage, his membership of the Academy and his close ties to some of the leading writers of the day – Ruskin, Dickens, Trollope – presented a daunting combination. To crown it all, his family life was a picture of Victorian propriety: a fact borne out in his painting *Many Happy Returns of the Day* (1856), in which a loving, close-knit family comes together to celebrate the birthday of a delightful, blue-eyed little girl. When the painting was exhibited at the Royal Academy that summer, the critics applauded its 'moral and improving' tone, comments which account, perhaps, for the fact that it was rather less popular than the carnival of *Ramsgate Sands* of two years before. The applause, however, must have been as music to Frith's ears, for he had used his own family as models. His wife Isabella is the doting mother gazing lovingly at the birthday girl, his daughter Alice. The old lady is once more Frith's mother and, at the top of the table, looking the very picture of contented – or smug – fatherhood, sits Frith himself. Holding a wine glass, he contemplates his happy lot.

Undoubtedly, Frith led a good life. But he also led a double life. Not content with being patriarch to one large and prosperous family, he also had a secret mistress, with whom he had a second family. At the same time as *Many Happy Returns of the Day* was being exhibited at the Academy, Frith's mistress was giving birth to their first illegitimate child – the first of an eventual seven, which would bring his full tally to no fewer than nineteen. Frith lived with Isabella and their twelve children – his official family – at Pembridge Villas in a respectable corner of

Notting Hill; while a mile or so down the road, in the rather less salubrious surroundings of Paddington, he set up home with his mistress and brood of illegitimate children. For many years, he managed to run both households without arousing his wife's suspicions. Then one day, so the story goes, Isabella spotted her husband in the street posting a letter. Nothing particularly remarkable about that, but for the fact that Frith was supposedly out of town that day; and indeed, Isabella received a letter from her husband later that same day, telling her what a lovely time he was having down at Brighton. Frith's cover had been blown.

For many years, the identity of Frith's mistress was a mystery. Recently discovered photographs, however, have identified her as Mary Alford, who was actually living with the family when the illicit affair began. Armed with these photos, critics have been able to identify Mary as a model in some of his paintings. In *The Rejected Poet* (1863), for example, she is the model for the beautiful Lady Mary Wortley Montagu who torments her suitor – Frith described her face as 'one which could break a man's heart'. Isabella died in 1880 and, a year later, Frith finally made an honest woman of Mary – a full twenty years after they had first become lovers and by which time Mary was 46 and Frith himself 62. *For Better, For Worse,* Frith's painting of the same year, shows a bride and groom departing from a London house and here, once more, autobiography weaves itself into the scene. The house has not been identified precisely, but is almost

certainly based on the same terrace of houses where Frith lived. The artist's interesting domestic arrangements were of course well enough known within a small circle of fashionable London society – and tolerated too. Yet they did have repercussions, of sorts: it is clear enough that they were the reason why, in spite of his commercial and critical success and his Royal patronage, Frith was never honoured by the Queen. Some actions could not be entirely overlooked.

The Shock City of the Age

No one in their right mind would suggest that either *The Derby Day* or *The Railway Station* is high art. Indeed, the critic Roger Fry described *The Railway Station* as 'an artistic Sodom and Gomorrah'. Frith was a businessman almost as much as he was an artist: this son of a publican understood how to turn a penny and, by his choice of subjects, manner of execution, use of the media and commercial arrangements, he did well for himself. Like other successful artists of the time, he became a very wealthy man; after all, it took a newly rich member of the burgeoning middle class to celebrate the burgeoning middle class. And – although it might just have been vanity on his part, of course – I like to think that by putting himself in the picture Frith was also signalling his willingness to rub along with his fellow city-dwellers. Something had

changed in Victorian Britain: a sense that perhaps the city with its noise and smoke and crowds wasn't such a nightmare after all, once you'd got used to it.

Inevitably, other painters saw how profitable Frith's paintings were and set out on a similar course. George Elgar Hicks's *The General Post Office, One Minute to 6* (1860) is another bustling canvas, freighted with incident. The title is self-explanatory – a scramble of anxious, overheated humanity trying to get its business completed before the shutters come down in the magnificent neo-classical General Post Office, St Martin's Le Grand (which was designed by the man who threw up the British Museum and much of Pall Mall). On the right of the canvas, porters force their way through the crowd, carrying newspapers in time to catch the free delivery for the following morning, while office boys, husbands, wives, lovers and children attempt to finish their everyday transactions. In Victorian days, this frenetic chaos was famous: spectators would gather simply to watch the bustle.

Similarly, Hicks's *Dividend Day at the Bank of England* (1859) and William Logsdail's *The Bank and the Royal Exchange* (1887) encapsulate the life, indoor and outdoor, of the City of London. In the latter, the scene is extremely detailed and precise and, framed by the Royal Exchange in the background and the Bank of England to the left, it includes portrayals of Logsdail's neighbours on Primrose Hill – all but one, as it happens, artists and their families and including Logsdail himself – atop an omnibus. Portrayals of public figures such as these would

have caught the attention of contemporary viewers, of course, but of rather more interest today are the moments of life in a tough city: a policeman orders a girl – begging with a baby and wearing a tattered shawl and clogs that are too big for her – to 'op it, as a well-dressed lady looks on in concern; the lady, by way of laboured contrast, is accompanied by a fluffy white dog that sports a blue bow around its neck and is better cared for than the nearby child. Paintings like these are marvellous examples of the vibrancy of Victorian London; they also give the lie to any notion that the Victorian middle class was ignorant of the lives that were lived around them. Rather the reverse: awareness of the awful lives of the poor was a reason to keep earning.

Indeed, how could they be ignorant when these paintings, like television today, made the same image available to vast numbers of people? Leeds, a city of under 400,000 people in the 1890s, might have 250,000 visitors to its City Art Gallery in a single year. The Royal Academy summer exhibitions would regularly pull crowds numbered in the hundreds of thousands.* Then there were the vast cultural and industrial exhibitions that were such a feature of mid-Victorian life. The most famous of these, of course, is the Great Exhibition at the Crystal Palace in London's Hyde Park, immortalised by Henry Courtney Selous in his *The Opening of the Great Exhibition by Queen Victoria on 1 May 1851* (1851–1852).

*In 1879, for example, the Royal Academy saw 391,000 visitors to its Summer Exhibition.

But perhaps the best example of all was the Manchester Art Treasures Exhibition of 1857.

When the great French historian Hippolyte Taine visited the rapidly growing city of Manchester, he described it as a 'great jerry-built barrack, a workhouse for 400,000 people, a hard-labour penal establishment'. Nor was he alone, as writers and philosophers flocked to see this 'Shock City of the Age' and to pass judgement upon it as a 'damp, dark labyrinth' where 'a sort of black smoke covers the city' and where 'the sun ... is a disc without rays'. Elizabeth Gaskell, in *North and South*, barely concealed her gripping portrait of Manchester as the cruel and harsh 'Milton'. Many painters preferred to get their experience of the city from a safe distance, as demonstrated by William Wyld in his *Manchester from Higher Broughton, 1852*, which displays an idyllic rural foreground with a hellish view of a reeking city far away. Wyld was but one of many Victorian painters who painted the city from the high ground of the moors to the west: you can almost see the city grow in these pictures, each later than the last, each with their belt of shrinking greenery shielding the viewer. It was a new world, but to be observed from a safe distance only – and for the Mancunian authorities, it was painful and humiliating stuff. It was time, they realised, to take this matter in hand: time, in other words, for an Exhibition that would celebrate the city and prove the critics wrong.

Local merchants subscribed sufficient funds to throw up an enormous glass-roofed building at Old Trafford and

then stuff it with works of art. They called the exhibition 'the greatest show on earth', and it seemed that the people agreed: over the space of 142 days, it drew in 1.3 million visitors from all over the world. So prevalent was the belief in the improving power of art that enlightened industrialists like the wool magnate Sir Titus Salt chartered special trains to bring their workers on all-expenses paid visits to the exhibition. Salt's 2,500 employees arrived in their Sunday best, accompanied by the works band.

The Manchester Art Treasures Exhibition was soon immortalised – which was partly the point of the exercise. Paintings such as Louis Haghe's pithily titled *Sir Thomas Fairbairn Handing Over the Address to the Prince Consort in the Art Treasures Exhibition, Manchester in 1857* captured the scale of the pavilion at Old Trafford and the ambition of the undertaking. It did not take long for patrons and artists to appreciate the propaganda potential of paintings able to command such widespread attention. One of the walls of the Manchester Exhibition was inscribed with Alexander Pope's ambition 'To wake the soul by tender strokes of art', and the sponsors of the enterprise had been clear from the start that it was to have a moral purpose. It was not, as Prince Albert put it, to be for 'the mere gratification of public curiosity'. The Manchester spectacle was also intended to demonstrate pride in the city and to try to pass on the Protestant ethics of the newly prosperous middle class.

Great set pieces of the era like the Manchester Art Treasures Exhibition and London's Great Exhibition were

all about the power of a public view. Everything was bigger, faster, louder, including the urban crowd. And increasingly there was a civic gospel too, explicitly set out by the leaders of the new industrial cities of Britain, an almost religious belief that, with vision, energy and ratepayers' cash, the Victorian city could become the envy of the world. The money was provided, helped along by new legislation that enabled taxes to be levied for the provision of galleries and museums. Such places were viewed as zones of 'rational recreation', designed not merely to aid relaxation but also to educate. Art had a higher purpose, as events in Manchester would make clear.

Manchester's most ambitious local politicians met at the city's Reform Club. Among the club's founder members was mayor and alderman Abel Heywood and under his leadership, the city's dreams of improvement were finally realised. Heywood and his allies were men who wanted the best for themselves and for their city. They dreamed of a permanent symbol of Manchester's greatness, a building that would proclaim the city's new status and sophistication from the rooftops. In the new Manchester Town Hall, they already possessed a potent symbol of their intentions: the building, designed by Alfred Waterhouse and erected between 1868 and 1877, is a showpiece of Victorian Gothic and deliberately suggestive of the great town halls of medieval European cities.

At the heart of the Town Hall, on the walls of the central Great Hall, was created a spectacular shrine to the city's new sense of itself: a set of twelve murals,

commissioned by the council from Ford Madox Brown (1821–1893) and painted between 1878 and 1893. These murals are impressive in their sweep and ambition, and helped to resuscitate the mural form in many of the country's new civic buildings. At this moment in the history of Manchester, however, they were setting out to do something terribly bold – something, even, rather cheeky. They were attempting to write – or rather, to rewrite – the history of Manchester to give it a noble pedigree. The result is an interesting mixture of great moments that featured in its history... and great moments that didn't.

Here, for example, is the opening of the Bridgewater Canal: a key development in the city's industrial growth. Here's the philanthropist Humphrey Chetham dreaming of his school for poor boys, which is still going strong as a music school in Manchester today. And here's the scientist John Dalton, engaged in one of his groundbreaking experiments. All of these are achievements of which Mancunians can be justifiably proud. But the baptism of Edwin – an event which marks the establishment of Christianity in England? That took place at York. And John Kay, the inventor who revolutionised weaving, actually came from Bury.

The creation of the murals led to humiliation for Manchester's city fathers, when one prominent antiquarian, W.E.A. Axon, was forced gently to point out the largely fictitious 'history' that Ford Madox Brown was being asked to immortalise. It was not merely a matter of a baptism here and a spot of weaving there: proposals for one mural, for example, described a battle at Salford in

the English Civil War that in fact took place at Aldport. Proposals for another emphasised the strong support given by Manchester to Prince Charles Edward (Bonnie Prince Charlie) and the Stuart cause in 1745; Axon replied that a more accurate version would show Manchester being rescued for the Crown by 'a man, a woman and a boy'. Although the paintings went ahead and were eventually completed, the resentment remained. Shortly before the artist's death in 1893, Manchester Council met in private and put forward a proposal to whitewash the murals and replace them with advertising. The resolution was never carried, but the painter's son claimed that the news of the resolution brought about an apoplectic fit which caused his father's death.

And of all the uneasy sensations that surrounded the creation of Manchester's murals, perhaps the most heart-sinking was this: desperate for Victoria herself to attend the inauguration of the Town Hall, the city's authorities decided to omit from the paintings the story of the 1819 Peterloo Massacre at Manchester, in which soldiers charged a meeting demanding parliamentary reform and abolition of the Corn Laws (which were keeping the price of bread artificially high), killing at least eleven people and injuring hundreds in the process. Liberals and radicals pointed out that the episode was a proud part of the city's cultural traditions – but to no avail. In the event, however, the Queen didn't come.

The history of the murals in Manchester Town Hall may be flawed, but the message that underlies their creation

and that of the Town Hall itself was nonetheless resonant: that the city of Manchester, driven by the industry of its middle-class elite, was ready to take its place in the front rank of civilisation. As the contemporary *Description* had it, the Town Hall symbolised both 'the opulence of the city, but also the great principle of self-government'. Such grand designs were certainly impressive, as *Chambers' Edinburgh Journal* noted:

> Manchester streets may be irregular, and its trading inscriptions pretentious, its smoke may be dense, and its mud ultra-muddy, but not any or all of these things can prevent the image of a great city rising before us as the very symbol of civilization, foremost in the march of improvement, a grand incarnation of progress.[5]

Baghdad by Kelvinside

Stirring events and transformations were also taking place further north – and this time Victoria would actually manage to make it along to see the changes for herself. In the second half of the eighteenth century, Daniel Defoe had described the city of Glasgow as 'one of the cleanest, most beautiful and best built cities in Great Britain'. Shortly after, however, came the Industrial Revolution: between the 1760s and the 1860s, the population of

Glasgow swelled from a mere 30,000 to over half a million people; with its giant cotton, iron and shipbuilding industries, the city became known as 'the Workshop of the Empire'. In the process, the medieval heart of the city became desperately overcrowded: the rich fled, leaving the area to poverty and disease. Some 50,000 people were crammed into cramped wynds – narrow closes and yards; in some parts, a thousand people lived in an area smaller than a football pitch. It was, as one inspector put it, 'one of the foulest ulcers that ever disgraced a modern city', and Friedrich Engels went one better: 'No person of common humanity,' he declared, 'would stable his horse' in such conditions.

As in Manchester, so in Glasgow: the authorities declared that something must be done. The process of change began rather doubtfully, with a deputation despatched on an all-expenses-paid fact-finding mission to Paris – but in this case, they came back with something useful. Mid-century Paris was in the throes of George-Eugène Haussmann's redesign, which resulted in the demolition of much of the city's medieval fabric and its replacement by wide boulevards and circuses. The visiting Glaswegians liked what they saw – and they returned bent on destruction. The Glasgow City Improvement Act of 1866 was accompanied by a series of photographs by Thomas Annan (1829–1887), graphically illustrating to any doubters the dreadful conditions that prevailed in the city. Soon afterwards, work began on a scale never before attempted in a British city. Slums were swept

away, thirty-nine new streets created, existing ones widened and realigned, and whole blocks rebuilt. The city's famous Tollbooth steeple was one of few remnants of the old town to be preserved, to become the hub of a new spacious urban district.

The seal was set on the transformation of the city with the inauguration of the city's new City Chambers, designed by William Young and opened by the Queen in 1888. Boasting mosaicked ceilings, it was a vast temple of civic power, but it is a mark of the collective pride in the rebuilding of the city that some 60,000 citizens had turned out to watch the laying of the building's foundation stone five years earlier. The founder of the National Trust, Octavia Hill, noted ecstatically that she 'felt as if some bright and purifying angel had laid a mighty finger on the squalid and neglected spot'.

The main reason Victoria came to town in 1888, however, was to attend the Kelvingrove Exhibition, which stands as one of the cultural highpoints of the era. Like the dozens of city art galleries built at this time, the museum at Kelvingrove embodies the Victorian conviction that art can raise up and ennoble a people. The motto, for example, of Birmingham City Museum and Art Gallery was 'By the Gains of Industry we Promote Art'. Rather more bracingly, John Ruskin noted: 'the first function of a museum … is to give example of perfect order and perfect elegance to the rude and disorderly populace.' And so, in a deliberate break from the bad old days when rich patrons hoarded artworks in their homes, the authorities in Glasgow decided to provide paintings and sculptures –

Thomas Annan, *Photographs of Old Closes and Streets, Glasgow*, 1866. Victoria and Albert Museum.

as one writer put it at the time – 'for the instruction and the gratification of the people at large'.

The Kelvingrove Exhibition was a true Victorian extravaganza, featuring a working dairy, an oriental smoking lounge, a Dutch cocoa house with waitresses in national costume, the world's largest terracotta fountain, a stuffed polar bear, live diamond cutting, and a giant Canadian cheese. There was Thomson's Patent Gravity Switchback railway, a balloon manned by Signor Balleni (who actually came from Warwickshire), busts of Queen Victoria done in soap, a loom making hygienic woollen underwear, a Bachelors' Café, an Indian fakir on a bed of nails, the Power Drop biscuit machine, and two Venetian gondoliers whom the Glaswegian public christened 'Signor Hokey and Signor Pokey'.

All this had been assembled with the express aim of raising money for what was to be the city's crowning glory – the ultimate symbol of transformation and improvement – a permanent palace of art. Set in a park to the north-west of the town centre, the building was enormous, with a floor area of almost half a million square feet. It had dark red and cream-striped walls with oriental towers and minarets, and was nicknamed 'Baghdad by Kelvinside'. Its Fine Arts section alone housed 2,700 exhibits – including paintings by Turner, Constable and Gainsborough – in ten galleries. The Exhibition resulted in a permanent museum, designed to trumpet to the world the energy and sophistication of Glasgow, in those days the second city of the Empire. The museum was paid for with profits from the exhibition, topped up by public subscription.

The notion that art could raise the morals and goodness of an entire population would of course be mocked by some Victorians, including William Frith. At this point, late in his career, the critics were still quarrelling with Frith, complaining that he was emphasising subject matter over beauty. It was a notion that he was happy to satirise. 'Beyond the desire of recording for posterity the aesthetic craze as regards dress,' he wrote of his painting *A Private View of the Royal Academy* (1883), 'I wished to hit the folly of listening to self-elected critics in matters of taste ... I therefore planned a group, consisting of a well-known apostle of the beautiful, with a herd of worshippers surrounding him. He is supposed to be explaining his theories to willing ears, taking some picture on the Academy walls as his text...'

The 'apostle' was a top-hatted Oscar Wilde on the right, and other figures on the canvas include Gladstone, Robert Browning, Lillie Langtry and the Archbishop of York. The critics, predictably, hated the painting, with the *Saturday Review* commenting:

> it has many of the qualities that attract a mob in
> a picture gallery. It is all on the surface – just like
> a straggling crowd – very spick and span, full of
> portraits of all sorts of celebrities, great and very
> little, and all of it perfectly vulgar.

The paying public, however, liked it, as they had liked Frith's earlier work, very much indeed.

With the help of artists like Frith, the Victorians were beginning to understand and embrace what the city could offer. A generation of citizens grew up unaware of a life not dominated by large, industrial urban areas – and a generation of artists emerged intent on capturing the poetry and beauty not of a rural past but of the most ostensibly unpoetic scenes. Take John Atkinson Grimshaw (1836–1893), for example, who found beauty in fog, smoke and lamplight. Born in Leeds, Grimshaw was the son of a policeman, and his was in many ways a classic Victorian life: he worked as a clerk on the Great Northern, and taught himself to paint on the side – and this in spite of the fact that his mother, when she discovered his other occupation, threw his paints on the fire in disgust. Wandering the streets of Leeds and Hull and the docks at Liverpool and Glasgow, Grimshaw saw something no artist had yet discovered: the beauty, romance and melancholy of the Victorian city. Grimshaw was in many ways its true champion, and atmospheric paintings such as the rain-sodden street in *Park Row, Leeds* (1882) and the moonlit harbour of *Shipping on the Clyde* (1883) demonstrate this abundantly.

From the town hall to the artist's studio, it appeared that Victorian Britain had at last taken the city to its heart. Looking around at the schools and libraries, the art galleries and public baths they had built, some evidently thought they were on the way to achieving an earthly paradise. 'We are almost induced to believe,' said one city councillor, 'that the day of modern civilisation is at its height.' But not every aspect of the modern world would be so easily embraced.

TWO
THY LONG DAY'S WORK

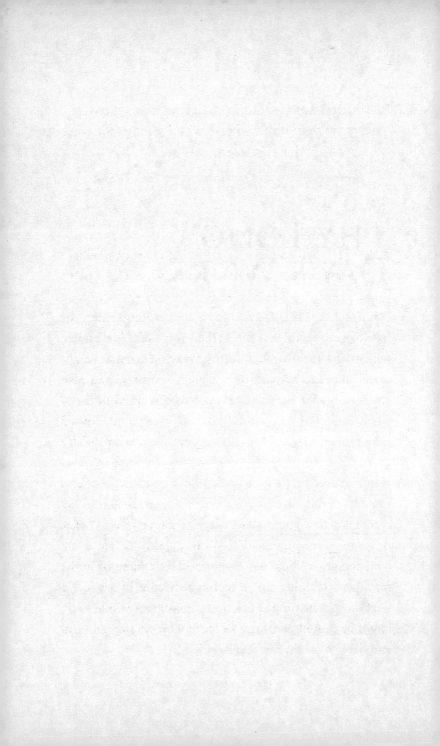

'You see, Tom … the world goes on at a smarter
pace now than it did when I was a young fellow …
It's this steam, you see.'

George Eliot, *The Mill on the Floss* (1860)

THE MILLS OF THE booming cities of northern
England and central Scotland, driven by the
new economic dynamo of steam power, were
emblematic of the shocks that were revolutionising the
world of the Victorians before their very eyes. These mills,
which had transformed cotton-weaving from a small-
scale domestic activity into a giant industry, had also
changed utterly the lives of those who worked in them.
They each employed hundreds of people and housed
hundreds of machines, and each was filled with the din
of labour from morning to night. It was impossible to
communicate verbally in such places: sweating workers
instead rapidly learned to lip-read, or relied on the
rudiments of sign language. It was impossible to relax
too, even for a moment, for the dangers of so doing
were too great: loose hair might become entangled in the
machines, scalping the unfortunate victim in a trice; a
finger might be nipped off in the spindles; a whole body
might be caught unawares in the machinery, whipped up
and broken on the ceilings overhead.

For work-seeking migrants newly arrived in cities like Manchester or Leeds, the experience must have been deeply shocking. Yet it was work. The mills may have been disturbing and dehumanising places, but they also offered a wage: they beat starvation or begging for handouts. And so the mills rattled on and the cities swelled: in 1773, for example, Manchester was a town of a mere 22,000 people; twenty years later, its population had more than trebled; and by 1850, it was fifteen times larger than it had been seventy years earlier.

The artistic response to this shocking new world was at first confused, mirroring the reaction of society at large. While the lot of the urban poor became an urgent concern for those appalled by the effects of industrialism, this distress first took literary rather than painterly form: Benjamin Disraeli's *Sybil* (1845), Charlotte Brontë's *Shirley* (1849), Charles Dickens' *Hard Times* (1854), Elizabeth Gaskell's *Mary Barton* (1848) and *North and South* (1855), and George Eliot's *Silas Marner* (1861) and *Felix Holt, the Radical* (1866) were all published in these years. In *Mary Barton*, Gaskell even provides a 'Manchester Song' that juxtaposes the supposed rural idyll that many of the mill workers would have remembered against the bleak reality of their present lives:

> Oh! 't is hard, 't is hard to be working
> The whole of the live-long day,
> When all the neighbours about one
> Are off to their jaunts and play.

There's Richard he carries his baby,
And Mary takes little Jane,
And lovingly they'll be wandering
Through fields and briery lane.

But strong pressures were rising to record both in words *and* pictures the sheer diversity of poverty. This resulted in a classic sociological treatise, Henry Mayhew's *London Labour and the London Poor* (4 volumes, 1851–1861), which was illustrated with daguerreotypes, the new photographic invention. And journals like *Punch*, *Fun*, *Household Words* (founded by Charles Dickens), *Illustrated Times* and, especially, the *Illustrated London News* all set a high standard in visual commentary.

Victorian painters, though, were slow to look this brave new world in the eye. Manchester, as we have already seen, was better viewed from a safe distance – or so many artists of the time felt, and painted accordingly. Later, they would descend from their fastnesses and engage with life on the streets, but in the pictures that many Victorian artists painted of ordinary people at this time, we see the same unwillingness to look hard at the world that was taking shape around them.

Frederic James Shields's *Factory Girls at the Old Clothes Fair, Knott Mill, Manchester* (1875) is a good example of a style of painting that, while ostensibly realist, nevertheless fails to square up to frequently disturbing circumstances. We are presented with a group of factory girls having a jolly time buying dresses; there is not a hint

of the actual factory in which they spend most of their day. And in Eyre Crow's *The Dinner Hour, Wigan* (1874), we see another group at a spinning mill, this time having a leisurely rest and a bite to eat. One of the subjects is even managing to spend a little time with her child. Another has bare feet, but they're absolutely spotless – there doesn't seem to be a speck of dirt in the entire yard. Moreover, and unlike their real-life counterparts in the factories, these figures all seem in possession of a full set of fingers. Even the chimneys are behaving themselves, as they putter out genteel little plumes of smoke. Some of the detail in such paintings is perfectly realistic: Eyre Crowe, for example, bought a large number of working women's shawls and petticoats at a pawn shop in Wigan in order to ensure that the clothes were accurate. The rest of the scene, though, is decidedly rose-tinted; and the often hideously grim conditions faced by just such industrial workers feature nowhere in these paintings.

Work life may have been hard enough – but home life could be just as bad, because with the modern city came the slum. At the heart of towns all over Britain, a horror story was unfolding, as workers flooded into these booming industrial cities – only to find that there was nowhere to live. There were simply too many people arriving and not enough houses; as a result, the newcomers often lived like animals. They crammed into existing houses any way they could fit, several families often sharing a single room, or even a cellar. Sanitary conditions were hellish. A doctor in Manchester reported finding one privy – little more

than a pit at the end of a narrow alleyway – that was shared between 380 inhabitants. One inspector described houses clustered around a yard six inches deep in 'night-soil' – a Victorian euphemism for excrement – into which bricks had been tossed so residents could get across. Unsurprisingly, disease was rampant. And, for every city like Glasgow that belatedly sought to address these social horrors – commissioning the likes of Thomas Annan to spread the word in photographic form – there were ten neighbourhoods that received no such investment. Mid-Victorian painters like Crowe and Shields gentrified the lives of the urban poor because they had yet to discover the city's distinctive aesthetic. The urban poor were the invisible Victorians – but it could only be a matter of time before the conditions of their lives were held up to the light.

A Place of Hardship

On Saturday 4 December 1869, a new sixpenny weekly newspaper hit the London newsstands. *The Graphic* had been founded by William Luson Thomas (1830–1900), who was a wood engraver and publisher by trade and a social reformer by inclination. Thomas wanted explicitly to challenge the market domination of the *Illustrated London News*, which had been founded in 1842, and which had since enjoyed a monopoly over its market. *The Graphic* was aimed at the same middle-class readership and included all

sorts of material, from reports of garden parties to political news, with much attention paid to science, literature and music. It announced itself to the world as 'a superior illustrated weekly newspaper, containing twenty-four pages imperial folio, printed on fine toned paper of beautiful quality, made expressly for the purpose and admirably adapted for the display of engravings'.

Where *The Graphic* differed from its rival, however, was in its commissions: from the outset, it sought work from a new generation of artists, for Thomas wanted his illustrators to get out and find examples of how life was really lived in Britain, from farming fields to gin-palaces. In its early years, the publication presented full-page engravings of such scenes from working-class life – the gin-palaces and fields joined by factories and markets, workhouses and soup kitchens, all depending for their power and authority on strong doses of social realism. *The Graphic* and its artists quickly made a name for themselves. The publication was greatly admired and sometimes lovingly reinterpreted by Vincent Van Gogh, who lived in England as a young man, between 1873 and 1876. Van Gogh would go every week to the windows of *The Graphic* to see the new issues; several years later, when living at The Hague, he bought an almost complete run of the magazine, describing his collection as 'a kind of Bible to an artist'. He noted: 'For me the English black and white artists are to art what Dickens is to literature. They have exactly the same sentiment, noble and healthy, and one always returns to them.'

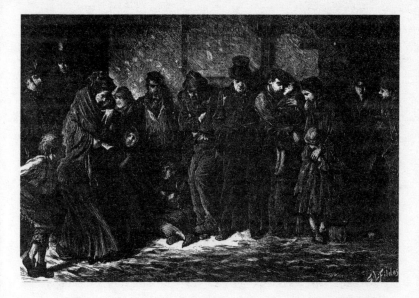

Luke Fildes, *Houseless and Hungry*, 1869.
The Graphic.

In 1869, the very first edition of *The Graphic* featured an engraving entitled *Houseless and Hungry*, by Samuel Luke Fildes (1843–1927). Fildes was brought up in Liverpool by his grandmother Mary Fildes, a publican and radical political activist, and much of his own social awareness may be traced back to this early political influence. Mary had been on the speakers' platform at the 1819 Peterloo Massacre in Manchester, and was among those wounded. If Fildes had not taken in radicalism with his mother's milk, then, he certainly somehow imbibed a taste for it from his father's mother, and his inclination found a good deal to work with on the streets of London.

The 1834 Poor Law Amendment Act required anyone without a roof over their head to present themselves at a police station, there to obtain a ticket entitling them to a bed for the night in the 'casual ward' of the local workhouse. The workhouse system in Britain was a response of the Victorian authorities to the shocking state of their cities. The principal impulse driving the creation of this system wasn't sympathy or charity – but blame, for it was their firm conviction that many of the poor had brought their misery on themselves. The workhouse system was intended to scare them out of poverty, or at least out of fecklessness. The new regulations of the 1830s ruled that those who fell on hard times should no longer be given handouts at home: instead they must present themselves at the new workhouses; in 1841, almost 200,000 paupers were driven to endure this regime. A clergyman, writing to those framing the Poor Law Amendment Act of 1834, sums up the new philosophy:

> The workhouse should be a place of hardship, of coarse fare, of degradation and humility. It should be administered with strictness – with severity; it should be as repulsive as is consistent with humanity.

These institutions, guided as they were by a system of segregation, classification and supervision, were prisons in all but name. Once admitted, new arrivals would be stripped of their clothes, which would be sterilised, and their possessions,

Luke Fildes photographed by Ralph Winwood
Robinson in 1892.

which would be placed in storage and returned only upon departure. Inmates would then be forcibly washed, deloused and disinfected with carbolic soap and made to put on a deliberately uncomfortable uniform. Unmarried mothers often had to wear a special yellow outfit as a badge of shame. Families were split up, with one wing for women, another for children, and another for men. All connecting doors were kept locked. Children taken from their parents could be sent off to work in factories or the mines. It was reported in *Punch* that in one workhouse, an infant of five months was separated from its mother, being only 'occasionally brought to her for the breast'; the magazine accompanied its story with a scathing cartoon, entitled *The Milk of Poor-Laws Kindness* (1843). Once separated, meanwhile, you were further classified by type, with one space reserved for old and infirm adults – or 'the blameless' as they were known – and another for the lowest of the low – the undeserving poor. Able-bodied adults without a job could be officially designated the 'idle and profligate'.

Conditions in such places were always hard and the fare invariably 'coarse': in 1846, for example, an investigation found that paupers at the Andover workhouse had been reduced to sucking the marrow out of rotting bones for food. Moreover, the provisions of the bill explicitly forbade the provision of extra rations on Christmas Day, or any other feast day – and these particularly punitive rules were only slowly relaxed. In 1847, the new Poor Law Board, which succeeded the Poor Law Commissioners, relented further and sanctioned the provision of Christmas extras.

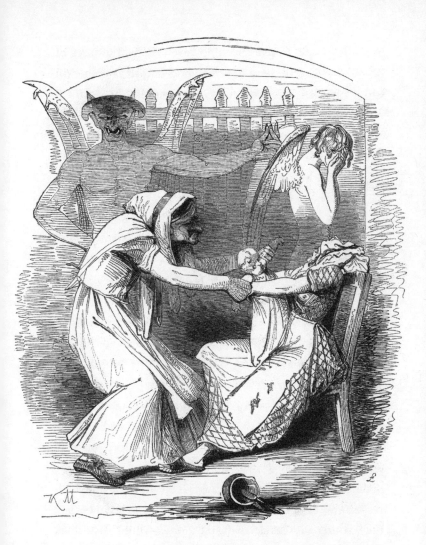

Punch: The Milk of Poor-Laws Kindness (1843).

For all this new festive cheer, however, the workhouses of Britain were no place in which to find oneself, whether on Christmas Day or any other day. The people who dreamed up the workhouse concept were no doubt sincere. But it is a peculiarly Victorian notion that help must always come with strings attached – in this case the help bit seems often to have got lost altogether in the air of punishment that pervaded such places.

Fildes and *The Graphic* were quick to respond to the presence of the workhouses and to the horror stories that emanated from them. 'When I first came to London,' Fildes later remembered, 'I was very fond of wandering about, and never shall I forget seeing somewhere near the Portland Road one snowy winter's night the applicants for admission to a casual ward.' His painting of men, women and children huddled against a wall on a snow-swept street, recreates the scene, reportedly modelled for him by occupants of a local casual ward, at least one of whom (the fat man in the middle of the painting with his hands in his pockets) he rewarded with jugs of porter from a nearby pub. As Fildes explained, each is deliberately drawn as representative of a social type: at the left of the painting the 'hungry, cold and seedy, yet half-respectable adventurer' taking directions from a policeman; the labourer with his sick wife; the mother whose black cloak indicates widowhood or, perhaps, being the cast-out mother of an illegitimate child – for her fine clothes indicate a recent fall in status; in the shadows at the right-hand edge of the picture, a 'ruffian garrotter or ticket-of-leave burglar' and the crutch and red coat of the professional beggar. Posters on

the wall behind them labour the point. 'Child Deserted £2 Reward' reads one, alongside 'Lost, a Pug Dog. £20 Reward.' This was painting as dramatic, campaigning storytelling. It made waves: when John Everett Millais saw the drawing in the magazine, for example, he immediately recommended the artist to Charles Dickens, who commissioned Fildes to produce the illustrations for his last – and unfinished – novel, *The Mystery of Edwin Drood*.

In 1874, Fildes' original sixteen-inch illustration would emerge at the Royal Academy summer exhibition with a different name and in a rather different form: *Applicants for Admission to a Casual Ward* was an eight-foot oil, which lent the characters much more in the way of space, and with a mood emphasised by 'realistic' dark and subdued colouring. The painting caused a tremendous stir among the Academy's middle-class patrons and, like William Frith's work before it, had to be protected by a policeman and a rail. It was hailed as 'the most notable piece of realism', in which the painter had shown 'the startling impression of all wayward and unlovely reality'.[1] Public attention was guaranteed by the addition of a letter written to Fildes by Dickens himself, which describes his own shocking exposure to the world of the casual ward:

> Crouched against the wall of the Workhouse,
> in the dark street, on the muddy pavement-
> stones, with the rain falling upon them, were
> five bundles of rags. They were motionless, and

had no resemblance to the human form. Five great beehives, covered with rags – five dead bodies taken out of graves, tied neck and heels, and covered with rags – would have looked like those five bodies upon which the rain rained down in the public street.

… We went to the ragged bundle nearest the Workhouse-door, and I touched it. No movement replying, I gently shook it. The rags began to be slowly stirred within, and by little and little a head was unshrouded. The head of a young woman or three or four and twenty, as I should judge; gaunt with want and foul with dirt, but not unnaturally ugly.

'Tell us,' said I, stooping down. 'Why are you lying here?'

'Because I can't get into the Workhouse.'[2]

There followed a good deal of debate as to the suitability of such images – when the *Saturday Review* got a look at Fildes' picture, it sniffed that it was 'too revolting for an art which should seek to please, refine and elevate'.[3] But the fact that reproductions sold by the thousands shows that the mass market made possible by the country's frantic industrialisation had other ideas. Fildes was bringing off pictorially what Dickens and others had already done in fiction and Mayhew in journalism, and new techniques of mass production made it possible to spread the message way beyond the people expected to visit a picture gallery.

Paintings like *Applicants for Admission to a Casual Ward* were the cinema newsreels or television documentaries of their day, and awareness of the issues they addressed rippled out to a wider audience. And, like most newsreels and television documentaries, they were not a true facsimile of life but were rather a doctored version, designed to demonstrate a deeper or broader truth than the chance spectacle allowed.

Images purporting to deal with the raw stuff of Victorian life, however, were always in a minority: the successful mill owner was more likely to commission a portrait of himself or his family than he was to hang upon his walls some gloomy representation of the miserable lives of his employees. And besides, even those everyday scenes which appeared in the pages of *The Graphic* or the *Illustrated London News* did not include much of the nasty side of poverty – representations of the squalor, grime and the ever-present fear of violence. They tended, instead, to present a picturesque vision of the world: one which told a story while giving the viewer a reassuring sense of his own good fortune, that he was not persecuted by want in the way that others were. They often seem less radical than compassionate, turning what might have been a spur to political action into a matter of personal catharsis.

A good example is Fildes' *The Widower* (1875–1876), which presents the image of a burly labourer in his simple cottage, clutching his child who, head caught in the light, has fallen back limply in death. The man's eldest daughter, who has had to take the place of the mother of the family,

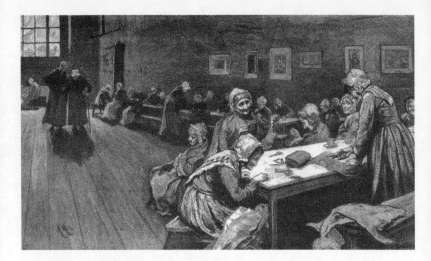

Hubert von Herkomer, *Old Age*,
1877. *The Graphic.*

bows her head while three smaller children, indifferent to
the tragedy, play with a puppy on the floor. The painting
was well received on the whole, although *The Times* still
grumbled that the painting had gone too far for comfort:
'It is a great pity,' it complained, 'that painters do not bear
in mind the fact that their pictures are meant to adorn
English living-rooms.'

Fildes was joined in the pages of *The Graphic* by other
artists who would similarly make a measured impact on the
culture and politics of the day. One such was the German-
born Hubert von Herkomer (1849–1914), whose *The Last
Muster: Sunday at the Royal Hospital, Chelsea* was shown
at the Royal Academy in the summer of 1875. This painting

was also based on a *Graphic* engraving, modified to show a group of Chelsea pensioners during a service in the Chelsea Hospital chapel. One old soldier has suddenly realised that his neighbour has died, and feels for his pulse. Two years later, an engraving usually considered to be the twin of *The Last Muster* appeared in *The Graphic*. Entitled *Old Age*, the picture presented a very cheerless scene in the women's quarters of a workhouse: all bare floorboards and windows and tired women bent over a scrubbed wooden table. A year later, however, Herkomer revised the engraving as a painting: *Eventide: A Scene in the Westminster Union, 1878* (1878), which depicts the inmates of what is now identified as the St James's Workhouse in Soho. The scene is at first sight similar to that displayed in *Old Age*, for the women are still grouped around the table at the end of a long and sparsely furnished room. But the scene in the painting has been subtly altered: now the room looks quite comfortable and sports a tablecloth, a vase and prints on the wall. The women, no longer dismal and bent, are smiling as they address themselves to their sewing; one holds a Bible on her lap and another enjoys a cup of tea. The inclusion of a young woman in their midst shows the contrast between youth and age, a popular Victorian theme. The shift between the original *Graphic* sketch and the final *Eventide* painting was further proof that wealthy patrons just didn't want to buy pictures that showed the truth about how their fellow Britons were living.

There were plenty of other Herkomer paintings showing the realities of life for poorer people. *Pressing*

to the West: A Scene in Castle Garden, New York (1884),
for example, shows poverty-stricken immigrants waiting
at New York's immigration and employment centre; *On
Strike* (1891), which dramatises the effects of industrial
unrest on a single working-class family. My own favourite,
Hard Times, 1885 (1885) is less crowded, merely showing
an unemployed labourer and his family walking from town
to town, looking for work. The painting tackles the issue
of the families who found themselves without any income
as a result of economic depression. Again, the painting
is an engineered reality: the wife and two children in the
picture were the family of James Quarry, who poses as the
itinerant labourer, but was, in fact, in work. Herkomer
captured the road by having a glass-fronted hut built
for him in Coldharbour Lane, near his house at Bushey,
Hertfordshire. The painting was castigated as mawkish
and sentimental – and later as 'art on the way to make
socialists of us'.

A third principal *Graphic* artist was Frank Holl (1845–
1888), who lived just long enough to establish his reputation.
His most famous painting was *Newgate – Committed for
Trial*, which established his name as the leading social realist
painter of his time when it was exhibited at the Academy
in 1878. Holl had been invited to Newgate by its governor,
Sidney Smith, and visited the infamous prison several times.
'I shall never forget,' he exclaimed, 'the impression it made
upon me! Prisoners of all sorts of crime were there – the
lowest brutal criminal – swindlers, forgers, and boy thieves
– all caged together, awaiting the results of their separate

trials, and in one or two cases, the misery of their friends in seeing them in this hopeless condition, fell but lightly on their brains dulled by incessant crime.'

The painting, however, demonstrates again that the social realist painters were constrained in what they could and could not paint. The dreadful Newgate here looks to be not such a very terrible place after all: the floors are improbably clean, the light is good, and the prisoners may be wretched but at least enjoy the luxury of having visitors. *Newgate*, displaying as it did the developing Victorian interest in humanitarian concerns – for visitors were indeed permitted, at certain hours of certain days, to come and peer at the prisoners penned inside a specially designed cage – was met with general approval by the critics. There were notable exceptions, though: one exclaimed, 'how an artist personally so healthy bright & manly can year after year give way to this melancholy habit of mind & brush is beyond comprehension.'

Holl's breakthrough work had been the mournful *The Lord Gave and the Lord Hath Taken Away* (1869), which depicts a family gathering in the aftermath of a father's death. The painting appealed so much to the widowed Queen Victoria that she tried to buy it from its owners, although to no avail. Nothing daunted, however, the Queen instead commissioned a fresh painting from Holl; and *No Tidings from the Sea* duly appeared in 1871. This painting was equally dark and suggestive of the nearness of death, although this time the setting was shifted further down the social scale to depict poor people. It had been

created after Holl had spent two months in the fishing village of Cullercoats on the coast of Northumberland, during which time a number of fishing boats, caught at sea by a terrible storm, failed to return to port. Working at the time in one of the cottages, Holl witnessed a woman 'with hair dishevelled, and wild eyes ... muttering and moaning distractedly, wandering from door to window, from window to door, half-mad with suspense and misery'. The woman's grief haunted him for days. In the painting, the teapot is on the hob and the bed is ready, but the husband will not return. The woman has come in from a lamplit vigil, her bonnet still hanging down her back, and she sits bent over the back of the chair weeping. Queen Victoria, doubtless pleased by the painting's content, paid £100 for it – rather less, incidentally, than the price of *The Lord Gave and the Lord Hath Taken Away*, which had sold for £262. (Holl, incidentally, was only one of many Victorian artists who took to observing and depicting the lives of fishing communities: the Cornish villages of Newlyn and St Ives were especially popular.)

It is a nicely ironic arrangement: artists depict the lives of the less fortunate – and accumulate for themselves a reputation and a large bank balance in the process. For artists like Fildes and Herkomer, however, social realism in the *Graphic* mould only ever formed a part of their output: Fildes alternated such work with more gentle and pastoral scenes, while Herkomer experimented with a variety of rural landscapes. But both knew on which side their bread was buttered, for they went on to make fortunes (in Herkomer's

case a princely £250,000) from painting the portraits of the wealthy. Fildes, indeed, received the commission to paint the official Coronation portrait of King Edward VII and Queen Alexandra in 1902. Portraiture was a quick, easy and profitable line of work, not to mention much more popular. The earlier work of these artists tended as a result to be eclipsed – although late in life, Herkomer maintained consistently that his duty had in any case been to record *all* strata of society for posterity.

The Art of Work

One of the most famous Victorian paintings, Ford Madox Brown's crowded, busy canvas, *Work* (1852–1865), shows a gang of navvies engaged in the perennial task of digging a hole in the pavement. The moral of the picture is spelled out in the Biblical quotations on the frame, glorifying the social and moral purpose of labour: 'Seest thou a man diligent in his business, He shall stand before kings' and 'In the sweat of thy face shalt thou eat bread.' With its brilliant colours and closely focused detail, the picture is a mass of different vignettes, piled up, one on top of the other. Each one of them, though, is there to make a point.

Brown had begun the painting after seeing a group of men at work near his house in Hampstead. He announced that the home-grown labourer was 'at least as worthy of the powers of an English painter as the fisherman of the Adriatic,

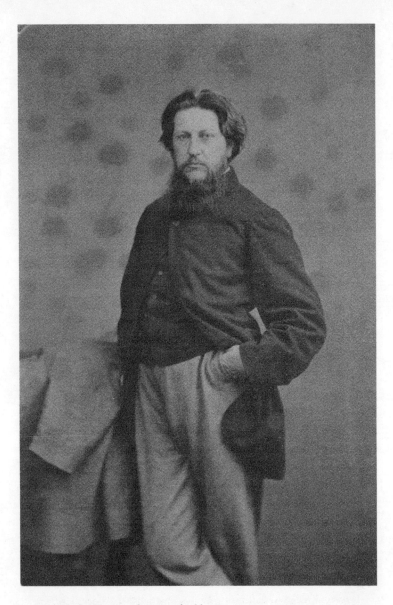

Ford Madox Brown photographed by
W. & D. Downey in the early 1860s.

the peasant of the Campagna or the Neapolitan lassarone'. So the navvies – young chaps 'in the pride of manly health and beauty', as Brown put it, and one of them, bizarrely, holding a rose in his teeth – occupy the middle of the painting and are shown in bright sunlight. Grouped around them are well-dressed ladies, itinerant migrants from Ireland, beggars, urchin-like children, street traders and respectable ladies and gentlemen all clustered on a few square metres of pavement.

But Brown finished the canvas at the instigation of a client, T.E. Plint, a stockbroker from Leeds with a keen interest in evangelism. Plint bought the picture before it was finished – and promptly began customising his purchase in a series of letters to Brown that dictated the content of much of the rest of the painting. So Brown added the figure of Thomas Carlyle (in the soft hat at the right of the picture), and first one and then another prominent Christian Socialist to demonstrate, as Brown put it, the importance of 'brainworkers', who 'seeming to be idle, work, and are the cause of well-ordained work and happiness in others'. Plint also asked Brown to change one of the fashionable women into 'a quiet, earnest, holy-looking one with a book or two and tracts'.

The rest of the painting is similarly packed with moral messages. On the wall a poster exclaims 'Money!! Money!! Money!!' In *Past and Present* (1843), Carlyle had divided society into workers, master-workers and master-idlers, and the division is evident in the picture. Opposite the two intellectuals is a strange, barefoot man with a basket of wild flowers – Brown explained that he was 'a ragged wretch who has never been taught to work' and therefore has to go out

into the countryside to find weeds to dig up and sell in town. Behind him come a couple of wealthy women, who have no need to work. In the shade at the back is a rich MP – if only he could be made to listen to Carlyle and his friend, he might understand the social obligations of wealth. The Irish migrant workers – 'a stoic from the Emerald Island, with hay stuffed in his hat to keep the draft out', as Brown put it; 'a young shoeless Irishman, with his wife, feeding their first-born with cold pap' – would work if they could but find a job. And yet there lurks a suspicion that perhaps Brown was trying to subvert his patron – is that a sneer on Carlyle's face? And why are the tracts on the evils of drink being ignored, while a lad brings a tray of beer for the navvies? In spite of these doubts, however, the overall intent still shines through – this is a hymn to the toil that was building a new world.

Brown himself knew the value of labour, having pored over *Work* for eleven years. 'I do not hurry with it,' he wrote, 'because it is such an enjoyment.' It is a painting which affirms the importance of labour, both spiritual and social. Work, it says, binds a disparate society closer together; provides dignity and fends off the despair that springs from an idle and meaningless life. A glimpse of a possible undesirable workless future is provided by the young children who inhabit the front of the picture and who have been left to fend for themselves following the recent death of their mother. Brown points out that the pretty-but-idle young lady on the left might find a worthier project in *them* than in her pampered greyhound which is a good deal better fed (and dressed) than they are.

Further, barely glimpsed, vignettes illustrate the country's underbelly of corruption and aggression: a female orange-seller is bullied by a policeman; Mr Bobus – who had already appeared in *Past and Present* as a figure more interested in power than in bettering the condition of the world – lurks in the background.

In contrast to the cheerful good health of Brown's navvies, Henry Wallis's *The Stonebreaker* (1858) shows a man shattered by work, the inmate of a workhouse who has sat down and died by the side of the road. A stoat sits on his foot to emphasise his stillness and defeat. This time the frame is inscribed with the line 'Now is done thy long day's work' from Carlyle's *Sartor Resartus* (1831). In the hierarchy of manual labour, stone-breaking sat near the very bottom and was frequently prescribed by the Poor Law guardians as a last resort, to see that there was some return on public money from those who sought refuge in the workhouse. The man in the painting has been worked to death and, more than any other version of this subject, Wallis's low-key painting, set at the fall of dusk, captures the utter weariness of physical toil. The picture has a clear political purpose, and justifies its place in the protests against an inhuman social legislation of the time. The *Illustrated London News* was pretty appalled, considering that the painting 'shocks the sight and offends the sense', but the *Morning Star* believed it ought to be 'presented to one of our metropolitan workhouses and hung up in the boardroom'.

Other paintings which deal with the grotesque work practices of the day include Frederic Shields' *One of our*

Breadwatchers (*c.*1866), a cleverly titled picture of one of the children equipped with rattles and stationed all day in a shelter in the snow, to scare away birds which might eat the seeds. Paintings like these had a cumulative effect, adding to a growing clamour for social change and for legislation that might at the least minimise the injustice and hardship that scarred the face of the country. It was not until 1847, however, and after several failed attempts, that Lord Shaftesbury's proposals for a maximum ten-hour day were at last passed by Parliament. Shaftesbury had produced a deep impression on his fellow legislators in describing visits he had made to hospitals in Lancashire, where he found many factory workers who had been crippled and mutilated under the conditions of their work; they presented every variety of distorted form, he said, 'just like a crooked alphabet'.

It was not so much the sight of dying stonebreakers that would stir the public conscience, but rather the sight of child sweeps – 'climbing boys' – being despatched to clean chimneys up and down the land: a version of 'Work' very far removed from Brown's handsome and dignified navvies. The image of the child sweep had been a classic and notorious image of cruelty and injustice ever since the appearance in 1789 of William Blake's 'Chimney Sweeper', whose 'father sold me while yet my tongue / Could scarcely cry "'weep! 'weep! 'weep! 'weep!" / So your chimneys I sweep and in soot I sleep.'[4] It was an image based very much in fact: it is estimated that there were still 4,000 small boys involved in the

trade as late as 1853. A Master Sweep would use such boys to climb up the inside of flues and brush them clean, with metal scrapers used to remove hard tar deposited by wood smoke. These youngsters were apprenticed and tied to the trade from as young as seven years of age; and the Master Sweep was paid a fee which was to feed, clothe, and teach the child his trade. Many Sweeps' Boys were parish children or orphans, although others were sold into the trade by their families. Some grew up to be Journeymen (assistants to the Master); the remainder were cast off to other trades.

Regulation was extremely light, although there existed in the capital the London Society of Master Sweeps with its own set of rules, one of which stipulated that boys must go to Sunday School to study and read the Bible. But employers were notorious for abusing and exploiting such boys; they were frequently depicted, as in Charles Kingsley's *The Water Babies*, as scoundrels. (In Dickens' *Oliver Twist*, a particularly vicious chimney sweep called Gamfield wants to take Oliver as an apprentice, but at the last minute the magistrate refuses to sanction the move, for 'Mr Gamfield did happen to labour under the slight imputation of having bruised three or four boys to death already.') Children would be forced to sleep in cellars on bags of soot and washing facilities rarely existed. There were no safety clothing or safety regulations to protect the boys, who might choke or suffocate to death from dust inhalation, become trapped in narrow flues or fall from rotten stacks to their death. The luckier ones merely

suffered from deformed joints, burns, and a form of testicular cancer caused by carcinogenic chemicals in the soot. Eventually, the public outcry against the practice led to a search for a substitute and the invention of a special brush with a telescoping handle that allowed a sweep to reach right up the chimney without the need actually to enter it. In terms of legislation, however, it was not until the 1864 Chimney Sweeps (Regulation) Act, promoted by the energetic and philanthropic Lord Shaftesbury, which introduced a fine of £10 (a large sum in those days) that the practice of hiring small children began to peter out; a further Act of 1875, which required police authorisation for use of child sweeps, caused it gradually to cease, following press interest in the death of a child sweep called George Brewster, who suffocated while sweeping flues at a hospital in Cambridge. He was 12 years old. The post-mortem examination revealed his head was congested and his lungs and windpipe full of black powder.

The reluctance of certain Victorian artists to deal with the reality of life for many children can be seen in Frederick Hardy's *The Chimney Sweep* (1866). Hardy (1826–1911) set out to paint three young children clustered around a fireplace, obviously curious and excited by what they see. In spite of the title, there's not much chimney – and not that much sweep – to be seen. Instead, a large black cloth covers the fireplace and, poking out from under it, we can just see the soles of the sweep's blackened feet as he disappears to do his work. It's a charming domestic

scene. The painting was hugely popular and endlessly reproduced, but what's interesting is that, while the models were real and the fireplace was real (it was in the artists' colony at Cranbrook, Kent), what you don't get is any sense of the poor child who had to go up the chimney. This is not meant to be social commentary.

But many Victorian artists *did* respond to the social changes that Shaftesbury sponsored in these years. One of the most sugary of such paintings – to my taste – is *Shaftesbury, or Lost and Found* (1862), by William MacDuff. At first sight, this is pure sentimentality. A boy in red jacket and black cap – the uniform of the London Shoe Black Brigade – has his arm around a small street urchin as they gaze into a shop window. The tool of the taller boy's trade, a boot-cleaning stand, has been left on the pavement, alongside a crumpled poster advertising a Ragged School. The smaller boy is a chimney sweep; the taller is pointing at a portrait of Shaftesbury, who was not only president of the Ragged School movement but a co-founder of the London Shoe Black Brigade, designed to take boys off the streets by giving them organisation, employment and education. The Brigade had begun in 1851, to take advantage of the vast influx of visitors to the Great Exhibition. The taller boy wears the red coat of the central London branch of the organisation. Once you begin to understand some of the context, the picture is no longer just a piece of schmaltz, but a piece of vibrant campaigning. When *Lost and Found* was displayed at the Royal Academy in 1863, Shaftesbury was invited to the

opening dinner; the following year, his bill was finally passed. The huge public affection for 'the poor man's earl' is testified to in the commemorative statue of Eros by Alfred Gilbert at Piccadilly Circus.

* * *

The efforts of Shaftesbury and others to eliminate the most pressing social injustices of mid-century British society were acknowledged, albeit slowly, and social and industrial legislation was gradually enacted to help regulate a rapidly changing society. This was a change founded as much in a sense of fear as in a recognition of injustice: it was implicitly understood that improved working conditions would enable the country to avoid social turmoil and revolution. As one writer put it: 'As a stranger passes through the masses of human beings round the mills he cannot contemplate these crowded hives without feelings of anxiety ... the population is hourly increasing in breadth and strength.' The consequences of such growth were serious cause for alarm: 'What can be stable with these enormous towns?' asked one early nineteenth-century prime minister, Lord Liverpool. 'One serious insurrection in London and all is lost.'

On 10 April 1848, that day seemed to have come. Across the Channel, Europe was in revolutionary ferment, with uprisings from Naples to Prague. The French king had been deposed. Karl Marx had just published the *Communist Manifesto*. In London, a huge demonstration was planned, to

insist on new rights for British citizens. The protestors were known as Chartists, after the Charter they had published listing their demands, most of which might seem pretty modest to us today – votes for adult males, equal electoral districts, a secret ballot. But the authorities in London, urged on by a hysterical press, feared the overthrow of the State itself. And they prepared for the worst.

The Royal Family was despatched from Buckingham Palace to the safety of the Isle of Wight. The police – their numbers swollen by thousands of volunteer 'Special Constables' – took up positions in strategic points around the capital. They guarded the bridges over the Thames, with cavalry and foot soldiers on standby. At the British Museum, no chances were being taken. The director of the Museum declared: 'If the building should fall into the hands of disaffected persons it would prove a fortress capable of holding ten thousand men.' Up on the roof, bricks and stones were stockpiled – to be hurled down by loyal museum staff onto the feared swarms of rioters below. At Somerset House, home of the Admiralty, a portcullis was built across the doorway. At the Bank of England, sandbags lined the roof, with guns positioned in the apertures. London waited.

In the event, about 20,000 protesters gathered on Kennington Common in South London. It might have seemed an impressive crowd, but it was far smaller than had been predicted – and confronted with almost 90,000 police, the Chartists agreed not to march to Westminster. Three cabs were allowed to leave the Common to present

a petition to Parliament – where it was quietly ignored. At the Stock Exchange, relieved City traders sang the national anthem in relief that mob rule had been averted. And it was to stay that way. The great majority of the mid-Victorian working class seem to have wanted not Socialism but the opportunity to become middle class (which perhaps explains why so many of its members volunteered to put down the Chartists if it came to it.) The revolution was not going to happen here.

The bible of aspirational Britain was written by Samuel Smiles. Born in 1812, the wonderfully named Smiles had spent his early years as an energetic agitator for parliamentary reform. But he was put off by Chartism's threat of violence, and became convinced that the solution to society's ills was for each man to improve *himself*. To spread the word, he wrote *Self Help* (1859), which is a hymn to Victorian values, to enterprise, self-reliance and hard graft. It's optimistic, energetic, often sentimental, full of stories of heroism against the odds and pithy tips for success.

Self Help sold 20,000 copies in its first year and featured the inspirational tale of a working man – James Sharples (1825–1892), a blacksmith who had raised himself through art. Sharples was one of thirteen children, the son and grandson of blacksmiths. He didn't go to school, and started work in a Blackburn foundry at the age of ten. But he nursed a passion for art. He would walk eighteen miles to Manchester and back to buy paint and canvas. Something about Smiles's book must have appealed to Sharples, because he wrote to its

author telling him that to master anatomical drawing, he rose an hour earlier than usual – that is, at 3 a.m., before embarking on a day at the foundry that ran from 6 a.m. through to 8 p.m. – in order to get his brother Peter to model for him. (How Peter felt about this arrangement is not recorded.)

The result of these strenuous efforts was *The Forge* (1844–1847) which, in Sharples' words, 'simply represents the interior of a large workshop such as I have been accustomed to work in, although not of any particular shop'. The painting portrays a precision operation – a group of men working as one unit to manoeuvre the end of a large iron shaft into the blistering heat of an open furnace. It is merely one of many operations taking place in a giant ironworks that can be glimpsed through the doorway stretching way back into the distance. It's impossible not to be moved by such a painting, which took nearly three years to complete, the hours snatched here and there between work and sleep. When it was finished, Sharples was still only 22 years old.

Sharples' painting is one of the first to show the people and the places that were firing the Victorian revolution. It's full of a sense of respect for skilled labour because the artist was an insider – an ironworker as well as a painter. Samuel Smiles knew a self-help hero when he saw one. He kept Sharples' portrait in his own domestic shrine to men he admired. He wrote to him, 'I am much gratified that you appear in it in your working garb. I like your face: it is so sturdy and honest, as you have proved yourself to be.'

Like a true Victorian entrepreneur, Sharples made the most of his big break. He spent the next five years creating an engraving of the work that he could circulate to the fashionable periodicals of the day. The quality of the draughtsmanship, and the story behind it – helpfully appended by Sharples on a separate sheet – helped make it a huge hit. The Bank of England and the Foreign Office bought copies; Ruskin ordered a dozen of them – and Smiles, of course, would make of the artist a moral exemplar. All of which did Sharples no harm – but *The Forge* was nevertheless his only work. He tried to make a living as an artist but was eventually forced to return to engineering.

Like Sharples, Godfrey Sykes (1824–1866) possessed intimate knowledge of ironworking, and his *Sheffield Scythe Tilters* (1856–1859) is, like *The Forge*, a celebration of craftsmanship rather than an illustration of the repetitive labour of the assembly line. Sykes was especially proud of his Sheffield roots – the city was no Johnny-come-lately to industry, having been a centre of metal production since the seventeenth century – and the artist painted scenes of forging and grinding to make blades, many of which found their way into the possession of local city grandees. The processes these paintings show were, in fact, already out of date when they were painted – and so there is nostalgia here for a world succumbing to the advance of the machine age, as well as pride in the now-vanishing and frequently hereditary art of the master craftsman.

But there is also another side to Sykes's paintings, for the scene he reproduced – Abbeydale Works at Sheffield –

had been well known in the past as a focus of industrial unrest, concentrated on attempts by the Grinders' Union to operate a closed shop at the factory in the face of employers' attempts to hire non-union labour. In the resulting unrest, a keg of gunpowder was detonated on the night of 7 November 1842, severely damaging the premises in the process. While painting there in the 1850s, Sykes must have been aware of Abbeydale's reputation. Later investigations revealed that the beating of non-union labourers and 'rattening' – stealing or damaging their tools – had been widespread for decades. Against this background, the artist's image of the satisfied worker can hardly be taken at face value.

The works of artists such as Brown, Sharples and Sykes may have sprung from very different contexts, but they were all designed to draw attention to the social and spiritual importance of labour, its nobility and its craft – rather than simply its role in the economy. Such paintings foreshadowed changes to come, both political and aesthetic: in particular, the rise of an organised labour lobby in Britain; and the Arts and Crafts movement, that sought to grasp at the individual in the midst of what was now a mechanised culture. Most significantly, these paintings were searching for meaning, asserting the importance of humanity in what, in many ways, had become an increasingly dehumanised society. Down in London, other artists were on a similar mission.

Gustave Doré photographed by
Samuel Lock and George Whitfield in 1877.

Pilgrimage

The vast wealth and commerce of the Empire may have transformed Victorian London into the biggest, richest metropolis in the world – but in the process, it had become two cities. In the West End lived the wealthy, in luxurious villas and terraces; East London, with its swelling population of immigrants, sailors and destitute families, had become – like Africa – a heart of darkness in the Victorian imagination. Concerned philanthropists and writers made anxious forays into this hidden, menacing territory. 'I propose to record,' wrote one, 'the result of a journey into a region which lies at our own doors – into a dark continent that is within easy walking distance of the General Post Office.' To Henry James, lately arrived in the city, 'London was not a pleasant place ... only magnificent ... the biggest aggregation of human life, the most complete compendium in the world'. But it was also 'the largest chapter of human accidents ... clumsy and brutal and has gathered together so many of the darkest sides of life' that it would be 'frivolous to ignore her deformities'.[5]

Many explorers had no intention of ignoring society's deformities and set out to penetrate the perilous interiors of Britain's cities. For some, the purpose was to record a sense of real life without, perhaps, prying into the very depths. Emma Magnus's *Won't You Buy My Pretty Flowers?* (1887) and Dorothy Tennant's *Street Arabs at Play* (1890) are cases in point, for they

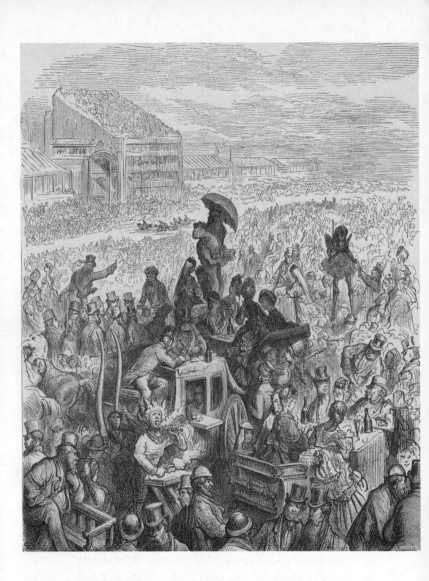

Gustave Doré, *The Derby – at Lunch*,
from *London: A Pilgrimage*, 1872.

capture a sense of poverty and of want, without actually horrifying the viewer in the process. The French artist Gustave Doré (1832–1883), however, had another task in mind. Fired by tales of the extraordinary scenes to be found in the capital, he set out to see for himself. Doré's *London: A Pilgrimage*, published in 1872, and complete with an accompanying text by Blanchard Jerrold, is one of the century's most extraordinary works of art – a meticulous and lurid record of late Victorian London. The rich are noted living it up at the opera or gathering at a garden party: he even captures, in *The Derby – at Lunch* (1871), a luncheon party on Epsom Downs. But it is the East End images that crackle with dark and fantastic detail. Where other artists flinched, Doré remained an unblinking observer.

Doré explored the city thoroughly in company with Jerrold, who wrote:

> We had one or two nights in Whitechapel, duly attended by police in plain clothes; we explored the docks; we visited the night refuges, we journeyed up and down the river; ... we saw the sun rise over Billingsgate, and were betimes at the opening of Covent Garden market; we spent a morning in Newgate ... we entered thieves' public houses; in short I led Doré through the shadows and the sunlight of the great world of London.

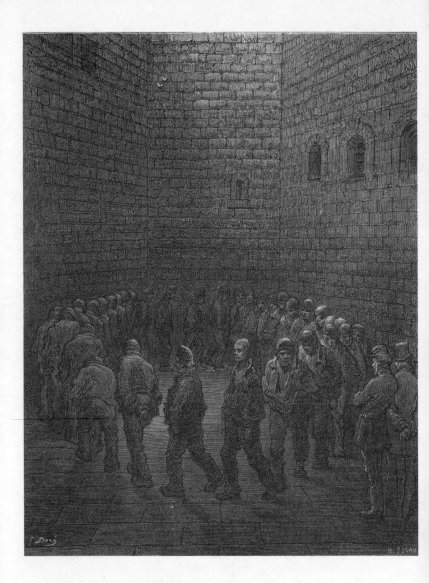

Gustave Doré, *The Exercise Yard at Newgate*,
from *London: A Pilgrimage*, 1872.

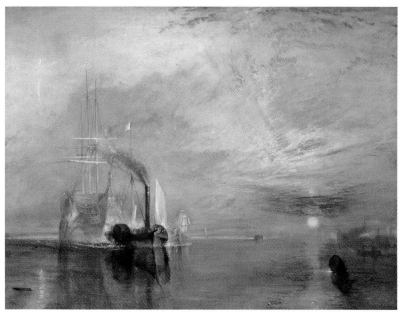

J.M.W. Turner, *The Fighting Temeraire, Tugged to Her Last Berth to be Broken Up, 1838*, 1839. National Gallery.

William Holman Hunt, *London Bridge on the Night of the Marriage of the Prince and Princess of Wales*, 1863–1866. Ashmolean Museum, Oxford.

William Powell Frith, *Life at the Seaside (Ramsgate Sands)*, 1854. Royal Collection.

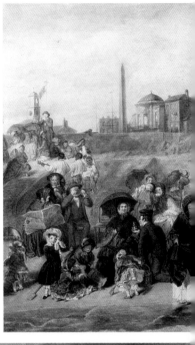

William Powell Frith, *The Derby Day*, 1856–1858. Tate Britain.

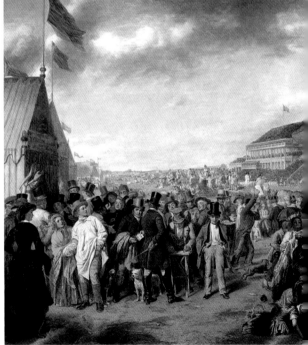

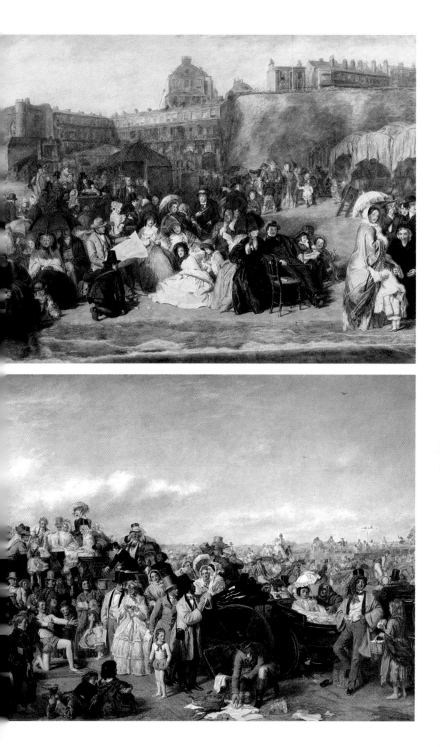

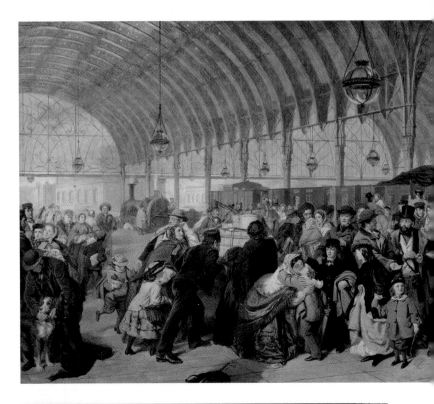

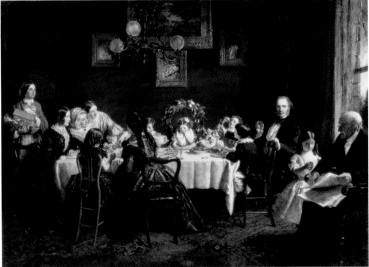

William Powell Frith, *Many Happy Returns of the Day*, 1856. Mercer Gallery, Harrogate Museums.

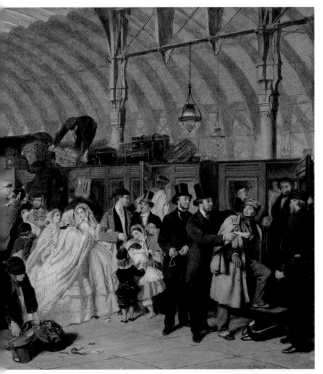

William Powell
Frith, *The Railway
Station*, 1862.
Royal Holloway
and Bedford New
College, University
of London.

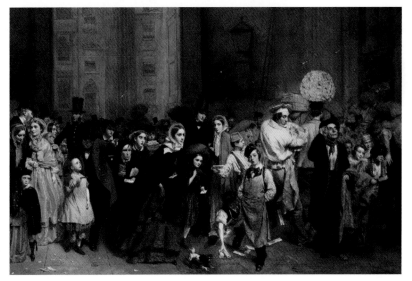

George Elgar Hicks, *The General Post Office, One Minute to 6*, 1860. Museum
of London.

(*Right*) William Powell Frith, *A Private View of the Royal Academy*, 1883. Private Collection.

(*Bottom, left*) Henry Courtney Selous, *The Opening of the Great Exhibition by Queen Victoria on 1 May 1851*, 1851–1852. Victoria and Albert Museum.

(*Bottom, right*) Luke Fildes, *The Widower*, 1875–1876. Art Gallery of New South Wales, Australia.

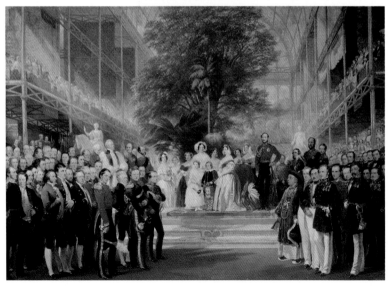

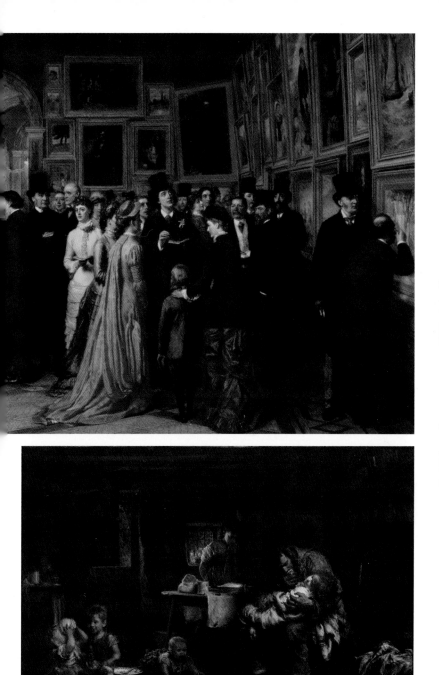

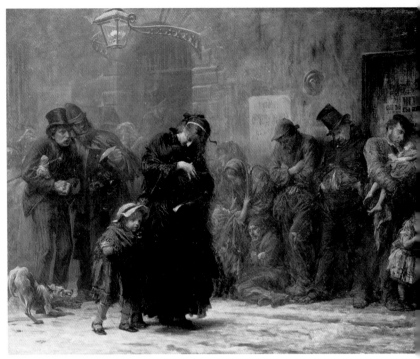

(*Above*) Luke Fildes, *Applicants for Admission to a Casual Ward*, 1874. Royal Holloway and Bedford New College.

(*Above, right*) Hubert von Herkomer, *The Last Muster: Sunday at the Royal Hospital, Chelsea*, 1875. Lady Lever Art Gallery, Port Sunlight, Merseyside.

(*Bottom, left*) Hubert von Herkomer, *Eventide: A Scene in the Westminster Union, 1878*, 1878. Walker Art Gallery, Liverpool.

(*Bottom, right*) Hubert von Herkomer, *Hard Times, 1885*, 1885. Manchester City Art Gallery.

Frank Holl, *Newgate – Committed for Trial*, 1878. Royal Holloway and Bedford New College.

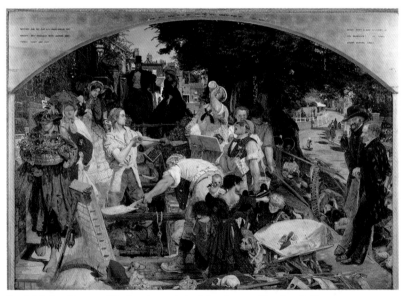

Ford Madox Brown, *Work*, 1852–1865. Manchester City Art Gallery.

Henry Wallis, *The Stonebreaker*, 1858. Birmingham Museum and Art Gallery.

James Sharples, *The Forge*, 1844–1847. M. Sharples (on loan to Blackburn Museum and Art Gallery).

George Joy, *The Bayswater Omnibus*, 1895. Museum of London.

William Quiller Orchardson, *Mariage de Convenance*, 1884. Kelvingrove Art Gallery, Glasgow Museums.

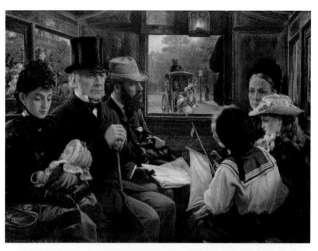

Alfred Morgan, *An Omnibus Ride to Piccadilly Circus, Mr Gladstone Travelling with Ordinary Passengers*, 1885. Private Collection.

Sir Edwin Landseer, *Windsor Castle in Modern Times*, 1841–1845. Royal Collection.

George Frederic Watts, *Found Drowned*, 1849–1850. Watts Gallery, Compton, Surrey.

Augustus Leopold Egg, *Past and Present* Nos. 1, 2 and 3, 1858. Tate Britain.

(*Above, right*) William Holman Hunt, *The Awakening Conscience*, 1853–1854. Tate Britain.

(*Bottom, right*) Edwin Long, *The Babylonian Marriage Market*, 1875. Royal Holloway and Bedford New College.

John
Everett
Millais,
Mariana,
1850–
1851. Tate
Britain.

John
Everett
Millais,
Ophelia,
1851–
1852. Tate
Britain.

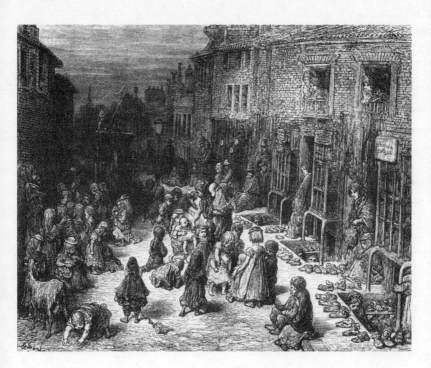

Gustave Doré, *Dudley Street, Seven Dials*,
from *London: A Pilgrimage*, 1872.

Some of Doré's images have become instantly recognisable
symbols of aspects of Victorian life, notably *The Exercise
Yard at Newgate*, *Dudley Street, Seven Dials* and *Over
London by Rail*, a vision of grubby back-to-back housing,
with tiny backyards in which washing hanging out to dry is
besmirched by the soot of the trains on the giant viaduct.

Doré was overwhelmed by the seething press of
humanity, the desperation and the grinding poverty,
and his combination of eyewitness observation and

meticulous execution gives his pictures a troubling frankness. These are real people, and yet their weary, woebegone faces become grotesques. You can feel the gloom and the gaslight, hear the mass of hungry children, see the sullen glares of the adults and almost smell the filth. There is the man who collects clothes cast off by the wealthy, accompanied by his tribe of feral children. There is the driver of a broken-down hansom cab, a street vendor with his lemonade barrel, a child selling sprigs of lavender. They, at least, have work of a kind; others beg to be admitted to a night shelter. Once inside, a visitor reads them an uplifting text from the Bible – but no one is listening. In the opium dens, meanwhile, addicts seek oblivion, and thieves, pickpockets and muggers gamble away their day's takings. Doré was criticised by those who noted an element of morbid hysteria and over-dramatisation in his work, creating, they suggested, a sharp chasm between rich and poor when the reality was a great deal more subtle. On the other hand, he managed to record the texture at the very bottom of life in London, complete with its accompanying filth and despair, and his vision is replicated by no one else.

Doré's memory was photographic. He didn't like to be seen drawing in public and so he lurked instead in dark corners making notes and sketches to be worked up in the morning – and the results of his labours made East London look like a city of endless night. This is a nightmare vision of the Victorian city as Hell, an inferno of the damned. Its wretched inhabitants are barely

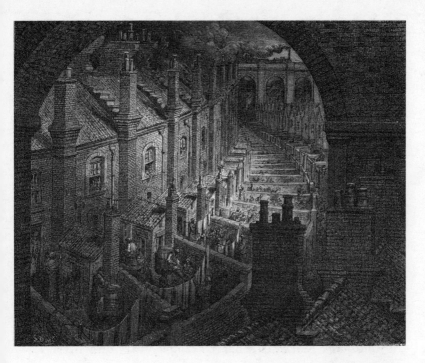

Gustave Doré, *Over London by Rail*,
from *London: A Pilgrimage*, 1872.

contained by the forces of order. Doré's vision confirmed
the fears of many that the population of the East End
was barely human; anxiety began to be expressed about
stunted adults and narrow-chested children. Perhaps the
populace could be herded into labour camps, suggested
one researcher. Others proposed mass sterilisation to
prevent the 'degeneration of the race'. One writer even
advocated 'the extermination of the unfit as a class'. If
something wasn't done, these voices seemed to be saying,

who knew what kind of monstrosity might emerge from East London's moral swamp? They soon found out, when gruesome murders began to be reported in Whitechapel.

'There is only one topic today throughout all England, and that topic was [sic] the Whitechapel murders of "Jack the Ripper".'[6] The lurid press coverage of the Ripper murders of 1888 demonstrates that, while Doré might have conceptualised the world of London in black and white, so too did a great many other people. From the distress of such areas as Whitechapel, it was felt, sprang by-products innumerable – crime, sexual epidemics, prostitution – which had the potential to infect the rest of society. This preoccupation was reflected in the myriad prurient cartoons and press illustrations of the period that dwelt on the sordid side of urban life. Take a *Police Illustrated News* cartoon, for example, that portrays the last moments of the first Ripper victim: Polly Nicholls is shown anticipating her prostitute's fee – 'I sha'rnt be long getting my bedmoney. Look at my smart bonnet' – while Jack lounges in a nearby doorway, a shy smile on his face and looking scarcely murderous at all.[7]

Some began to think about abandoning the city altogether: London, in the closing words of Doré's *Pilgrimage*, was altogether 'too charged with misery', the lights and bustle of the Whitechapel Road contrasting only too sharply with the darkness and fear of its side streets. Growing numbers of the middle class, then, began to move out, and their desire to escape to the fringes of the Victorian city produced one of the greatest of all its innovations –

'Polly Nicholls's Last Words', in *Police Illustrated News*,
12 October 1888. BL: British Newspaper Library.

the creation of the suburb, which was an achievement less showy than grand buildings and public works, but just as lasting in its influence. This was the Victorians' final answer to the problem of the city.

The rise of the suburb, of course, depended largely on the rise of something else – the omnibus. Until its invention, city workers could only live as far from the office as they could walk. Now these new contraptions spent their days travelling back and forth from what had once been outer London, ferrying lawyers and clerks and shopkeepers to work, and their wives to the shops or on days out with the children. What for us is simply commuting was liberation to the Victorians – and by end of the century, those who could afford it were making no fewer than 300 million omnibus journeys a year. Nor could artists resist this new subject matter, for the mixture of passengers thrown together on the new public transport provided the opportunity for a good deal of sly social observation of a type reminiscent of Frith. William Maw Egley (1826–1915), for example, went to some lengths to get his scene just right: for his *Omnibus Life in London* (1859), he painted the interior of his omnibus in a coachbuilder's yard at Paddington and his models on boxes and old planks in his back garden, so as to be able to capture the authentic feel of a rush-hour journey. All human life is once more on display: an old country woman; a servant, respectable but flustered and struggling with a superfluity of luggage; a city clerk sucking his cane vacantly as he stares at a pretty girl; Egley's own wife,

struggling with a recalcitrant child armed with tin drum and sticks. A pretty young married woman folds her parasol as she prepares to clamber aboard – and pauses, surprised, that her entrance is not generating the usual amount of attention. She is not in luck, today: already established in the omnibus is an even prettier girl – unmarried this time, veiled (and therefore modest) and striking just the right pose of docile virtue.

Other paintings took the chance to make clearer social observations. In George Joy's *The Bayswater Omnibus* (1895), a fashionably dressed young woman looks compassionately at her less well-off neighbours. Other paintings again were literally fantastic: Alfred Morgan, for example, presented *An Omnibus Ride to Piccadilly Circus, Mr Gladstone Travelling with Ordinary Passengers* to the public in 1885, apparently undaunted by the fact that the Prime Minister of the day would seldom be spotted in a London omnibus.

The consequences for the city of the invention of the omnibus were dramatic. In opening up great swathes of land to development, it sparked a construction boom like no other before: six million houses, for example, were built during the period. In the decade between 1891 and 1901 alone, the outer-ring suburbs of London expanded by forty-five per cent. Once the omnibus had been joined by the train and the tube, the expansion reached epic proportions. Diehard admirers of the Victorian city were contemptuous of the new spreading suburbs. One, Sydney Low, wrote that 'the life-blood [of London] is pouring into

the long arms of bricks and mortar and cheap stucco.' But the suburbs offered space, peace and seclusion at the end of a working day. As the nineteenth century rolled on, this was how people increasingly *wanted* to live, and the art of the time captures the spectacle of this clever arrangement for posterity.

THREE
THE ANGEL
IN THE HOUSE

THE SPIRIT OF QUEEN Victoria seems, at this distance, to infuse almost the entire century. Her influence has been exaggerated: the inventors, manufacturers, financiers, generals and politicians would doubtless have followed the opportunities they delighted to call their destinies, whoever sat upon the throne. There is no doubting, either, the influence of her husband, from his championing of the 1851 Great Exhibition in Hyde Park (what Thomas Hardy called 'a precipice in time') to the popularisation of the Christmas tree. Albert left the stage early and, for much of the fifteen years following his sudden death from typhoid fever in December 1861, Victoria was invisible to most of her people. In the field of domestic life, however, she remained a model. She had given birth to nine children, and the destiny of her female subjects was to reproduce (an average of six or more children in mid-century – the poorer the family, the larger) and to form the calm centre of family life. The phrase 'the Angel in the House' has been used to characterise this role. It is the title of a poem by the (probably rightly) forgotten Coventry Patmore, in talking about his wife.*

*Virginia Woolf thought it ought to be one of the ambitions of the female writer to kill the Angel in the House. In fact, Patmore was referring to love, rather than the woman's role. No matter, the term stuck.

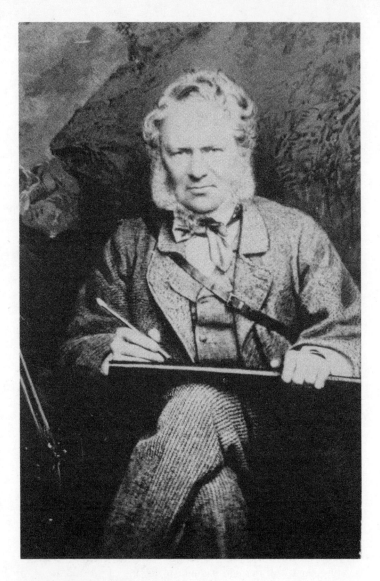

Sir Edwin Landseer photographed by
J.C. Watkins (undated).

Images of Victoria – as monarch, wife and mother, at home, at work and at play – were ubiquitous. Such traditional-minded paintings as Sir George Hayter's *State Portrait of Queen Victoria* (1837–1838), loaded with requisite glittering court ornamentation, were set against rather cosier images of Victoria and Albert welcoming the nation into their beautiful homes. The objective of Sir Edwin Landseer (1803–1873) in his *Windsor Castle in Modern Times* (1841–1845) is to create a conscious informality – something implied in the painting's title. The young and devoted couple are pictured in the comfort of the Green Drawing Room at Windsor – but amid relatively modest comfort, just grand enough to please. A vase stands on a high pedestal, as though to remind us that this is a scene of wealth and power, and we catch a glimpse, too, of a formal garden through the open window. But ranged around Victoria and Albert are images of leisure and relaxation: the couple's favourite greyhound and terriers play at their feet; assorted game birds, the spoils of a morning's recreational shooting, are set out on the ground and on a footstool; the young Princess Vicky holds (oddly, to our eyes, but presumably not to those of the Victorians) a dead kingfisher in her hands; and all the while, Victoria, the proud wife, looks devotedly at her energetic and sporting husband. This is the monarch, her husband and their children living as a normal family – a more extreme contrast to Hayter's stuffily formal portrait of the Queen can hardly be imagined.

Other paintings trace the trajectory of Victoria's life, in the process rounding out her image for posterity. In Sir Francis Grant's *Queen Victoria Riding out with Lord Melbourne* (1839–1840), the young monarch looks sporty and vigorous, with a tendril of hair even daring to dangle below a royal ear as she rides into the field with the Prime Minister of the day; while Landseer, in *Queen Victoria at Osborne House* (1865–1867), captures the widowed monarch in the deep mourning of her middle life, again on horseback and now in the company of her devoted Scottish companion, John Brown.

Osborne House was Victoria and Albert's cherished family home on the Isle of Wight, and it stood as a haven of respectable domesticity. Victoria, in this context, was not only monarch and ruler of an empire: she was also a loving wife to Prince Albert and a dutiful mother of nine, the supreme 'Angel in the House'. At Osborne, this ideal of a solid and happy family life was made a public reality. The new seaside property – designed by Albert himself, handsomely, but with thrift and economy in mind too – was purpose-built for a young couple with a growing family. To Victoria, it was 'my Little Paradise', and, while it certainly isn't 'little', there is undoubtedly something rather intimate and homely about the place. The couple referred to Osborne as *gemütlich* – snug and cosy – and, for Victoria, it provided a retreat from the business of being monarch. Here, she could escape the world of the court and be alone with her husband and family. 'God knows,' she sighed, 'how willingly I would always live

with my beloved Albert and our children in the quiet and retirement of private life and not be the constant object of observation and of newspaper articles.' And so the word went out that Victoria's monarchy was to be dignified and respectable – a world away from the rakish reigns of her two predecessors, William and George IV.

Not that this virtuous image always chimed with the difficult reality of the situation. Victoria may have been celebrated as the ideal mother figure of the age, for example, but she was not terribly keen on childbearing. She called the whole business the 'shadow side' of marriage, and resented the fact that it interrupted her sex life. Nor did the Queen much care for small children, especially when they were incapable of anything other than what she called 'that terrible frog-like action'. In fact, she seems to have been less suited to the role of mother than to that of lover, particularly as it seems clear that she also suffered periodically from post-natal depression. But there was nothing very much that she could do about all this: for the Queen, as for her subjects, there was no reliable means of artificial birth control available to respectable women and consequently very little that they could do to avoid becoming pregnant. And so it was that Victoria was more or less permanently with child for most of her early married life.

At home at Osborne, the couple could indulge their favourite fantasy, which was that they were just like any other British middle-class family. The house today is full of pictures of the family: not so much royal pictures as *family* ones, like Franz Xaver Winterhalter's *The Royal Family*

(1846), Victoria's own favourite. Winterhalter painted this piece at Osborne itself, and it shows the couple with five of their children shortly after the family moved in. The formality of the subjects' clothing is juxtaposed against the informality of the carefree young princesses ranged in the foreground. The Queen, meanwhile, gazes out directly at the viewer, her arm wrapped protectively around the young Prince of Wales, her future heir: maternal love and royal lineage conveyed in a single gesture. To our taste it looks staged, artificial and sugary – who has ever seen the Solent that extraordinary blue? But most interesting is that here we see Victoria, Queen of the mightiest nation on Earth, and yet the picture that she wants to project is not one of power but of herself and her husband at the centre of the family.

The invention of photography in the 1850s made sure that many images of this family survived for posterity, evidence of the extent to which Victoria and Albert's values were disseminated to all their subjects. Victoria, herself knowledgeable and enthusiastic about the new medium and more than aware of its public influence, was the first monarch to be more photographed than painted: a photograph taken by Henry Collen in 1844 portrays her as a loving mother – not a royal sovereign – her arm held protectively around Vicky, who clutches her doll and leans in towards her mother's bosom. Informal, intimate and simply framed, it is a snapshot of perfect domesticity: *just* the image Victoria wished to portray to the outside world.

Henry Collen, *Victoria and Vicky*. Queen Victoria
and her first daughter, photographed by Henry
Collen in 1844.

Photographic portraits of the Royals became treasured collectables, part of a booming trade at the time. There was a craze for *cartes-de-visites*, small photographic prints which were pasted onto card and added to albums. One famous portrait by William and Daniel Downey of Princess Alexandra (at this point, Princess of Wales) carrying her daughter Louise on her back (1867) sold 300,000 copies in one year alone, and, by the 1860s, people were talking of 'cartomania', with between three and four million of the things being sold annually. Cheap to make and to collect, they provided a neat way of flagging up just what sort of person you were or the kind of family to which you belonged.

Soon, it wasn't only pictures of the Royals that could be added to one's prized photo album – this miracle of technology allowed everyone to get a look in. The average Victorian family did not own a camera – but armed with a few shillings, its members could head to one of the Photographic Studios now springing up on every high street in Britain during the 1850s. Portraiture, once only for the well-to-do, became cheap, mass-produced and available to all; it was a natural leveller. Photographers could provide backdrops varying from a typical middle-class drawing room to more elaborate, mock-glamour scenery of dressing table or boudoir: fashionable settings that could project the subjects' position in society – or lift them out of their real status.

The methods involved can seem startling today. Because of the long exposures needed, there were various

methods for keeping a sitter still. A popular one involved a metal clamp hidden behind the sitter's head; more extreme methods included doses of laudanum – one practitioner advertised his photography 'without pain' by using gas. Another would suddenly draw a revolver and shout, 'Dare to move a muscle and I'll blow your brains out!' as a means of terrifying his sitters into motionless submission. These early photographs projected careful and valuable images to the world of the stable and secure Victorian family: the *paterfamilias*, his devoted and dutiful wife and their array of tidy children. The reality could be rather different.

A Double Standard

The London home of Marion and Edward Linley Sambourne can be found at 18 Stafford Terrace in Kensington. Linley (1844–1910) was a cartoonist for *Punch* and Marion (1851–1914) a full-time housewife and mother to their two children, Maud and Roy. They were a hard-working and prosperous couple who put their hearts and souls into the creation of a cherished family home – the house remains virtually unchanged from the time they took possession in the 1870s. Like many Victorians, the Sambournes liked to show off their possessions: there are 144 chairs in what is now the Sambourne House museum, for example, and 900 pictures on the walls. Minimalist it ain't.

Linley Sambourne, while certainly never considering himself a Bohemian, liked to mix with the local arty crowd – Lord Leighton lived round the corner and he was also chums with the Pre-Raphaelite artist, John Everett Millais (1829–1896). Examples of their work – mainly engraving copies – hang on every wall, jostling for space with Linley's own sketches. Linley was a man of modest means, who worked hard to provide a comfortable home for his family. Sometimes, he'd splash out on a prize bit of furniture; for the most part, though, he was a thrifty fellow, bidding for lots in house clearances, buying items on credit, and not always bothering to wallpaper behind the paintings that hung on his walls. Unusually for a man, Linley played a large part in the design and furnishing of the house – its wonderful stained glass windows, with a large S for Sambourne, were his design. But, as in any middle-class home, it was Marion who ran the household: this reality was even reflected in one of those same stained-glass windows, in which an L for Linley lies flat on its side with a large M for Marion striding above it. There was no doubt about who was the boss at home.

Marion ran her domestic empire from the Morning Room. Theirs was not a particularly large Victorian house but it still required a staff of four – a cook, a housemaid, a parlour maid and a groom. Marion sat at her desk, writing letters, doing the family accounts and working out what each of the staff should do each day. This was her account of the parlour maid's duty: '07.00 Bring my hot drinking water, sweep down and thoroughly wash stairs and get

bathroom ready – and lavatory. Own breakfast. 08.00 Draw up blinds and empty bath away ... 08.30 Clean grate in drawing room and thoroughly dust and sweep room, wipe round parquet. Clean all brass ... 09.30 Open beds and turn over mattresses to air; take away slops; see glasses clean, marble clean and taps.' And so the list goes on... until: '8pm, assist and wait at table, turn down beds; 9pm supper; 10pm letters to post; bed.' In all, it was a 15-hour day.

As well as employing staff to run the household, Marion also relied upon what had become the Bible for the woman of the house: *Mrs Beeton's Book of Household Management*, a book to be read, marked, learned and inwardly digested. If you could learn your Mrs Beeton, you might become the perfect domestic goddess – and a rather daunting one at that. 'As with the commander of an army,' wrote Mrs Beeton, 'so it is with the mistress of a house ... A woman must rule her household or be ruled by it.'

Isabella Beeton may be the most famous cookery writer in British history, but she seems to have been a slapdash cook (famously, one of her recipes for a Victoria sponge left out the eggs). Her genius instead lay in compiling the first modern cookery book – made up, as it happens, of recipes she lifted from other people's books – by listing the ingredients *before* the method, an entirely practical concept but novel at the time. But she did far more than simply give clear instructions for a successful soufflé. Her book is also a moral tract. The Sambournes, for example, were a sociable couple and liked to entertain – Mrs Beeton

could help them host and plan the perfect dinner party. 'Hospitality is a most excellent virtue,' she advises sternly, 'but care must be taken that the love of company, for its own sake, does not become a prevailing passion; for then the habit is no longer hospitality, but dissipation.' (Which translates as: Be sociable but don't overdo it.) The *Book of Household Management* had an opinion on every facet of domestic life. For example: 'Frugality and economy,' chides Mrs Beeton, 'are home virtues, without which no household can prosper; economy and frugality must never, however, be allowed to degenerate into parsimony and meanness.' (Be thrifty, then, but never stingy.) 'In conversation, trifling occurrences, such as small disappointments or petty annoyances, should never be mentioned to your friends. If the mistress be a wife, never let an account of her husband's failings pass her lips.' (Don't indulge in idle gossip and never, ever, criticise your husband.) And, given that she could also give instructions as to the best way to set a table for sixteen persons and could provide an illustration to boot – Supper Table with Floral Decorations, Arranged Sixteen Persons – you can see how Isabella Beeton's book became indispensable.

But Beeton's was just one voice among many telling a young wife how she could be an angel. There were plenty more. The paintings or reproductions that hung in the home carried clear messages – Henry Dunkin Shephard's *Home, Sweet Home* (1887) and another *Home, Sweet Home* (*c.*1880), this time by Walter Dendy Sadler (1854–1923), both present the ideal with pitiless precision:

the angel at the piano in one and the family gathered around the fire in the other are the pinnacles that must be achieved. John Ruskin spelt it out, lest there be any doubt on the matter: 'Man is eminently the doer, the creator, the discoverer, the defender ... But the woman's power is ... for sweet ordering, arrangement and decision. She must be enduringly, incorruptibly good, instinctively wise – not for self-development, but for self-renunciation.' Marion seems to have kept her part of this domestic bargain. But one wonders whether she would have been quite so loyal, if she'd been fully aware of what her husband had been getting up to while she was out of the house.

It all started rather innocently. At first Linley used photography to help his work as a cartoonist: he was a good draftsman, but found drawing figures a bit tricky, and photographs would, he said, help him get around that problem. He would use himself as a model for whatever pose was needed for that week's *Punch* cartoon. Then, he began cajoling members of his family – Marion, the children, even the servants – to don costumes and pose for him. But soon, he would require another sort of model altogether: there were some poses you simply couldn't ask your wife or daughter to adopt.

Using the rather predictable excuse that a serious artist needed to be familiar with the naked form in order to depict it in pictures, he started to hire in models and to take photos such as *Miss Cornwallis on a Bike* (15 June 1895) – wearing nothing but black stockings. (Quite why Miss Cornwallis needed to be naked in order for him to

Linley Sambourne, *Miss Cornwallis
on a Bike*, 15 June, 1895.

draw a cartoon of a vicar's daughter riding a bicycle is
a question it would have been very interesting to hear
him try to answer.) Clearly, Linley couldn't take photos
like this to be developed professionally, so he used his
bathroom – which, luckily for him, he didn't share with
his wife – as his own private dark room. And for the most
part, these mildly pornographic photos were taken in the
safety of the Camera Club on London's Charing Cross
Road, known for its discreet hire of private rooms.

A favourite model of Linley's was Maud Easton. His
diary entry for the day *Maud in Armchair* (*c.*1891) was taken
states: 'Wednesday Sept 30; Up 8am. Got on with portrait.
(Marion left at 1.15 for Worthing to visit her aunt.) At
2pm went and photographed Maud Easton in Folly Dress.
Hindered by workmen on roof. Left 4.30. Tea at home.'

A Mrs King was another favourite; and the Misses Pettigrew, Etty and Lily, were also much in demand. As his passion for nude photography grew, so Linley grew bolder. Always carefully choosing times when Marion was safely absent, Linley started to smuggle models into the family home. One particular session, for *Model Seated on a Lacquer Table*, involved Marion's delicate tea table as a prop – and in her Morning Room of all places. Marion was clearly kept in the dark, but her diary reveals she had an inkling that there was something going on: 'Lin off early to lunch in town – believe secret photography as usual!!!'

God forbid that anyone else should find out about Linley's goings-on, for the public shame could have spelt disaster for a 'nice' middle-class lady like Marion. Never had the outward image been so important: a home might have been private, but what constituted domestic life was very publicly debated. Thomas Carlyle complained that 'Undue cultivation of the outward' was 'the grand characteristic of the age'. Carlyle knew, as did everyone else, that public image was one thing, private reality another. We already know that William Frith could create such paintings as *Many Happy Returns of the Day*, while at the same time keeping a mistress and a second ménage around the corner from the family home. This, however, wasn't the half of it, and it is little wonder that even Victoria herself had some doubts about the values of the culture she exemplified: 'All marriage,' she wrote, 'is such a lottery – the poor woman is bodily and morally a husband's slave. That always sticks in my throat.'

Linley Sambourne, *Model Seated on a Lacquer Table*.

The Awakening Conscience

Even Mrs Beeton, that paradigm of middle-class respectability, was to fall foul of double standards. Her husband, having dallied with prostitutes, contracted syphilis and passed the disease on to her. As a result, she suffered endless miscarriages and eventually died at the age of 28, a week after giving birth to her second child. Nor was her fate exceptional: moral purity may have been the standard in public life, but the reality was often quite different. Venereal diseases were a fact of life in Victorian Britain: the spread in particular of syphilis, an inevitable by-product of prostitution, caused growing concern amongst campaigners for sexual respectability, who increasingly saw themselves as beleaguered by working-class permissiveness, illegitimacy and disease – in a subculture lacking self-discipline and respect. Prostitution was considered the 'Great Social Evil' and was viewed as the greatest threat to the institution of marriage. Venereal diseases were presented as God's punishment, the wages of sin – and it was a given that only women, and never men, could be the agents of infection. Such attitudes were even written into the statute books: successive Contagious Diseases Acts were passed by Parliament, principally in an attempt to regulate the health of the country's armed forces: the Act of 1864, for example, empowered the police in the country's main naval ports and garrison towns to detain prostitutes and subject them to mandatory medical examinations; and in 1869 it was proposed to extend the terms of the Act

to the civilian population. This idea, however, provoked a backlash from proto-feminist and civil liberties groups; the laws were finally repealed in 1886.

Men tended not to get married until they had reached a certain financial and social standing, allowing them to provide for a family, and, at all levels of society, the notion of a man gaining sexual experience from a prostitute was tolerated – certainly before marriage, and even after it, when wives were often constantly pregnant. Prostitution was booming by the 1860s, when London was dubbed 'the whoreshop of the world'. In 1862, when Dostoevsky visited the capital, he was obliged to push through crowds of prostitutes in the West End. 'In the Haymarket,' he recalled, 'I noticed mothers bringing their young daughters to do business. Little girls about 12 years old take you by the hand and invite you to follow them.' In 1859, the police knew of 2,828 brothels in London, a figure *The Lancet* considered to be about half the actual total; Mayhew estimated that approximately 80,000 prostitutes were working in the capital, although this statistic was complicated by the fact that unmarried sexually active women and married women supplementing low wages with occasional prostitution were often categorised as 'professionals'.

Running brothels was one profession that unmarried women could pursue – and often at a great profit. Mrs Theresa Berkley of Charlotte Street, just north of Soho, for example, made £10,000 in eight years, between 1828 and her death in 1836. Her big draw was the so-called 'Berkley horse', a sado-masochistic flogging

machine which drew clients in some numbers. (In France, flagellation was known as 'le vice anglais'.) The greatest issue surrounding venereal disease, however, related not to the prostitutes per se, but to the fear that men would pass on syphilis to their innocent wives and families. As a result, Christabel Pankhurst's later suffrage slogan would be: 'Votes for Women and Chastity for Men.'

The profession of prostitution, and the conditions out of which it grew, commanded a good deal of attention. Dickens and other writers associated prostitution with the mechanisation and industrialisation of modern life. Prostitutes were human commodities and engravings of the time cut through to the essential hypocrisy involved. Images published in *The Day's Doings*, a weekly specialising in a combination of gossip, sport, entertainment news and a generous helping of general prurience, focused upon the 'doings' of the country's middle class. 'That Girl Seems to Know You, George!' squawks one vinegar-faced wife to her top-hatted and embarrassed husband as they promenade through London: the image is entitled *An Awkward Encounter in Regent Street* (1871), and the gentleman is being accosted by a cheery prostitute who clearly knows him only too well. Another image, *Sporting Men and Sporting Women Celebrate Boat Race Night* (1871), shows a bawdy collection of gentlemen and prostitutes out for a good time; and a third, *Wronger and Wronged* (1870) portrays a prostitute with a certain sense of her own dignity, who encounters the cad who occasioned her fall – and cuts him dead.

An Awkward Encounter in Regent Street:
'That Girl Seems to Know You, George!',
The Day's Doings, 24 June 1871. Mary
Evans Picture Library.

Other artists, and in particular those of the Pre-Raphaelite Brotherhood (which had been formed in 1848) gazed upon such scenes with the utmost seriousness. *Found* (1854), an unfinished painting by Dante Gabriel Rossetti (1828–1882), takes a scene of utter tragedy, in which a countryman discovers that his former lover is now a London prostitute. His distress and anxiety are evident, as is the anguish of his flame-haired sweetheart who, Rossetti noted, was on the verge of 'doing herself a hurt'. The symbolism hangs heavily on the painting: the prostitute leans up against the sturdy wall of a churchyard; in the background, a lamb, soon to be led to the slaughter, stands on a cart covered in netting. Equally loaded with symbolism is *Thoughts of the Past* (1859) by John Spencer Stanhope (1829–1908), which portrays a prostitute in her lodgings, overcome with remorse for her situation. Her condition is shown by her gaudy cloak, the shabby dressing table with jewellery and money strewn across it, the cracked windowpane, unhealthy plant, torn curtain and a man's glove and walking stick on the floor. The view through the window also alludes to her corruption, for the Strand was a notorious centre of prostitution, while the presence of Waterloo Bridge and the Thames draws on the convention of the fallen woman drowning herself. (The irony in the painting – although viewers could not be expected to know this – was that one of the sitters, Fanny Cornforth, was in fact Rossetti's one-time housekeeper and long-term mistress, who also posed for *Found*.) Less symbol-laden than both of these paintings, meanwhile, Rossetti's watercolour *The Gate of Memory* (1864) shows a shawl-clad prostitute

peeping around a corner: she is watching children play in the street and mourning the ruin of her own life. Sentimental though it is, the painting is less histrionic than both *Found* and *Thoughts of the Past*.

This aspect of Victorian life was widely known and understood, even if it could not be publicly acknowledged by all. But pity for working-class women was one thing. If a 'respectable' woman was involved in sexual scandal, however, it might cause disaster – not only for her, but for all polite society. No moral tragedy could be worse than the destruction of the home brought on by a wife's adultery. Victorian legislators were convinced that this was the case, for the Matrimonial Causes Act of 1857 in effect legitimised sexual double standards by allowing wives to be divorced for adultery alone, while a husband's infidelity had to be accompanied by another offence – something trifling, such as incest, say, or bigamy, sodomy, bestiality, physical cruelty or desertion.

A year later, *Past and Present* (1858), a powerful and dramatic triptych by Frith's friend Augustus Leopold Egg (1816–1863), was displayed at the Royal Academy. It was presented without a title but with the following cryptic catalogue entry:

> August the 4th. Have just heard the B– has been dead more than a fortnight, so his poor children have now lost both parents. I hear she was seen on Friday last near the Strand, evidently without a place to lay her head. What a fall hers has been!

The three canvases tell a story in sequence and are the most morally didactic of the lot. In the opening scene, a husband sits ashen and stern-faced, clutching a love letter intended for his wife; he grinds a portrait of his wife's lover under his heel. She lies on the floor, a supplicant. The children's house of cards – built upon a French (for which read immoral) novel – is on the point of collapse. A painting on the wall shows Adam and Eve being driven from the Garden of Eden.

The second and third paintings present subsequent images – for the same moon shines in both scenes – of the subsequent lives of mother and daughters. In the second, the two abandoned daughters are shown some years later, sitting at the open window of the attic in which they now live. Tainted by their mother's sin, they are unable to occupy fully their place in society, much less marry 'well'. (Indeed, the unfaithful wife's corrupt influence over her children was given legal precedence in the 1839 Custody of Infants Act, which refused a woman convicted of adultery access to, or custody over, her children.) In the third, the mother has been reduced to sheltering under the Adelphi arches by the Thames, a traditional location of outcasts in Victorian society ('last refuge of the homeless sin, vice and beggary of London', as *The Athenaeum* commented). But she is presented almost as a Madonna, with a (bastard) child in her arms and a lantern above her that looks, at first glance, like a star. The posters plastered to the walls behind her further suggest the ambiguous stance taken by the painting: they display the prices and times of excursions to Paris, that sink of iniquity – and

yet they also display a variety of Haymarket plays that suggest the woman's status as an object of pathos. *Past and Present* may be loaded with symbols of disgrace, but it is not entirely unsympathetic.

This is painting as cinema, and was as gripping in its day as any Hollywood blockbuster. Like a good book or film, Egg's painting can be read in two ways: as a moral sermon, warning against the perils of female adultery; or as a protest against the arch hypocrisy of Victorian marriage laws. But the critics were horrified – paintings depicting the Victorian family were supposed to show comfort, security, warmth and *not* terrible dark truths. 'Mr Egg's unnamed picture,' thundered *The Athenaeum*, 'is divided into three compartments, each more ghastly and terrible than the other … There must be a line drawn as to where the horrors that should not be painted for public and innocent sight begin, and we think Mr Egg has put one foot at least beyond this line.' The public seemed to agree, for the painting remained unsold until well after Egg's death.

One particular incident in the 1840s would help to concentrate the minds of artists – and everyone else. On a bitter London night in 1844, a 40-year-old woman leapt from a bridge over the Regent's Canal into the water below. Remarkably, she survived – but the 18-month-old child she was cradling in her arms drowned. Rescued from the water, the woman was arrested and charged with murder and attempted suicide. Her name was Mary Furley, and within weeks she had become a

household name. The incident was first reported in *The Times*, which recorded daily dispatches from her court case. Furley, the court heard, had discharged herself from the workhouse where she and her illegitimate child had been mistreated, and had tried to make a living by sewing shirts. When this failed, she had chosen suicide rather than return to the workhouse.

Furley's execution was set for 6 May 1844, at eight o'clock in the morning. Dickens had attended her trial at the Old Bailey, and wrote a story condemning a system that punished the victims of poverty rather than tackling its causes. The poet Thomas Hood also took up her cause in his poem *The Bridge of Sighs*, which imagines what would have happened had she not been recovered from the water:

> One more unfortunate weary of breath, rashly importune, gone to her death ... take her up tenderly, lift her with care ... loving, not loathing. Touch her not scornfully, think of her mournfully, gently and humanly; not of the stains of her, all that remains of her now is pure womanly.

In *Found Drowned* (1849–1850), a title taken from a gloomy daily column in *The Times*, which published lists of women, mostly prostitutes, found drowned in the Thames, G.F. Watts (1817–1904) also changed parts of the story, showing Mary dead but omitting the child. And, like John Spencer Stanhope, he substituted the

G.F. Watts photographed by Julia Margaret Cameron in a portrait
entitled *The Whisper of the Rose*, 1865. Private Collection.

Regent's Canal with Waterloo Bridge, a site notoriously associated with the suicides of fallen women. In one limp hand she holds a token (possibly a pawn token). Or it might be a necklace with a locket – containing, perhaps, an image of her dead child? And once again, there is a suggestion of redemption in the position of her outstretched arms, echoing Christ on the cross. The implication is that she is no longer a moral reprobate, but someone worthy of redemption – the victim of a system that permits male seducers to go unpunished, while women are cast out of society. *Found Drowned* shows a woman who has been washed up by the tide – like a bit of debris. Similar works helped to force a change in public opinion – and a change in the law. Six years earlier, days after the date for her execution had been set, Mary Furley had received a reprieve, her sentence commuted to a seven-year transportation. It was harsh, but it was better than death.

The ambivalence in these works by Watts and Egg was echoed by other artists of the period. The state of ostensibly secure marriages is examined in such ghastly scenes as *Mariage de Convenance* (1884) by William Quiller Orchardson (1832–1910), in which a much older man sits at one end of an enormous, gloomy dining table as his butler pours wine and his trophy wife sits, bored and listless, at the other end. You can smell the resentment. In Frank Dicksee's *The Confession* (1896), it is unclear both what is being confessed but also – such is the evident pain and unhappiness of both husband and wife – which is

the party confessing. And Orchardson's *The First Cloud* (1887) explores the aftermath of a couple's first argument. The setting is opulent and aristocratic, but the largeness of the room serves merely to emphasise the great distance between husband and wife. The former has loosened his authoritative stance, his shoulders drooping and his hands falling awkwardly from his pockets. His wife's repressed anger, meanwhile, is indicated with her clenched hand; a screen to the left hints at secrets barely masked by the fragile façade of the relationship. And these paintings all portray *respectable* marriages.

In the world beyond the respectable, *The Awakening Conscience* (1853–1854) by the Pre-Raphaelite William Holman Hunt (1827–1910) portrays a young woman (the model was Hunt's own unsophisticated girlfriend Annie Miller) who is halfway to her feet, suddenly troubled. We see from the fact that she has a ring on every finger of her left hand except her wedding finger that she is unmarried. Her hair is down, however, indicating intimacy with the young man: she is a kept woman. But something has troubled her into a recognition of how the relationship will end. In case we are in any doubt, Hunt gives heavy-handed clues: a clock shows it is just before noon; a discarded kid glove hints at her discarded future; the music propped on the piano, *Oft in the Stilly Night*, is a song about former innocence; and under the table, a cat plays with an injured bird. This was a reproving tract on the contemporary urban problem of prostitution – and here the blame is laid squarely on the shoulders of the man.

There was nothing the Pre-Raphaelites liked so well as a fallen woman on which to feed; and here is the woman – however fallen – who has realised the error of her ways. Her face shines with remorse, reflecting the fact that, for her, redemption remains an option. Her lover, by contrast, remains flushed with lust and plays on, indifferent to her repentant purpose.*

As with the paintings which showed the bleak reality of daily life for poor people, there were some aspects which were too troubling for genteel patrons, however firmly they believed in the moral purpose of art. So Hunt's patron, the Manchester tycoon Thomas Fairbairn, asked him to rework the face of the young woman. Fairbairn – the son of one of the founders of the Industrial Revolution and an engineering magnate in his own right – found the tears on the woman's face too painful for polite society. She was repainted with a slightly more opaque expression. When the picture was exhibited at the Academy, opinions were sharply divided. 'Drawn from a very dark and repulsive side of domestic life,' one critic exclaimed; on the other hand, Ruskin could not get enough of its moral and improving tone in the face of 'the moral evil of the age'.

* * *

*These predominantly male portrayals of women frequently brought frustration in their wake. See the sonnet 'In an Artist's Studio' by Christina Rossetti – the sister of Dante Gabriel Rossetti – which dissects the Pre-Raphaelite conception of women as passive and objectified.

There was an obvious difficulty in reconciling a preoccupation with feminine chastity and art's traditional preoccupation with the nude, which artists did their utmost to circumvent. In May 1885 a letter appeared in *The Times* under the headline 'A woman's plea', protesting 'in the name of my sex – nay in that of both sexes' at the 'indecent pictures that disgrace our exhibitions'. The writer was immensely distressed by the displays of nudity which preoccupied too many artists, and worried that the revulsion of polite people meant that entirely innocent paintings were also being ignored. The consequence of so many paintings from which visitors 'must turn in disgust' was that it caused 'only timid half-glances to be cast at the paintings hanging close by, however excellent they may be, lest it should be supposed the spectator is looking at that which revolts his or her sense of decency'. The letter was signed a 'British matron'. In fact, it had been written by the Treasurer of the Royal Academy, an innocent and deeply religious man named John Horsley, whose anxiety about the display of nudity encouraged *Punch* to confer upon him the nickname 'clothes-Horsley'.

To be fair, Horsley's letter was answered in *The Times* by others asserting that it was high time he/she stopped being a prude. But the problem was obvious. In the middle of the nineteenth century, only married students at the Royal Academy were allowed to draw from the female nude. And it was alleged, not entirely plausibly, that the reason John Ruskin, the century's greatest artistic authority, had been

unable to consummate his marriage to Effie Gray was his wedding-night discovery that – unlike classical models – his new wife had pubic hair.*

In painting, artists could portray female nudity as long as it seemed very remote, historically or geographically, and, if your subject was mythical, you could get away with pretty much anything. Hence the popularity of oriental slave markets, odalisques and classical subjects. You can see why a male-dominated society would appreciate Edwin Long's *The Babylonian Marriage Market* (1875), showing what was said to be the Babylonian practice of procuring husbands for young women via auction.† Quite what was going through the mind of Thomas Holloway when he bought the painting in 1882, for a sale-room record of £6,625, to adorn the walls of the women's college he was establishing in Surrey is another matter.

The Babylonian Marriage Market is validated by its setting, the authenticity of which could readily be verified in the Assyrian rooms at the British Museum. In other works, however, charges of licentiousness could be staved

*The present theory is that it may have been that Ruskin was ignorant of, and disgusted by, menstruation. Pubic hair is, of course, a much better story for making the point about the malign influence of classical art.

†The story derives from the Greek historian Herodotus who described how 'the greatest beauty was put up first and knocked down to the highest bidder: then the next in order of comeliness – and so on.' Long depicts the would-be brides in order of ascending beauty but ingeniously covers the faces of the first and last girls. See George C. Swayne, *The History of Herodotus* (London, 1870).

off by providing only the merest allusion to antiquity. Edward Poynter's *The Cave of the Storm Nymphs* (1903) suggests Homer's story of the sirens who tried to lure Odysseus and his crew to a watery death, but the artist creates his own mythology in the form of 'storm nymphs', three girlish nudes who toy with treasures from the wreck of a ship, seen dramatically sinking in the stormy sea outside their cave. Frederic Leighton's *Idyll* of 1880–1881 (in which the model for the nymph was Lillie Langtry) does not derive from Greek mythology and, devoid of narrative, instead creates an idyllic mood with sun setting over pastoral landscape as two languorous nymphs listen to a piper's tune. These paintings offered the nude not merely in a classic context, but using techniques that echoed classical sculpture: Leighton, for example, was able to look to the seated goddesses from the East Pediment of the Parthenon in the British Museum – part of the Elgin Marbles collection – for the reclining poses and diaphanous drapery of *Idyll*'s nymphs.

Other classical painters like Lawrence Alma-Tadema chose the Roman world to sanction representations of the female body. The title of his *Tepidarium* (1881) – featuring a sweaty, open-mouthed young woman lying on a bearskin – refers to the lukewarm room of the Roman baths. Yet the only Roman object present is a strigil (a bathing instrument used to scrape oil off the body) which the woman holds in her hand – no prizes for guessing the symbolism here; the ostrich-feather fan in her other hand, instead of diminishing the sensuality, cleverly heightens

it. The artist only avoids crossing the line into pure titillation by the narrowest of margins. An earlier Alma-Tadema painting, *The Sculptor's Model* (1877), showed a completely naked woman, without even a strategically placed leaf or hand, being looked upon (benignly) by a bearded man with a vague resemblance to the artist himself. This nude had no cover to hide behind – either literally or metaphorically – and the Bishop of Carlisle was troubled. 'In the case of the nude of an Old Master, much allowance can be made,' he wrote, 'but for a living artist to exhibit a life-size almost photographic representation of a beautiful naked woman strikes my inartistic mind as somewhat if not very mischievous.'

Everyone was on safer ground with moral fables about the role of women. Sometimes you need a little context to grasp the story. Millais' *Mariana* (1850–1851) shows a sumptuously dressed woman stretching her back after hours sitting at her needlework. The picture refers to Tennyson's poem about a woman waiting for her lover, who will never come. Each verse ends with the refrain:

> She only said, 'The night is dreary,
> He cometh not,' she said;
> She said, 'I am aweary, aweary,
> I would that I were dead!'

As originally related in Shakespeare's *Measure for Measure*, Mariana has become unmarriageable because her dowry has been lost at sea. She wears blue, the colour of purity

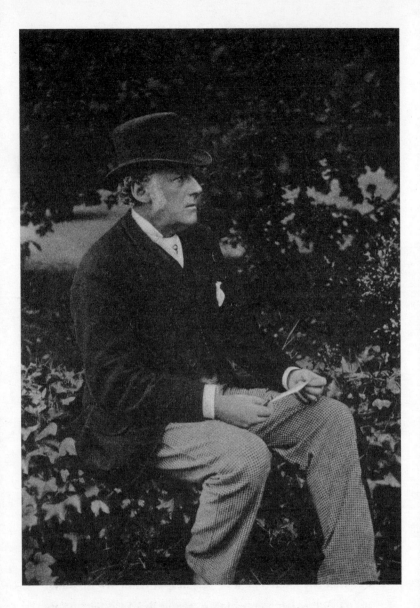

John Everett Millais photographed by
Elliott & Fry for *Pen & Pencil*, 27 August 1887.

and fidelity (the reason forget-me-nots are so named) and of the Virgin; and she seems to be staring at a picture of the scene in which Gabriel announced to Mary that she was to be mother of Christ without the inconvenient necessity of a man. Millais' *Ophelia* (1851–1852), is hardly more cheerful about the role of women. Astonishing for the luxuriance and precision of the vegetation, it shows the body of Hamlet's lover drifting downstream after she has been driven mad by grief. Each painting displays a different aspect of the powerlessness of women. The art of the period demonstrates the very limited number of roles available for those women who, by choice or chance, found the conventional position of 'angel of the house' uncongenial or unattainable.

Maids of All Work

The Outcast (1851), by one of the earliest social realists, Richard Redgrave (1804–1888), shows a young woman with her illegitimate child being expelled into the snowy night by her outraged father, as the rest of the family weep. She must fend for herself – and women who found themselves in this situation, whether rejected by their family or not, faced a strictly circumscribed range of choices. In 1841, Charlotte Brontë noted of a friend, Mary Taylor, who was planning to emigrate to New Zealand, that she had 'made up her mind that she cannot and will not be a governess, a teacher, a milliner, a bonnet-maker nor housemaid. She

sees no means of obtaining employment she would like in England, therefore she is leaving it.'[1]

The prejudice against the working woman ran deep. Ruskin's was just one voice amongst many promoting the idea that women were physiologically different to men, and that if women were taught Latin and Greek, valuable brain space might be used up that could be better used to hone sewing and home-making skills. Women, so the notion went, possessed only a finite amount of strength and the physical demands of menstruation (had Ruskin known about it) and bearing children meant they had less energy for mental activity. There was also a persistent notion doing the rounds that education could tip women into sterility. And on top of all of these was the understandable fear that educated women would take jobs away from men.

For the educated woman, the most frequent option was to become a governess in a respectable home. It was a socially acceptable profession, but also one fraught with difficulty. A governess in a middle-class household was a figure who lived with the children and who, because she was responsible for their education, was better paid than the servants. Indeed, a newly appointed governess was often advised, if she had a silver-backed hairbrush, to place it prominently in her quarters as an indicator to the servants that she was of a different class to them. Yet neither was this woman one of the family: instead, she lived in a sort of social limbo. Redgrave, who specialised in pictures of the downtrodden and oppressed, illuminated

her plight in *The Poor Teacher* (1844) – painted some three years, incidentally, before Charlotte Brontë's *Jane Eyre* and Anne Brontë's *Agnes Grey* highlighted this same issue in literature. Redgrave helpfully subtitled his picture *She Sees No Kind Domestic Visage Near*, and the title says it all. The painting depicts a pretty, young woman in full mourning dress, a black-edged letter in her lap informing her of a recent death in her family. The music sheet resting on the pianoforte – *Home, Sweet Home* – compounds her misery by recalling the family home she has been forced to leave in search of work. The governess sits forlornly at her table in the schoolroom, the remnants of her lonely supper – a dry husk of bread – nearby and a single tear trickling down her pale cheek. Behind her, her charges play gaily in the background, impervious to her sorrow. Although evening is drawing in, her job for the day is far from over – the table is piled with exercise books that will need correcting. Redgrave certainly knew how to crank up the pathos – but as if things in this painting weren't pitiful enough, an earlier version of this work had pulled on the heartstrings even more.

When the collector John Sheepshanks saw *The Poor Teacher* exhibited at the Royal Academy, he was much taken by it. But the sight of the forlorn governess sitting all alone in her room was just a little too much for him – and so he asked Redgrave to paint him another version, this time adding children playing in the sunlit background. This version, now renamed *The Governess*, pleased Sheepshanks a good deal – and the public and the critics could not get enough of it either.

'All could feel touched,' wrote Redgrave's son in a biography published almost fifty years later, 'by the representation of a young and pretty girl, just at the time when she would naturally rejoice in gaiety and merriment, immured in a vacant schoolroom to take her solitary tea and left, when worn out with her day's work, to muse over and long for home-love and happiness.'[2] For Redgrave too, this painting had a special meaning. His much-loved younger sister Jane was working as a governess when she contracted typhus and died at the age of 20. Richard Redgrave attributed her death to her unhappy working life and he never forgot the plight of genteel young women who'd fallen on hard times.

Much less attractive than governessing was to end up making clothes for richer women. In *The Sempstress* (1846), Redgrave depicts a poor woman with her eyes cast to heaven like some medieval saint, as she endures the toil of Thomas Hood's poem *Song of the Shirt* (1843):

> Stitch! Stitch! Stitch!
> In poverty, hunger and dirt
> And still with a dolorous pitch
> She sang the 'Song of the Shirt'.

Hood and Redgrave created an image of the seamstress with ladlefuls of pathos: pale, tired and hungry, she works alone long into the night. In reality, seamstresses either worked in dressmaking establishments or as 'slop workers', contracted out to work at home, often in small groups. Although long hours and poor pay characterised their working life,

seamstresses were often middle-class women down on their luck. Less attractive still was to be an uneducated woman and have a choice of life as a domestic servant or work in one of the factories. Huge numbers of women in Victorian Britain went into service – over a million in 1851. There are any number of Victorian paintings of domestics that show a rather cheery, idealised view of service: the maids painted by John Finnie (1827–1907) in *Maids of All Work* (1865) are enjoying a good gossip; the sweet-faced maid in George Dunlop Leslie's cloying *Apple Dumplings* (undated) seems perfectly contented with her lot; and the finely dressed skivvy who features in Frith's *Sherry, Sir?* (1853) and *Did You Ring, Sir?* (1854) looks the picture of calm contentment. ('I don't believe the engraving ever sold,' Frith noted of one of this pair of pictures, 'and I am quite sure it didn't deserve to sell.') The reality was of course often quite different, for this was back-breaking work – as Marion Sambourne's housemaids would rapidly have discovered – although usually still preferable to factory labour.

Something – for educated women at any rate – had to give. Take the tale of Caroline Norton, whose story could have been the subject of a melodramatic sequence of pictures. Norton was the upper-class wife of a Tory MP who, from the very first night of their arranged marriage, treated her terribly. He beat her; and when she became friendly with the Prime Minister, Lord Melbourne, he accused her of adultery and had her thrown out of the family home. Like the tragic heroine of Egg's painting, she too was denied access to her three young children. But

Norton fought back. She used her privileged connections with influential people like Melbourne to expose the double standards enshrined in the Matrimonial Causes Act. She also lobbied the Queen, complaining of the 'grotesque anomaly which ordains that women shall be non-existent in a country governed by a female Sovereign'. But Victoria – that most diligent wife and mother – didn't see it that way. She wrote back saying she deplored 'this mad wicked folly of Woman's Rights ... God created men and women different – let them remain each in their own position.'

But not even Victoria could stem the tide. A new breed of women – led by people like Caroline Norton – had begun to fight back for all women locked into unhappy marriages. In the second half of Victoria's reign, one law after another gradually ceded to women greater financial independence and a claim on their children if the marriage broke up. Even the dress reforms of the 1860s and 1870s played their part in this social change: no longer chained to the tyranny of the oxygen-depriving corset, women were freer to exercise and to move about in public without fear of collapsing from one of any number of serious, corset-induced physical ailments, including collapsed lungs, deformed livers, curvature of the spine and constipation. And education too played its part, with the universities slowly opening their doors to women: Girton College, for example, was established at Cambridge (or rather, on a site a safe two miles from the centre of the city) in 1869. Such changes did not come easily: as late as 1896, when the University of Cambridge

came to vote on whether women should be allowed to take examinations for degrees, *The Times* published train timetables so that male graduates in London could travel to the city to vote against the proposition. It was not until 1948 that women were granted full membership of the University and Girton given full status as a College. But by the end of the century, educated women had begun to make inroads into formerly male-only professions – by 1901, there were 212 female physicians; 140 dentists; 6 architects and 3 vets. In the arts, over half of musicians and actors were women.

Over a quarter of professional painters were now female – and they began to depict these changes in their work. They showed women playing tennis, riding bicycles and 'enjoying the intoxication that comes from unfettered liberty': walking around un-chaperoned in town, engaging in political campaigning – and divorcing their husbands. Many male artists, however, continued to paint the dutiful angel in the house – for the most part languid, mythical creatures and victims of unrequited love and madness. Many more turned satirist to ridicule this new breed of woman who was becoming increasingly – and worryingly – visible and vocal. The 'New Woman' expected to earn her own living, travel and live independently and choose her own partner – or indeed, choose to remain single. In the pages of the popular press, the term was a hostile one. The 'New Woman' was most often portrayed as masculine, aggressive and unattractive; and alternatively as a figure of fun, even to other women – as seen, for

example, in a *Punch* cartoon of 1895. Sydney Grundy's play *The New Woman* (1894), which first coined the term, was a comedy about these deeply unfeminine aspects of the modern intellectual woman. Its plot involved four progressive, domineering women who wrought havoc on conventional relationships. Oh, how audiences chortled! But it was the women who had the last laugh.

The Apple of Our Eye

In *The Governess*, Richard Redgrave is careful to paint his heroine's unfeeling young charges playing in brilliant sunshine, amid beautiful surroundings. There is a cold realism in such a scene too: for the children of the rich, life was better than it had ever been before. Never had children been so well provided for, and, for middle- and upper-class families, this was a golden age of childhood. It was the moment when a huge industry sprang up to cater exclusively for children – toys, magazines and books, for children and *about* children, flooded the market. And so did paintings, which tended to be cloyingly sentimental, sugar-sweet and heavy on the 'aaah' factor. We're now so familiar with these kinds of pictures that we forget that this was quite a new way of looking at children.

It was the Romantic poets who had first begun to see children as somehow special – and in the Victorian era, this was taken further. No one evoked the nostalgia

for childhood better than the illustrator Kate Greenaway (1846–1901), whose own idyllic childhood would provide the inspiration for all her work. 'Living in that childish wonder,' she wrote, recalling hazy summer days spent with relatives in the Nottinghamshire countryside, 'is a most beautiful feeling – I can so well remember it – the golden spectacles were very, very big.' Greenaway was the little girl who – like Peter Pan – never wanted to grow up; it is said she cried the first time she had to wear a long dress. Pictures such as *Lucy Locket Lost Her Pocket* (1881), filled with dreamy little children dressed in frilly smocks and mob caps, seem to be taken from a timeless, sugary and innocent childhood paradise.

These depictions were far removed from the real world, in which all manner of beliefs and foundations were subject to ceaseless erosion, and in which very many Victorian children endured misery and victimisation. Child prostitution flourished in these years: when Victoria came to the throne, the age of consent was 12; by 1875, it had been raised to only 13, and virgins in particular became highly marketable. There were brothels in London that openly catered for men who liked very young girls; such men were not necessarily all paedophiles; some, perhaps, were protecting themselves from disease by having sex with a girl who had never had sex before. The scandal of this 'Virgin Trade' was exposed in a brilliant piece of campaigning journalism by William Stead, editor for the *Pall Mall Gazette*. In 1885, he published 'The Maiden Tribute of Modern Babylon', an account of how he

Kate Greenaway photographed by
Elliott & Fry in the 1870s.

bought a girl for £5 from a mother who knowingly sold her into prostitution. And there was another, chilling reason that virgins were so highly prized: as with AIDS in some parts of Africa today, there was a belief that sex with a virgin could cure a man infected with syphilis. Stead was prosecuted and served three months in prison for his efforts, but his exposé contributed to a new Criminal Law Amendment Act which raised the age of consent to 16.

Set against this backdrop, it was little wonder that Greenaway's depictions of a sunlit and unchanging world were a hit. Her greatest champion – not that she needed one, for she was hugely popular in her lifetime – was Ruskin, who claimed to see in her depictions of children 'the radiance and innocence of reinstated divinity, among the flowers of English meadows'. His choice of words is telling – 'reinstated divinity' implied children were untainted by original sin. Childhood began to be imagined as something angelic, something to be cherished.

One group of artists specialised in such paintings of children. Despite the fact that by the middle of the century most children lived in cities – and often in terrible conditions – these artists chose to paint children in rather cosier circumstances. They were known as the Cranbrook Colony after the sleepy village of Cranbrook in Kent, to which they moved in the 1850s. For the artists of the Colony, Cranbrook was the perfect location – virtually untouched by the progress of time. Two of the leading artists in the group, Thomas Webster (1800–1886) and Frederick Hardy (1826–1911) immersed themselves in

rural life, renting cottages and depicting the daily lives of locals. At a time of massive, unprecedented migration to the cities, their work conjured up a rural way of life which most people were simply no longer leading. But they also seem to invoke simpler rural values. Webster's *Roast Pig* (1862) is a good example, invoking a rustic world filled with tidy, scrubbed children inhabiting a tidy, scrubbed cottage, with a hefty roast dinner on the way.

Just as these artists had fled the horrors of the Victorian city, so in their paintings the artists of the Cranbrook Colony escaped into a rose-tinted world of uncorrupted innocence. Frederick Hardy's *The Chimney Sweep* made short work of the actual child sweep whose feet we glimpse vanishing up a sooty chimney. But underlying the Cranbrook paintings were very adult values. Young girls appeared as youthful versions of the angel in the house, mimicking the spiritual and moral roles of their mothers. Boys helped their fathers in the fields, or let off steam in lively games of football. And that was precisely what the critics loved about these cosy, cloying works:

> 'As long as an interesting mother dotes over her lovely infant,' one wrote, ecstatically, 'as long as sunshine streams in at the cottage window and content smiles from every face, as long as the husband is prosperous in his work and happy in his pipe and ale, as long as sun-burnt children go forth in joyous bands to glean the harvest field – what cares the painter or the peasant for the politician's suffrage.'[3]

Some artists did try to be more realistic. In *The New Frock* (1889), Frith's little girl looks normal rather than cherubic – albeit very pleased with herself as she lifts her apron to display the frills of her dress to the world; and the horrid mop-haired subject of Landseer's *A Naughty Child* (1834) does indeed look extremely naughty, banished as she is to a corner for having smashed her writing slate in a fit of pique. Some artists employed children in their paintings as a means of cranking up the emotional tension a little further: in George Goodwin Kilburne's *The Pawnbroker* (undated), a desperate widow is negotiating with the eponymous pawnbroker, who leans across the counter towards her. Our eye is caught, however, by the small child who accompanies her mother and who is gazing, unflinchingly, out of the canvas and into our eyes. Similarly, Emily Osborn's *Nameless and Friendless* (1857) presents another desperate widow, a struggling artist trying to sell her paintings to an art dealer; and once more accompanied by her child – this time, a winning little boy in a cap.

Other paintings could pack a philosophical punch: in Millais' *Bubbles* (1885–1886), made famous by its use as an advertisement for Pears soap, a cherub gazing dreamily at a soap bubble that floats above his head seems innocence personified. But the bubbles signify the fleeting nature of happiness and of life itself. Similarly, the solemn-faced girls in Millais' *Autumn Leaves* (1855–1856), surrounded as they are on all sides by decay and mortality, look as though they need no lessons in transience. Thomas Faed

(1826–1900) took this quality of realism yet further: and in *The Mitherless Bairn* (1855), a homeless orphan is taken in by a family of cottagers, even though they themselves are living in abject poverty. Sure, it tugs at the heartstrings, but it leaves no warm glow; you can see why Van Gogh was a fan. In *Worn Out* (1868), meanwhile, a carpenter – no doubt a widower – sits slumped in his chair having spent all night watching over his sick child.

The death of children – whatever class you belonged to – was a dark thread that ran through the lives of very many Victorians. Two pictures by Frank Holl set the scene. In *Hush!* (1877), a woman scolds her eldest child for making a noise while her sickly baby lies asleep in the cradle. In its companion piece *Hushed* (1877), the cradle is still. The mother now buries her head in her hand, inconsolable with grief, while her helpless child stands by. As was the case with his Northumberland scenes, these paintings came from Holl's own observations: in this instance, a scene of sickness and death witnessed during a visit to North Wales. *Hush!* and *Hushed* – the Victorians loved a good melodrama. Each painting is a frozen moment in a play. Why is the baby sick? How long has passed between the two scenes? How will the remaining sibling be affected by her mother's grief? The walls of countless Victorian sitting rooms were hung with such pictures of desperate, mourning parents and their angelic dead children.

These angels in the house died in huge numbers, with tuberculosis, scarlet fever and typhus claiming thousands of lives each year, and no amount of money able to keep the

spectre of death from the door. Nor were these paintings all mawkish rubbish – often, they merely depicted what was happening in homes all over Britain. Take the Tait family of Carlisle. The Reverend A.C. Tait and his wife Catherine had seven children. Then in the spring of 1856, scarlet fever struck the village – and the couple could do nothing but watch as one after another their children succumbed. The first to die was Charlotte on 6 March; Susan Elizabeth died on 11 March; Frances Alice on 20 March; Catherine Anna on 25 March; and Mary Susan on 8 April – that is, five daughters dead in five weeks. As for the wretched poor, trapped in the Victorian city slums – almost one child in five died before their fifth birthday – if disease did not get them, then malnutrition or starvation would. For every painting like James Waite's *The Apple of Their Eye* (undated) – in which an appropriately apple-cheeked little girl stands on a footstool, the object of parental adoring gaze – there were dozens of others demonstrating a bleaker version of reality. Luke Fildes' famous portrayal of *The Doctor* (1891) at least spares the ill child, who has been watched by the eponymous tender-hearted doctor through a long night of sickness and whose recovery is coming with the sunrise; the painting was based on Fildes' own son, who was not so lucky. Other artists despatch their children: George Elgar Hicks's *Young Frederick Asleep at Last* (1855) shows us an angelic infant who might be sleeping but who is in fact dead; and Frank Holl once more lights on tragedy as his subject in *Death of the First Born* (1877), which prompted *The Graphic* to exclaim:

Who would choose to live in contemplation of such a domestic tragedy? The choice of subjects is surely a mistake, and is one far too prevalent just now, to judge by the amount of 'agony' piled up in this exhibition.

The often terrible living conditions of the time could lead some mothers to desperate – and horrifying – measures. On 30 March 1896, a bargeman travelling down the Thames at Reading saw a package floating in the water, hooked it up, and, on opening, found it contained the body of a baby girl. She had been strangled: around her neck was a length of white tape, pulled tight and tied in a knot under her left ear. This grim discovery led to one of the most gruesome murder cases in Victorian history. When the bargeman handed over the package to the police, a microscopic analysis of the wrapping paper around the body disclosed a faintly written name and address. It led them to 45 Kensington Road, Reading, the home of Amelia Dyer, a 57-year-old woman who took in babies for a living. She was what the Victorians called a 'Baby Farmer'.

In Victorian Britain, the prospects for unmarried mothers were bleak. They had no rights whatsoever. The Poor Law of 1834 had ruled that fathers would no longer be held financially responsible for their illegitimate offspring. Single mothers would have to fend for themselves: either that, or hand over their children to a baby farmer, who for a fee would adopt them, with the promise of a better life. In Amelia Dyer's case it was a promise rarely kept.

The body of Harry Simmons (left) murdered by Amelia Dyer (right). Thames Valley Force Police Museum.

Amelia Dyer would dress up in her best clothes to meet desperate mothers at the railway station and persuade them to give her one-off payments for adopting their babies, instead of monthly stipends. This enabled her to murder each child immediately and then acquire another to take its place. She was rumoured to have an accomplice in Godfrey's Cordial, a syrup laced with laudanum, dubbed 'the Quietness'. It is estimated that Dyer might have killed as many as fifty children – including Harry Simmons, whose photograph is preserved in police archives – before she was sent to the gallows at Newgate on 10 June 1896.

This appalling case led to new laws to protect vulnerable children – and, mercifully, there were a few

other options for the struggling unmarried mother. The Foundling Hospital in Coram Fields in London – the very first children's charity to take in unwanted babies – had been set up in the eighteenth century, but it was really in the Victorian era that the foundation came into its own. Other than the workhouse, where there was no provision for the care of babies and these mothers would in any case be separated from their children, the Foundling Hospital was the only place which would take in illegitimate children. Moreover, the Hospital didn't merely feed and shelter them – it also gave them an education.

This was the great age of philanthropy. The nineteenth century saw a significant shift in help to the poor, from an essentially benign approach to one that was more judgemental and that set out to see such poor wretches rehabilitated. At the Founding Hospital, rehabilitation was usually provided in the true Victorian style, with strings attached. Gaining entry to this institution was, for a start, extremely difficult and dependent on a strict set of rules. The first rule stipulated the child had to be illegitimate – but it could not be just any bastard; instead, the mother had to show that she had previously been of 'good conduct' before her misfortune. All the rules were laid out in a book of regulations written by John Brownlow, who had himself been a foundling at the Hospital before (rather unusually) rising to become Hospital Secretary. According to these edicts, the ideal candidate was a woman of good character with no rich relations who had

'yielded to artful and long-continued seduction, and an express promise of marriage, whose delivery took place in secret (and whose shame was known to only one or two persons)'. And so, for every single child that was allowed in, five were refused because, in the judgement of the authorities, they were not deserving cases.

John Brownlow had a daughter, Emma Brownlow (1832–1905), who had been brought up in the Foundling Hospital. She became an artist and painted a series of pictures that illustrated the lives of the children deposited there. In *The Christening* (1863), she shows what happened on gaining admittance. They would be rechristened that very day – often assuming the surname of the rich benefactors who supported the charity. This was of course a religious ritual, but it also had the function of removing the children from their previous contaminated identities – and this in turn, unfortunately, also meant removing them from their contaminated parents. When, later, mothers wrote requesting the chance to be reunited with their children, they were destined to be disappointed.

Various paintings by Brownlow portray the rosy side of life for the foundlings. One, entitled *The Sick Room* (1864), shows an unwell foundling lovingly cared for by a doctor and nurse, with other concerned children gathered round. In *Taking Leave* (1868), which illuminates one of the rules enforced at the Hospital, a young boy and girl go up before the Board of Governors to be instructed about how they should behave as they embark on an

apprenticeship designed to equip them to be useful and productive members of society. And in *The Foundling Restored to its Mother* (1858), perhaps the most poignant in the series, every foundling's fantasy is imagined: the little girl's mother has come, open-armed, to reclaim her, and complete with a box of toys to ease the emotionally charged reunion. Her respectable and modest dress suggests that, although once fallen, she has the potential to be redeemed. (To hammer home the point, Biblical paintings hang on the wall behind: one representing her wicked past, *Herodias with the Head of John the Baptist*; another, her redemption, *Elijah Raising the Son of the Widow of Zarephath*.) Standing benignly between the mother and child is John Brownlow himself. Before him lie the various documents relating to the foundling's life; on the floor, discarded, lies the receipt issued when the mother had first handed over her child.

Emma Brownlow's paintings tell us a lot about life in the Hospital. But there's something of the corporate video about them – her father ran the place, after all, and she was one for the rosy glow rather than the cool gaze. Dickens, who lived round the corner and who took a keen interest in the foundlings, gave a rather more honest view of their lives. In *Oliver Twist*, he immortalised John Brownlow and made the foundling Oliver a hero, and also took a rather less moralistic view of the mothers who had abandoned them. Nor did he confine himself to fiction about this side of life – he helped set up the 'Urania Home' for fallen women too. Yet Emma Brownlow's achievement

– and the achievements of many other observers of the Victorian domestic scene – is nevertheless considerable. As a result of her paintings, we know a good deal more than we otherwise would have done about the lives lived in the shadow of an orthodox Victorian family.

FOUR

A WORLD OF WEALTH AND POWER

'Keep always at it, and I'll keep you always at it,
and you keep somebody else always at it.
That's the whole duty of man in a
commercial country!'

Charles Dickens, *Little Dorrit*

D
URING THE AUTUMN OF 1850, a stunning apparition in glass and cast iron arose on the southern bank of the Serpentine in London's Hyde Park. This vast building was the Crystal Palace, designed by Joseph Paxton and prefabricated in Birmingham before being transported to London for assembly. It was one of the engineering marvels of the Victorian age and its scale and ambition are remembered in *The Inauguration of the Great Exhibition, 1ˢᵗ May, 1851* (1852) by David Roberts (1796–1864), which portrays long galleries and barrel-vaulted ceilings high enough to shelter full-grown elms, complete with flocking sparrows. (The Queen was not enamoured of the sparrows, and sought a solution. 'Sparrowhawks, ma'am,' was the reply from the ageing Duke of Wellington.)

The Crystal Palace, created to house the 'Great Exhibition for the Works of Industry of All Nations', had gone from the drawing board to completion in a mere nine months, and it was opened on that first day of May and with due fanfare by the Queen and Prince Consort.

Albert had been deeply involved in the organisation of the Exhibition; and Victoria was suitably ecstatic, calling its opening 'the greatest day in our history'. *The Times* went one better, announcing that it 'was the first morning since the creation of the world that all peoples have assembled from all parts of the world and done a common act'.

In a speech of the previous year, Albert had set out the Exhibition's ambition – anticipating *The Times*'s comments in the process. 'Nobody,' he declared, 'who has paid any attention to the peculiar features of our present era, will doubt for a moment that we are living at a period of most wonderful transition, which tends rapidly to accomplish that great end, to which, indeed, all history points – the realisation of the unity of mankind.'

If the later exhibitions at Manchester and Kelvingrove were redolent of a deep civic and regional pride and confidence, the Great Exhibition of 1851 was specifically international in its scale and reach. Henry Courtney Selous' painting, *Opening of the Great Exhibition, 1ˢᵗ May, 1851* (1851–1852), illustrates this global flavour: as the Archbishop of Canterbury offers a prayer, Victoria and Albert stand centre stage, flanked by dignitaries from around the world, dressed in their finery and with medals gleaming. Taking up pride of position in the foreground is a representative of the Chinese government, all got up in ceremonial robes – or at any rate, that was who everyone initially thought he was. Eventually, *The Times* got at the truth of the matter: the 'Chinese official' was, in fact, He-Sing, the captain of a junk moored in the Thames,

who had decided to go and take a look at the Opening Ceremony for himself. As he wandered into the Crystal Palace, everyone assumed he was a Chinese state official, and ushered him forward. Excitedly, he then pushed through the various lackeys, performed an elaborate bow in front of a bemused Victoria, took a position next to the royal party – and was duly immortalised for his trouble. Something of the spirit of Victorian enterprise obviously rubbed off on him, because after his appearance at the Great Exhibition, He-Sing started to advertise himself as the 'Acting Imperial Representative of China' – and audiences flocked to the junk on the Thames. He renamed the vessel the 'Museum of Curiosities' – and his crew took to performing nightly demonstrations of Chinese swordplay to a paying audience.

In five months, the Great Exhibition attracted six million visitors – more than double the population of London at the time – and its handsome profits helped to finance the foundation in London of what are now the Victoria and Albert, Science, and Natural History Museums. Its international element, right down to He-Sing himself, reflected a specific Victorian awareness of Britain's role in the world – of the country's place, that is to say, at the *centre* of the world. 'Remember that you are an Englishman,' said that arch-imperialist Cecil Rhodes, 'and have consequently won first prize in the lottery of life'. Victorians were convinced that their age was the greatest in the history of civilisation – and moreover, that it would last for ever.

It was this sense that underlay the ornate opening ceremonies, the glitter and the spectacle that occurred in Hyde Park throughout the course of that London summer: an understanding that the Great Exhibition was nothing less than a great national beauty pageant, a gathering designed to show off Britain and her achievements to the world. For it is notable that in spite of the mass of international displays gathered beneath the Crystal Palace's vaulted roof, it was exhibits originating in Britain and her colonies that dominated matters. The building was filled to the brim with cotton-spinning machines, steam hammers, locomotives, telegraphs, steam turbines, printing machines, scientific instruments and other emblems of British industrial prowess; the Dickinson Brothers, a London printing and publishing company, produced a series of fifty-five large coloured lithographs entitled *Comprehensive Pictures of the Great Exhibition*, which portrayed all these goods and more. This was the craft and genius of an ultra-modern society on display and it was set beside the rag-tag offerings of other, less fortunate countries: a carved bed from Austria, Belgian statues and Tunisian rugs. The message was loud and clear: Britain was the most advanced technological and industrial nation in the world – and this was its moment to shine. (Not that all the exhibits on show at the Great Exhibition would change the world quite so dramatically. Victoria was especially taken by a bed that automatically tipped you into a bath in the morning. Or, for a busy doctor, there was a one-piece suit handy for quick call-

outs. Women, meanwhile, might have been interested in a corset that 'opened instantaneously in case of emergency' – though the emergency remained unspecified.)

These are not emphases understood with the benefit of hindsight. Even at the time, the Great Exhibition was recognised to be a turning point in the country's history: the moment when Britain stood back, took stock, and realised the extent of her own power. Franz Xaver Winterhalter, in *The First of May 1851* (1851) neatly encapsulates the turning of this corner, showing as he does two worlds, the past and the future. The old Duke of Wellington, victor on the battlefield at Waterloo over thirty-five years before, offers a casket as a first birthday gift to Victoria's baby son, the future Duke of Connaught. But Albert is looking away, distracted by the silhouette and lure of the newly opened Crystal Palace. The past is past; here lies Britain's destiny and future. And how had this happened? As if to remind the millions who came to the Exhibition, greeting them at the entrance was a gigantic symbol of what underpinned Britain's extraordinary power: a 24-ton lump of coal.

The Census of that same year confirmed what everyone already knew: with over fifty per cent of the population now resident in towns or cities, William Blake's 'green and pleasant land' had become the world's first urban nation. Britain was now the workshop of the world: the first truly industrialised society. The horrors and wonders, isolation and excitement, inequalities and opportunities of urban life all appeared in their modern

guise for the first time in nineteenth-century Britain – and it was coal that was the catalyst. The Victorians were fascinated by the raw materials – the coal, the iron, the steel – of economic success. Sheffield, for example, was at this time Steel City, already producing over half of the world's steel by the time of the Great Exhibition. The figures are astonishing: annual steel production grew from 49,000 tons in 1850 to a full 5 million tons in 1900; and by the end of the century, nearly a million tons were being exported all around the world. As a result, the alloy was also given pride of place at the Crystal Palace, in the shape of an ingot of Sheffield steel, weighing over a ton. The title of *The Wealth of England: The Bessemer Converter* (1895) by William Holt Yates Titcomb (1858–1930) says it all. Through such machines as the Bessemer converter – a home-grown invention that revolutionised production by quickly transforming tons of pig iron into steel – Britain grew rich.

Similarly, the country could boast of its inventive engineers, famed the world over. John Lucas (1807–1874), in his portrait of a *Conference of Engineers at Britannia Bridge* (1851–1853), gathers together Britain's leading inventors for an entirely fictional meeting. George Stephenson, Isambard Kingdom Brunel and Joseph Locke, among others, stand together in front of the shapely iron arches of Stephenson's new Britannia Bridge of 1850, linking Anglesey to the Welsh mainland. William Bell Scott's *Iron and Coal* (1861), proudly subtitled *In the Nineteenth Century the Northumbrians Show the World*

What Can be Done With Iron and Coal, echoes Ford Madox Brown's *Work* in its emphasis upon the pride and skill of the working man and in the breadth of the society it captures. Scott (1811–1890) depicts a scene at Stephenson's works at Newcastle: his high-level railway bridge is in the background; at the bottom right is a blueprint for a steam engine; a coal barge passes by on the river and, on the docks below, a deal is struck between two businessmen. In the foreground, a smartly dressed little girl sits on a gun case manufactured just upriver: she has brought her father's hot lunch and is holding a school arithmetic book. Family life, commerce, heavy industry and education: Victorian values are distilled in this terrific picture. Such were the men creating the modern world; and each of these paintings broadcast a palpable pride in the industrial and technical advances of the age, and demonstrated the Victorian sense that Britain truly was showing an example to the world.

The development of the railways was intrinsic to this rapid industrialisation of Britain. Outside the cities, a quiet landscape was being transformed by the thundering roar of the steam locomotive. The Queen and Prince Albert first tried out the new machine in 1842: we don't know what Victoria thought of it, but Albert's reaction was recorded for posterity: 'Not so fast next time, Mr Conductor, if you please.' Nor was he alone in his discomfort: early passengers were very often unnerved by this utterly new experience. One woman recalled being in a carriage with an elderly gentleman who clearly didn't yet know how to behave on a

train: he was excitedly dancing about, jumping up to stick his head out of the window and gabbling on about the extraordinary light. As it happened, this strange man was Turner – and he would go on to record his excitement in *Rain, Steam, and Speed – The Great Western Railway*, in which the sheer power of this brand-new machine bursts out of the canvas.

The railway was a catalyst of social change too, thrusting together people from all backgrounds – and often for the first time. William Frith would observe the consequences of this great social change for coastal communities such as Ramsgate in his celebration of the seaside, *Ramsgate Sands*. But the railway carriage itself offered limitless opportunities for spiced encounters. It was even a place to transgress a little, to flirt and to fall in love: Abraham Solomon's *First Class – The Meeting, and At First Meeting Loved* (1854) outraged critics with its frank portrait of a young man and woman talking to each other in an overly familiar fashion, while the girl's father snores nearby. Solomon (1824–1862) was forced to repaint the scene, planting the girl firmly in a corner while her respectable father chats to the young suitor – an altogether more acceptable state of affairs. In *Second-Class – the Parting* (1854), showing the final moments before a family is divided, presumably for ever, by emigration, Solomon also depicts the differences between first- and second-class compartments. These could be stark, especially in the early days of railway travel: while first-class passengers could depend upon well-sprung seats

and leather headrests to ease their bumpy journeys, those in second class were carried on wooden benches and in carriages that – at least in the early days – were open to the elements, not to mention to the smoke and flying sparks from the engine.

Thousands of people bought shares in the ever-expanding rail network: *railway mania*, they called it, as people attempted to cash in on this new phenomenon. Shares in the private railway companies changed hands in a frenzy of speculation – until a great market crash at the end of the 1840s lost investors £800 million and helped to dampen the frenzy. But the railway would remain a ubiquitous feature of life, as the country was rapidly connected together: there were just over 2,000 miles of line in 1844, but 13,000 miles in 1890, part of a network that stretched from Wick to Holyhead to Penzance. Competition between the private railway companies could be ferocious, which helps account for otherwise curious facts: that, for example, two large London termini – St Pancras (home of the Midland Railway) and King's Cross (home of the Great Northern Railway) – directly adjoin each other in the heart of the city. Nor were these labours kept for the home market, for Britain built railways all over the world: in France, Italy, Belgium, Spain, Russia, India, Argentina and Australia. 'Coal,' exclaimed one writer, 'the stored up sunlight of a million years – is the grand agent ... Liberty lights the fire ... Civilisation is the engine taking the whole world with it!'

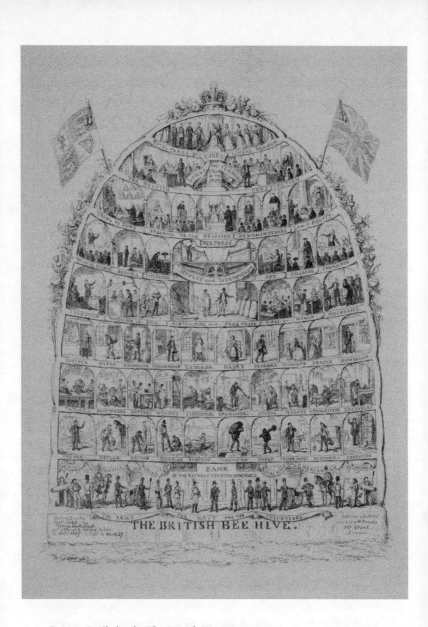

George Cruikshank, *The British Bee Hive*, 1840.
Victoria and Albert Museum.

In *The British Bee Hive* (1840), George Cruikshank demonstrates very effectively how the Victorians liked to imagine their world. It dramatises the tiered hierarchy of British society and the different positions on the social scale: royalty on top, followed by the aristocracy, the Church, the arts and the professions; these are supported by industry; and by the workhouse at the bottom. The rungs of this social ladder could be climbed – so the theory went – by dint of hard work and integrity. The beehive was a frequently used metaphor for the industrial process: the decoration of many Victorian buildings featured bees, which functioned usefully both as symbols of hard work and of the acceptance of the prevailing social order. But in this changing world, the focus of power was beginning to move in new directions. The wealth being produced by industry and commerce was creating a whole new class, with vast material resources at the ready – and these newcomers now began to infiltrate, to outspend and to challenge the old aristocracy.

Take the extraordinary house called Cragside, on the edge of what is now the Northumberland National Park and built in 1863 on the profits from ships, guns and machinery. Cragside was a wonder of its age: constructed on a rocky crag high above the Debdon Burn at Rothbury, it was crammed with ingenious gadgets and was the first house in the world to be lit by means of hydroelectricity, harnessed by the waters flowing through its own estate. Even the variety and scale of Cragside's gardens are remarkable: surrounding the house on all sides is one of the largest 'hand-made' rock

gardens in Europe; and in the pinetum below, England's tallest Douglas fir soars above other woodland giants.

The owner of this remarkable house and estate was one of the 'new rich', William – later Lord – Armstrong (1810–1900). Born the son of a merchant at Newcastle, Armstrong was, in classic Victorian fashion, not merely an industrialist, but also an inventor and landscape architect. He became fascinated by engineering and was the inventor of a hydraulic crane that used water pressure to create power. He also founded a manufacturing plant at Elswick on the banks of the Tyne, the scale of which is portrayed in *The Elswick Works*, a watercolour Armstrong commissioned from locally born artist Charles Napier Hemy. Even today, Armstrong's legacy remains visible in the north east of England: Jesmond Dene Park, for example, was an Armstrong bequest to the city of Newcastle; and the Swing Bridge on the Tyne – until the Gateshead Millennium Bridge was inaugurated, the only bridge across the river that moved – was designed with the express intention of allowing ocean-going ships to reach the factories at Elswick, the expansion of which had hitherto been held back due to their inaccessibility to the sea; the bridge was powered, needless to say, by hydraulics. The trading life of Newcastle was greatly stimulated following the completion of the Swing Bridge in 1876: Armstrong's shipyard at Elswick opened in 1883; and shipments from the Durham coalfield began rapidly to expand.

In 1869, with business booming, Armstrong decided it was time for a stately home of his own. He employed the architect Richard Norman Shaw to design him a house

which reflected his status. Over the next fifteen years, Cragside, which had been built in 1864 as a small hunting lodge, was transformed. It is a glorious place, and it sends out a wonderful mixture of messages. With its towers and half-timbering, the house looks back to a traditional past and hints at a grand family history that Armstrong didn't actually have. But in spite of this traditional skin, Cragside was a modern marvel. Its hydraulic power was channelled through an engine room in the bowels of the building. This power provided the house with hot and cold running water, central heating, fire alarms, a Turkish bath, an electrical gong, an automated turnspit and a passenger lift. It was also the first house in Britain to be lit by electricity. Crammed full of innovations as it was, Cragside was described at the time as the 'palace of a modern magician'.

It was not magic that Armstrong wielded, but power: he might have been a government minister for all his influence. At Cragside, he entertained world leaders: the Shah of Persia, the King of Siam and the Prime Minister of China came here to admire his inventions and his authority. The house was in effect Armstrong's shop window, a giant advertisement for his armaments business. Nor was it a mere matter of foreign leaders who paid homage to his power and influence, for the cream of British leaders came also – recognising where clout increasingly lay. When the Prince of Wales himself visited, Armstrong commissioned one of his favourite artists, Henry Hetherington Emmerson (1831–1895), to paint a scene of pleasure and style: in *The Prince of Wales*

at Cragside in 1884 (1884), the Prince and his party are portrayed reclining at their leisure on the terrace.

Armstrong's extensive art collection formed a vital aspect of the trappings of an aristocratic lifestyle. But there is significance in his choice of paintings: whereas blue-blooded collectors tended to go for the kinds of things they'd seen on the Grand Tour of Europe – in which Italian and Dutch old masters figured largely – Armstrong plumped for the work of living, breathing British artists, and often local ones at that. In general, the new Victorian moneyed class preferred it this way – for one thing, you knew what you were getting, with no fear of being ripped off with fakes knocked up in someone's garden shed. Armstrong's tastes were very much of his time, veering towards the sentimental with much in the way of paintings of children and animals. His dog, Silky, was the model of choice for the mutts in most of these paintings, appearing nuzzling his dead shepherd master, for example, in Emmerson's cloying *Faithful Unto Death* (1884) – although to be sure, this favouring of animal subjects was echoed by many a Victorian painter and collector.* But this tendency to emphasise the living and the local also owed a good deal to the strong regional pride that is such a characteristic of the time:

*Emmerson was in good company: see, for example, a series of animal-themed paintings by Sir Edwin Landseer, including *Eos, a Favourite Greyhound, the Property of HRH Prince Albert*, 1841 (Royal Collection), the subject of which is commemorated by a grave and a bronze in the castle gardens at Windsor; *Coming Events Cast Their Shadows Before Them (The Challenge)*, 1843–1844 (Duke of Northumberland Collection); and his famous *Monarch of the Glen*, 1851 (Private Collection).

many modern municipal galleries in the cities of northern England, for example, owe the core of their collections to the wills of Victorian philanthropists and industrialists. And it is certainly the case that Armstrong was not alone in his cultural interests: other Victorian businessmen developed a passion for collecting art. One northern cloth magnate, Abraham Mitchell, commissioned Henry Herbert La Thangue (1859–1929) to paint *The Connoisseur* (1887), a flattering portrait of Mitchell seated in his own private art gallery: he is pictured contemplating his collection, with magnifying glass at the ready to spot the finer points of brushwork. In the background, meanwhile, his family engages in the more frivolous pursuit of tea and conversation.

Armstrong's commercial success propelled him into the aristocracy. In 1887, he became Baron Armstrong, one of 200 new titles created in the last 30 years of the century, 70 of them from industry and business. The painting he commissioned of himself at Cragside, however, is studiedly modest – at heart, it says, 'I'm just an ordinary bloke in slippers catching up on the news. And it wasn't blue blood that got me this rather nice house.' In Emmerson's painting, *The 1st Lord Armstrong Sitting in the Dining Room Inglenook of Cragside* (*c*.1880), Armstrong is sitting reading the paper – and in order to drive the point home, the frame comes inscribed with the legend: *East or West, Hame's Best*. The aristocratic old guard mocked the new boys, calling them the 'beerage' (because so many of them were brewers) – but in a dramatically changing world, soon found they had little choice but to bend to the rising power of industrial Britain.

The Roll Call

For all of the dynamism of the Elswick Works and the shipyards, it was armaments and the business of war that made William Armstrong rich. His guns and warships sold around the world; and he would test his new inventions on his estate, firing rounds off into the wooded valleys surrounding Cragside. His most influential invention was the Armstrong gun, which has been described as the first modern gun, and which would be transported and deployed around the globe, as the country's empire waxed. In the aftermath of the Great Exhibition, which had displayed British industrial prowess and commercial acumen to the world, the country now wanted a great military triumph to match. But the first conflict to follow the Exhibition – the bitter and bloody war fought in the Crimea between 1854 and 1856 – would provide Britain with nothing of that sort.

The Crimean War was fought between an alliance of British, Turkish and French forces and Russia, with the British objective being to shore up the power of the declining Ottoman Empire in order – among other things – to keep the Mediterranean free of Russian influence. It was the first major war fought by Britain in forty years and is sometimes considered the first modern war, employing as it did such assets as the telegraph and the train. But, from the British point of view, it was a military catastrophe and a shocking failure on more or less every front. Events in the Crimea showed up appalling deficiencies. Soldiers

were ill-equipped, badly fed and had almost no medical support. The guns were hopeless, which led directly to the development of the range of Armstrong guns, rolled out in response to the unfolding Crimean military disasters; their creator, seeing need and opportunity in the Russian bloodshed, pressed ahead with the development of his new and modern range of munitions.

The events of the Crimean War showed officers of the British Army to be snobbish, stupid and incompetent, and regular soldiers often breathtakingly courageous. Back home, the public was desperate for news from the frontline, and so the conflict in the Crimea* became the first to be played out in the media, from the critical coverage of *The Times*'s war correspondent, William Howard Russell, to the propagandist images of Roger Fenton, the first war photographer on hand to record the action. Nevertheless, it was in painting that some of the most dramatic records of the war were to be captured: the watercolour painter William Simpson (1823–1899) was despatched to the battle by the art dealers Colnaghi, in order to prepare lithographs of the campaign, while the artist Edward Alfred Goodall (1819–1908) covered the war for the *Illustrated London News*. Some of these images were positively cheery: Simpson's *A Christmas Dinner on the Heights before Sebastopol* (1855), for example, shows a well-fed, well-clad and well-lit group

*The Crimean War is something of a misnomer, as the conflict saw associated engagements not only in the Crimea, but also in the Baltic and White Seas and in the Russian Far East.

of officers dining in their nicely appointed tent. And even as the news of disaster came creeping out of the Crimea, the British managed to extract a measure of triumph in the figures of the nurses Mary Seacole and especially Florence Nightingale, who appears against the backdrop of a scrupulously clean hospital in *One of the Wards of the Hospital at Scutari* (1856). It was the function of many artists to provide good news stories to a shaken national self-esteem.

The most pressing and pervasive problem revealed by the Crimean War was an invisible one – the problem of class. Ordinary soldiers usually came from the lowest strata of British society; generally illiterate, they would often join as a last resort to avoid prison or the dreaded workhouse. Wellington called such recruits 'the scum of the earth', and they were treated accordingly. Floggings were routine, rations – meat, bread and rum – sparse and monotonous, and accommodation crowded and claustrophobic, with twenty men often sharing a small room. Nor was there any way out, for advancement from the ranks could be all but impossible: most of them would never achieve any promotion. Their commanders, on the other hand, came from the very highest echelons of society: they had to, because officers had to buy their commissions, which didn't come cheap. The price of a captaincy was £1,800, while a major came in at £3,200 – princely sums at the time and by no means within reach of any but the very well-off. Such a system, in which rank was bought regardless of experience or talent, created an army that was in effect the plaything of the toffs: officers spent as

much time hunting on their estates, going to balls in London and yachting at Cowes as doing such trifling things as drilling their men. One aristocrat, the Duke of Cambridge, summed it up: 'The British officer should be a gentleman first and an officer second.' The events of the Crimean War would illustrate piteously the shortcomings of such a system.

The most notorious Crimean gentleman-officer came from Deene Park, near Corby in Northamptonshire. This was the ancestral home of James Thomas Brudenell, Seventh Earl of Cardigan. Cardigan had bought his lieutenant-colonelcy for a staggering £40,000, and, as commander of the Light Brigade of Cavalry, he was to play a crucial role in events in the Crimea. At the outbreak of war, Cardigan was already a well-known figure in Britain – albeit for all the wrong reasons. A well-known womaniser, he was also referred to as the 'Homicidal Earl' because of his taste for duelling with his officers and flogging his men; when he left his splendid estate to go to the opera, he was routinely booed. At times, in the Crimea, he behaved more like a holidaymaker than a soldier – staying on his yacht, drinking champagne and enjoying the services of his French chef. Cardigan's boss and the commander of cavalry in the Crimea, meanwhile, was his brother-in-law, Lord Lucan, who had married, bullied and then left Cardigan's youngest sister; the two men were not on speaking terms. To complete this picture of dysfunction at the top of the military chain of command, above these two enemies was Lord Raglan, Commander-in-Chief of the British army and an elderly soldier who

had not so much as set foot on a battlefield in forty years. Cardigan, Lucan and Raglan were together responsible for one of the most dreadful episodes in British military history – the massacre of 25 October 1854 that became known as the Charge of the Light Brigade.

Not that you'd think it was so very dreadful from the many depictions of the battle painted later – such as Simpson's *The Charge of the Light Brigade at the Battle of Balaklava* (1854) and Richard Caton-Woodville's *The Charge of the Light Brigade* (1895), both of which show grand sweeping views of the battlefield, acts of great heroism and triumph over despair. The former, painted in the aftermath of the famous battle, wisely keeps its distance from the actual scene of bloodshed and concentrates instead on presenting panorama and vast scale, succeeding in conveying a scene of distant heroism in the process. In fairness to Simpson, he did attempt the painting three times before it was approved and later bought by Cardigan. He notes in his autobiography that in the final work he had 'taken greater care than in the first two to make his lordship conspicuous in front of the brigade'. While Simpson arrived in Balaclava three weeks after the battle, Caton-Woodville (1856–1927) painted his version a remarkable forty years after the event, when the events of that day were well understood. It nonetheless conveys a similar sense of heroism, although from rather closer quarters: in this painting, even the horses appear over-brimming with pride.

So what actually happened on that October day? The British were defending the Crimean port of Balaclava

against the full might of the Russian army, which held the approaches to the deep valley on the landward side of the town. Cardigan's Light Brigade was positioned on the valley floor outside Balaclava; Raglan, higher up on the ridge, could see the advancing Russians threatening an outpost on the valley rim. He sent a written order to Lucan, telling him to advance the Light Brigade to 'try to prevent the enemy carrying away the guns'. The problem for Lucan was that, from where he was standing, he couldn't see the threatened British position. 'What guns?' he spluttered to the enthusiastic Captain Nolan, who had cantered over with the order: the only guns he could see were the Russian ones at the far end of the valley. Nolan waved his sword in the general direction of the valley. And so, suicidal as such an action would be, Lucan trotted over to Cardigan and ordered him to attack down the length of the valley. 'Certainly, my Lord', responded Cardigan, 'but allow me to point out to you that there is a battery in front, a battery on each flank, and the ground is covered with Russian cavalrymen.' 'I cannot help that,' came the retort. And so Cardigan took up position on his horse (named Ronald) at the front of the Light Brigade, muttered, 'Here goes the last of the Brudenells,' and led the charge. A bounder Cardigan might have been, but he did at least have guts.

The result was carnage. Captain Nolan, seeing what was about to happen, galloped into the charge, waving his sword once more. Was he saying, 'No, no, you're wrong – those are the guns'? We will never know, for

he was one of the first to die, killed by a fragment of a Russian shell. The Brigade rode on, and a hail of bullets, shrapnel and cannonballs thundered into the advancing cavalry; a third of its 670-odd members were killed or wounded by the Russian forces in the space of 25 minutes. A French marshal watching commented: 'It's magnificent. But it's not war.'

Back in Britain, it would take a while for the sheer folly of the Charge to become known, and public reaction at first focused on the heroism of those who had taken part. When Cardigan – who had survived the charge – returned shortly afterwards, he was given a hero's welcome, and bands played 'See! The Conquering Hero Comes' as he (and Ronald) were mobbed by admiring crowds. He criss-crossed the country making triumphant speeches retelling details of the Charge, and the knitted waistcoat that he had worn in the Crimea became the must-have fashion item of the season.

Artists joined in the adulation, and paintings showed Cardigan as the man of the hour: in the dining room at Deene Park today there still hangs a portrait by Henry Payne (1868–1940) of *Lord Cardigan Leading the Charge of the Light Brigade at the Battle of Balaklava, 25 October, 1854* – again, painted a full thirty years after the event – in which the hero insouciantly rides Ronald into the thick of the action, impervious to the cannonballs fizzing through the air around him. Another painting, *Lord Cardigan Describing the Charge of the Light Brigade to Prince Albert and the Royal Children at Windsor on 18 January, 1855*, by James Sant (1820–1916), which hangs

in the central stairwell of the house, illustrates the extent to which Cardigan was feted by high society.

But, as soldiers started to return from the Crimea, the truth behind the Charge of the Light Brigade began to emerge. A pamphlet called *Was Lord Cardigan a Hero?* questioned his behaviour at Balaclava, claiming that he had been spotted fleeing back to base, riding through the advancing ranks of his own men, 'as though the very devil pursued him'. *The Times* accused Cardigan of 'the falsification of history'. The ostensible heroism of the officer class began to be called into question, and public sympathy turned towards the ordinary soldiers – to those who had unquestioningly to follow their superiors' suicidal orders. Weren't these men the real heroes? Tennyson would encapsulate this new public mood in 'The Charge of the Light Brigade':

> 'Forward, the Light Brigade!'
> Was there a man dismayed?
> Not though the soldier knew
> Someone had blundered.
> Theirs not to make reply,
> Theirs not to reason why,
> Theirs but to do or die.
> Into the valley of Death
> Rode the six hundred.[1]

Artists too began to respond to the changing attitudes and to the dreadful news emanating from the Crimea. Some focused upon the pathos of the individual soldier's plight, or to that

of his family waiting at home. *Home Again* (1856) by James Collinson (1825–1881) portrays a soldier of the Coldstream Guards returning to his country cottage; when the painting was first exhibited, it was accompanied by a notice explaining that the subject had been involved in an accident that had led to blindness – and that as a result both the soldier and his family faced the bleakest of futures.* Thomas Faed's *The Soldier's Return* (1856) presents another traumatic homecoming: here too the soldier is injured and, as he slips through the door to no hero's welcome, his oblivious family continue to read about the war's progress in the newspaper. Ford Madox Brown's *Waiting: An English Fireside of 1854–55* (1854–1855) dispenses with the image of the soldier altogether: instead, the painting concentrates on the classic image of the wife patiently awaiting her husband's return.

Other artists continued to focus on the battlefield: and the most famous of these was Elizabeth Thompson, later Lady Butler (1846–1933), who captured better than any other artist the plight and suffering of individual soldiers. Take, for example, *The Roll Call* (1874) which turned heroic military painting on its head. Instead of aristocratic derring-do, gallant horses and even more gallant gentlemen, it depicts a muster of ordinary soldiers after a Crimean battle, bedraggled and exhausted from fighting. An officer on horseback emerges from the left of the picture, but the focus of attention is the

*In 'The Last of the Light Brigade' (1891), Rudyard Kipling explored the plight of the survivors of the Light Brigade in their old age, when many of them had little or no financial means of their own and no support from the government.

huddled mass of regular troops, as their sergeant ticks off the names of those who have survived the engagement. The men are exhausted: there is blood in the snow and one of the soldiers lies dead at the feet of his comrades. Thompson said: 'I never painted for the glory of war, but to portray its pathos and heroism.' And yet the violence of the event and the heroism of the soldiers are rendered all the more potent in the painting by being implied rather than shown.

When *The Roll Call* went on display at the Royal Academy, it caused a sensation and it joined the select list of paintings that required a guard: 'A dense crowd before my grenadiers,' Thompson noted, as policemen were called upon to protect the painting from eager fans. Later, *The Roll Call* was sent on tour: at Liverpool, 20,000 people saw the picture in three weeks; at Newcastle, it was advertised by men with sandwich-boards which read '*The Roll Call* is coming!' The painting turned Thompson into a star. ('I may say,' she wrote phlegmatically, 'that I awoke this morning and found myself famous.') A quarter of a million postcards sold within a week, and the Queen insisted on buying the picture. It had been commissioned for £100 by Charles Galloway, an important Manchester industrialist and manufacturer of boilers and heavy engineering equipment, and he was understandably reluctant to part with his painting. But Victoria would have her way; and he was finally persuaded to hand over *The Roll Call* to his sovereign 'on condition', Thompson wrote, 'that I should paint him my next Academy picture for the same prices as he had given for the one he was ceding, and that the Queen should sign with her own hand six of the artist's proofs

when the engraving of her picture came out'. As it turned out, the artist would not hold Victoria to this agreement.

The question on everyone's lips, however, was: how could a 27-year-old woman depict war with such startling reality? Thompson's research had been meticulous – she sought out survivors of battles to give first-hand accounts of what happens when armies clash and steel meets flesh. When she painted *The Battle of Balaclava in 1854* (1876), her dark vision of the return of the survivors of the Light Brigade, she consulted veterans of the campaign and even persuaded some of them to model for her: the wild, staring eyes of the central figure of *Balaclava* are those of W.H. Pennington, an actor who had taken part in the original action. Like *The Roll Call*, *Balaclava* is an acknowledgement of the heroism of the ordinary soldier; it invites you to consider the human cost of war. It won't do, therefore, to dismiss Butler as just another apologist for a now unfashionable imperialism. In fact, her husband, General William Butler, remarked in his autobiography that 'it is a misfortune of the first magnitude in the lives of soldiers of today ... that the majority of our recent wars have their origins in purely financial interests or sordid Stock Exchange ambitions.'[2] His wife's paintings set out to enlist our sympathy for put-upon Tommy Atkins, the man celebrated by Kipling in his *Barrack-Room Ballads*:

> For it's Tommy this, an' Tommy that, an' 'Chuck
> him out, the brute!'
> But it's 'Saviour of 'is country,' when the guns
> begin to shoot.

Elizabeth Thompson (Lady Butler) photographed
by Fradelle & Marshall in 1874.

Lady Butler's Crimea paintings earned her the nickname 'the Florence Nightingale of the brush'. They were executed twenty years after the event – perhaps they would have been impossible to bring off at the very time that British soldiers were showing their courage in the face of their officers' bone-headedness. At the end of the war, both France and the Ottoman Empire might have been able to point to dearly bought gains. But the only thing the British had gained – and though it was a tremendous benefit for the ordinary soldier, it hardly amounted to a serious strategic improvement – was a series of reforms designed to ensure that never again would Tommies find themselves ordered into battle by men whose only qualification for command was the fact they had deep enough pockets to buy a commission.

Imperial Dreams

The Victorians didn't invent the British Empire. The first Empire of the eighteenth century had seen Britain seize and then lose its thirteen colonies in North America; by the middle of the nineteenth century, British interests ran a third of the slave trade and had already controlled India and Canada, for example, for nearly a century. But it was in Victorian times that the idea of a *political* Empire first became a pressing issue, and a source of pride for ordinary people in Britain. It was in India that the question of the Empire's contemporary meaning was first crystallised – and

in bloody and dramatic fashion. Until the middle of the nineteenth century, India was governed not by the British government but by the East India Company – a private enterprise, albeit one with extremely close ties to the British authorities, with a presence on the subcontinent dating back to the early years of the seventeenth century, and with a full monopoly on Indian trade. It was an arrangement that suited the politicians very nicely, for it enabled them to sit back, permit the Company's administration of the country and cream off the revenues from trade, in return for doing and investing very little themselves.

Such a relationship between government and commercial interests was not unique to India: it was replicated in British territories throughout the world, for there was no unified imperial policy emanating from London. It was also the case that these overseas commercial interests were often more eager to build business with foreign countries than to tie their territories firmly to Britain itself. The process of empire-building, in other words, was not at this time principally concerned with the acquisition of land – but with commerce and trade. In India, the Company would run its possessions in its own way – and it would take an explosion to make the British government realise that its de facto control of the subcontinent was at best extremely tenuous.

We know a good deal about the individuals who travelled to India with the East India Company to seek their fortunes. Take Sezincote, an extraordinary English mansion in the Mughal style, with red sandstone walls, a central copper-

plated dome, minarets, peacock-tail windows, jail-work railings and pavilions, a temple to the Hindu sun god and a curving orangery framing a Garden of Paradise with fountain and canals – and all set amidst the uplands of the Cotswolds in Gloucestershire. Sezincote was designed around 1807 by the architect Samuel Pepys Cockerell (1754–1827) – who had worked in the subcontinent for the East India Company and was a descendant of the famous diarist – for his brother Charles Cockerell (1755–1837). Interior and garden design were provided by Thomas Daniell (1749–1840), the great painter of Indian architecture and landscape, with assistance from the landscaper Humphrey Repton (1752–1818). The house was the original inspiration for the Pavilion at Brighton and it stands as a unique reflection of Britain's early forays into India.

Charles Cockerell ran the post office for the East India Office at Calcutta, and it was here that he met Daniell. The two men shared a great love of all things Indian: Daniell's paintings, for example, are romantic depictions of India as an eastern paradise into which reality rarely dares to encroach. Nor were Cockerell and Daniell alone in their love of the country: as well as making a great deal of money there, many other East India Company employees were seduced by what they found in India. These were the White Mughals, many of whom lived with Indian women and gradually took on Indian clothes, habits and even religions. Such a profound fusion of cultural identities is epitomised and mirrored in the extraordinary design of Sezincote. The house combines Muslim and Hindu elements, for example,

respecting both religions equally: the dome, the minarets, the arch over the front door and the peacock-tail arches are all Islamic; the square top windows, octagonal columns and the bridge (adorned with statues of cows) are all Hindu. But if one ventures inside the house, the design is quite different. There's nothing eastern here at all: instead, one is surrounded by the familiar elements of an English country house.

But Sezincote is a pre-Victorian house, and emphatically of its time; for, as the century advanced, there was a marked change in attitudes towards India. Calls began to be heard for the conversion of the heathen Muslims and Hindus: William Wilberforce, scourge of the slave trade, announced: 'Theirs is a cruel religion. All practices of this religion have to be removed.' Where missionaries had previously been banned from India by the East India Company, they now began to pour into the country. In this new mood, no one would have dreamed of building a little Hindu temple in the English countryside, like the one created in the grounds of the Sezincote estate. Instead, such sites were denounced as dens of vice, and religious traditions were outlawed. As Victorian imperialism waxed, the British wanted to do more than trade: they wanted to civilise.

In the face of such proselytising, Indian resentment grew. Outright rebellion started in the army, where the Company's armed forces depended upon ranks of sepoys, or native soldiers. The sepoys had been growing increasingly unhappy about their low wages and lack of hope of promotion. Matters came to a head when the British developed and deployed a new Enfield rifle. It was

far more powerful and accurate than any previous musket. But rumours spread that the paper covering its cartridges was coated with pork and beef grease. The top of the cartridges had to be bitten off before loading, and there was outrage among the sepoys that the fats of forbidden animals had been chosen for this purpose; it was seen as an attempt by the British to force Christianity on India. What is startling is that the rumours had some basis. Pork and beef fat *had* initially been used, although the East India Company rapidly realised its mistake and substituted sheep fat. But, by then, it was already too late.

When eighty-five sepoys refused to bite off their cartridge tips at the town of Meerut near Delhi on 9 May 1857, a rebellion broke out. In one night, over fifty officers were killed, and violence spread to Delhi itself. A proclamation was published calling for all Hindus and Muslims to join forces to stop the British from trying to convert them – and what became known as the Indian Mutiny engulfed the north west of India, with panic rushing through the white population of the country. News quickly spread of terrible atrocities against European men, women and children: at Cawnpore, for example, it was reported that 197 women and children were mutilated and then dumped in a well, some still breathing. One officer wrote to his mother that he had found 'blood on the walls; locks of hair lying about; and a little child's shoe'.

In Britain there was outrage at what was seen as native ingratitude and betrayal, and fear of what might yet be visited on women and children. In *An Alarm in India* (1858), Edward Hopley (1816–1869) portrays an

officer's quarters under threat of attack. A British officer and his wife, a baby at her breast, peer out of a window and arming themselves in preparation for the onslaught. Yet music on the piano – 'The Campbells are coming', a traditional bagpipe tune – anticipates the relief of Lucknow by Sir Colin Campbell and the Highland regiments. In *The Campbells Are Coming, Lucknow September 1857*, better known as *Jessie's Dream* (1858), Frederick Goodall depicted a scene from the relief of the siege at Lucknow. It was said at the time that a corporal's wife called Jessie Brown had heard the bagpipes of the approaching Highlanders, on their way to relieve the besieged city; and in the painting, she points in the direction of the sound. The story of Jessie was probably just that – a fiction. But then, much was fictional about the reporting of the Mutiny. It was widely claimed, for example, that the savage Indians were raping European women: in fact, there was no proof whatsoever that this was true.

But sometimes, artists went just a bit too far. In the original version of his painting *In Memoriam* (1858), based on the massacre at Cawnpore, Joseph Noel Paton (1821–1901) depicted bloodthirsty sepoys about to burst in on a group of British women tearfully awaiting their fate. One holds a Bible; another kisses her baby a last goodbye, while a severed hand lies on the floor before them. When the painting was displayed at the Royal Academy, there was public outrage: women swooned at its barbarism and it was renamed *The Massacre*; the press declared that the painting was 'cruel and in woeful bad taste. It should never

have been hung.' Paton eventually caved in to the pressure and replaced the murderous Indians glimpsed through the doorway with courageous Highlanders, hastening the women's rescue, although the severed hand remains. This new version of the painting maintained intact the myth of the British female as sexually inviolate: it was one thing to talk about Indians raping and mutilating white women – but quite another to portray it.

The sense of outrage and anger at the Mutiny was intense, and was spurred on by the evangelical likes of Charles Spurgeon, the 'Prince of Preachers', who stood up in front of a congregation of 25,000 at the Crystal Palace and called for a holy war on the Indians: the event was captured as 'Mr Spurgeon Speaking on Humiliation Day' by the *Illustrated London News* of 7 October 1857, which encapsulates the hysterical mood of such mass meetings and the desire for vengeance. In response to incendiary speeches, enlistment in the army duly swelled as soldiers rushed to sail out to India in order to avenge the dead. Henry Nelson O'Neil's famous picture *Eastward Ho! August 1857*, was exhibited at the Academy Exhibition of 1858 at the height of this wave of patriotic outrage and portrays troops setting off to reinforce the British garrison in India. The heroic men leave their wives and children at the quayside: they cannot wait to get to their destination and exact revenge. One newspaper – in language typical of the time – praised it as 'a robust and healthy style of art'. After the Mutiny, O'Neil (1817–1880) followed up his painting with *Home Again* (1859) portraying the soldiers' return from the

subcontinent. Some characters appear in both paintings – but in the latter they are exhausted after the campaign they have fought and their arduous journey home. Chastened or not, one thing is for sure – they are Britain's heroes. When engravings were offered for sale shortly after, the demand was overwhelming. Such paintings satisfied a typically Victorian love of pictures that told a story, one with characters, a beginning and an end – and a strong dash of sentiment. This time, the topical twist gave the story a glitter-sharp edge.

The suppression of the Mutiny by British troops found its apotheosis in Edward Armitage's hugely popular *Retribution* (1858). In this very large and unconvincing canvas, Armitage (1817–1896) invokes Britannia herself: she has sailed out to India in order to grapple with a Bengal tiger, an avenging expression on her face and a sword in her hand, drawn for the kill; lying at her feet are the now obligatory dead woman and child. In reality, the violence of the British response to the Mutiny was brutal, going beyond anything the mutineers had done. Villages were ransacked and burned; some mutineers were made to lick up the blood of the dead or were smeared in pig fat before execution; others were strapped to the mouths of cannon and blown apart. There was nothing particularly 'civilising' about it.

The Mutiny took a year fully to subdue; it led to the dissolution of the East India Company in 1858 and the establishment in its place of the Raj. Two-thirds of this vast subcontinent was directly administered by the British from Calcutta, while the rest remained under the control of

autonomous princely states. Imperialism would remain very much concerned with commerce in the years that followed – but henceforth, India would be ruled directly from London, and the Empire itself would become a consciously national project. This shift in imperial policy was sealed in 1876 by the proclamation of Victoria as Empress of India. After this date, the monarch became increasingly engaged with the business of the Empire, and this in turn brought her back into public life after her long period of secluded grieving for Albert. The only imperial territory she ever actually visited was Ireland, but, as a result of her increasingly public profile as Queen and Empress, Victoria became the most famous woman in the world.

Two additions to the London landscape emphasised and gave expression to the self-congratulation of this new imperial policy. Sir George Gilbert Scott's lavish and expensive Albert Memorial at Kensington Gardens (1872), centring on a large statue of Albert seated in a vast Gothic shrine and holding a catalogue from the 1851 Great Exhibition, celebrated Britain's imperial gains with its depiction of Asia and Africa as backward places in need of imperial rule and ordered commerce. The new India Office, meanwhile, was situated in what is now the Foreign Office on Whitehall. The building – completed in 1868 – speaks volumes about how the British were coming to see themselves as an imperial nation. The building was festooned with images of the new imperial order: soldiers and administrators clad in togas, for example, to demonstrate that the British Empire was the successor

to the Roman one, and with the same ideals – justice, order, military might – governing its policy. Henceforth, there would be no more chatter about converting and civilising the natives. Instead, the new regime would be arm's length in nature, with East remaining East and West remaining West – and there would be no more Sezincotes built in the green British countryside. A certain grudging tolerance *was* given to Indian customs, and this, on one level, meant a certain degree of formality, even politeness. The design of the new office of the Secretary of State for India reflected this new attitude: the room boasts two fireplaces, so that visiting Indian princes would feel at home in the cold English climate; and there are two doors to the room, so that visiting princes of equal rank could enter simultaneously without either losing precedence.

Alongside such niceties, however, came a much firmer grip on government. Discipline was enforced and segregation increased: the Indians referred to this twin strategy of tolerance and harshness as 'the knife of sugar'; Rudyard Kipling described it rather more forcefully as 'knuckle-dusters under kid gloves'. But the notion that the Empire was essentially an improving moral force was persistent. One can see it at work in *The Secret of England's Greatness* (1861) by Thomas Jones Barker (1815–1882). In the Audience Chamber at Windsor, Victoria hands a Bible to a grateful African supplicant; Albert looks on impassively, in company with the Prime Minister, Lord John Russell, and the Foreign Secretary, Lord Palmerston. It is a dignified scene; it is also clear exactly who is the boss.

Victoria herself embodied this dual attitude rather better than anyone else. She claimed she was very fond of her colonial subjects, though in reality this tended to translate into employing Indian servants and attempting to learn Hindu scripts. But she was no peacemaker. 'If we are to maintain our position as a first-rate power,' she said, 'we must be prepared for wars somewhere or other continually.' And, true enough, British troops would do battle over the Empire somewhere in the world almost every year for the rest of Victoria's reign – from the Opium Wars in China and the Maori Wars in New Zealand, to the Zulu and Boer Wars in South Africa and long-running engagements on the North-West Frontier of the Raj. War in these years became a 'distant noise' and an interesting spectator sport – but one which affected relatively few people at home. And, with all these wars, the reputation of the soldiery grew. The military now carried out acts of 'pacification' in exotic places. They were depicted in art and popular literature as performing heroic deeds in faraway places, although there was a persistent fascination with those military events which had gone wrong. This growing sense of distance from the effects of conflict was further enhanced by the development of firearms: with the advent of the machine gun after the 1850s, Victoria's 'little wars' tended to involve very considerable numbers of indigenous peoples being killed and relatively light casualties for the British. As Hiram Stevens Maxim – the American inventor of the first fully automatic machine gun and a naturalised British citizen – put it: 'In 1882

I was in Vienna, where I met an American whom I had known in the States. He said: "Hang your chemistry and electricity! If you want to make a pile of money, invent something that will enable these Europeans to cut each others' throats with greater facility".'

Some Victorian artists were altogether disinclined to explore such aspects of imperialism, instead preferring to focus on the strangeness and exoticism of foreign landscapes. Edward Lear (1812–1890) is better known for such quintessential English nonsense as *The Owl and the Pussycat*, but his artistic gaze also fell on the East: in *The Pyramids at Gizah* (1873), these monumental and ancient structures are set against a long avenue of acacia trees – and shrunken in the process. Other paintings depict the East as glowing and luxurious, but also hedonistic and decadent: John Frederick Lewis (1805–1876), who spent ten years in Egypt, meticulously details in *The Midday Meal, Cairo* (1875) the bowls of luscious fruit, the coloured fabrics, polished glass and glossy porcelain that make up some notional average scene in the Levant.

Other paintings of the period run distinctly counter to the prevailing climate of imperial triumphalism, as artists cast a cold eye on the failures and reverses which accompanied imperial endeavours. Such events were regarded as 'no end of a lesson', retribution for easy complacency or incompetence. *The Remnants of an Army* (1879) by Lady Butler has as its subject one of the British army's most dreadful calamities – the retreat from Kabul

of a column of Anglo-Indian soldiers, together with their wives, children and camp followers, in January 1842. It turned into a rout, with the loss of approximately 16,000 lives and only one registered survivor, army surgeon Dr William Brydon, who escaped on horseback to the British fort at Jalalabad. *General Gordon's Last Stand* (*c.*1893) by George William Joy (1844–1925) has none of the shocking despair that characterises Thompson's painting. In the 1870s, General Gordon, who had gained military fame in China, was sent to the Sudan to subdue a Muslim African revolt against British rule. In 1885 an army of Mahdists succeeding in overthrowing the British garrison at Khartoum and hacking Gordon to pieces. Joy romanticises the scene with Gordon, a classic British hero, staring down the Mahdists and sporting the very stiffest of upper lips even as his inevitable death approaches. Yet in the same period, Thompson – influenced, perhaps, by her new husband – was painting scenes such as *Evicted* (1890) which shows an Irish tenant farming family being stripped of its land and therefore of its livelihood. Such scenes, showing the reality of colonialism from the perspective of those colonised, were not altogether popular. When *Evicted* was exhibited at the Academy, the Prime Minister, Lord Salisbury, noted tartly: 'There is such an air of breezy cheerfulness and beauty about the landscape which is painted, that it makes me long to take part in an eviction myself.'

Rich and Poor

For many Victorians, ever-increasing wealth, global dominance and the Empire represented a colossal market – and a rapidly expanding industrial base gave an opportunity to make that market work. The system was simple: the colonies supplied food and raw materials, the mills and foundries of industrial Britain clothed and furnished the colonies, and the colonies despatched cheap and often exotic goods for purchase by the Victorian consumer. A booming middle class meant that for the first time a lot of people were wealthy enough to buy non-essential goods – and so a modern consumer society was born, and the face of the country changed to suit its needs. Industry was withdrawn into new zones and shops took its place; while urban amenities were improved both by local government (pavements, lighting, policing) and by private enterprise. This rapidly expanding middle class now had two things it had not had before – money and choice – and the market provided plenty of goods to buy. The new bourgeoisie now opened their purses and went shopping: middle-class housewives began to leave their homes and step out into transformed town centres. To meet this demand, shopkeepers began to rethink how they sold their wares, as shops grew bigger and began to sell a wider range of goods, swallowing up smaller shops in the process. The modern department store was born.

Take Liberty in London's Regent Street. This department store was opened by Arthur Liberty in 1875

specifically as an emporium for goods imported from the Empire – fabrics, wallpapers and rugs from the Far and Near East, porcelains, lacquerware and antiques from China and Japan. Arthur Liberty even called the building that housed his store 'East India House'. Department stores like Liberty revolutionised the way people shopped. These were grand spaces that anyone could enter and walk around: they could browse departments, untroubled by over-solicitous shop assistants; they could even leave without spending a cent. On the outside, window dressing became a new art form; on the inside, lavatories, restaurants, tea-rooms and hairdressers pampered increasingly expectant customers. Mechanical lifts were introduced, at first advertised for the use of the 'old, fat, feeble, short-winded, or simply lazy – or those who desire a bit of fun!' – and were soon followed elsewhere by escalators. When the first of these contraptions opened, an assistant stood at the top, ready to offer smelling salts or brandy to anyone who had found the adventure too unnerving. But most of all, the department store was about glamour, and that would rub off on the customers. Arthur Liberty had grand ambitions: he wanted to change the whole look of fashion in dress and decoration – and he was remarkably successful. The store became hugely influential: museums, recognising value and staying power, began buying Liberty objects for their collections; and when in 1884 Liberty added dresses to its racks, it was possible for the discerning customer to buy an entire Liberty lifestyle. James Collinson's *At the Bazaar* (1857)

and Henry Tonks's *The Hat Shop* (1892) both present this new world of genteel browsing, respectable customers, consumer durables and large glass windows displaying goods to the passers-by.

Advertising began to change the face of Britain's cities. Like other department stores, Liberty found it could stamp its corporate identity on the public consciousness by branding each piece of the operation – bags, boxes, wrapping paper – with its corporate logo. And as with Liberty, so with any ambitious shop or business: the consumer boom gave birth to mass advertising and all the gimmicks to which we have grown accustomed – including celebrity endorsement. 'Just as sure as the sun will rise tomorrow,' claimed one Victorian celebrity, 'just so sure it will enlarge and beautify the bosom.' The product was Madame Fontaine's Bosom Beautifier; the celebrity was Oscar Wilde. The Royal Family was roped in too: Victoria and Albert were used to advertise all sorts of products, from porridge oats to tooth powder to hair treatments. Britannia was portrayed sampling Mazawatter cocoa; and old soldiers sipped their patriotic Bovril.

The colourful clutter depicted in Alfred Concanen's lithograph *Modern Advertising* (1874) – showing the scene at a railway station – and Orlando Parry's *Street Scene* (1835) – picturing an average Victorian urban thoroughfare – makes one wonder how any Victorian passenger ever found his train or pedestrian her destination. One estimate suggests that over 1,150 million advertising handbills were distributed in London in an average mid-Victorian year.

Sandwich-men carrying billboards walked the streets; slides were projected onto giant screens in the West End. Victorian Britain was drowning under a sea of advertisements, far more than we have even today. 'Advertisements,' it was wailed, 'are turning England into a sordid and disorderly spectacle from sea to sea.'[3]

Even paintings were not immune to the rising tide. *Girl With Dogs* (1893) by Charles Barber (1840–1917) was used to advertise Sunlight soap. Millais' famous *Bubbles* was bought by T.J. Barratt, the managing director of Pears soap, and the painting was duly transformed by the addition of a bar of soap. What Millais thought of this isn't clear: his son always claimed that he was furious about it – but at the time Millais was the most popular painter in England, and his healthily Victorian commercial streak would suggest he was perfectly happy with the arrangement.

This newly bourgeois world claimed its victims too: for most of the Victorian era, the working class was largely powerless. We have already seen how Hubert von Herkomer's *Hard Times, 1885* (1885) delivers a portrait of a starving rural family, travelling from town to town in search of work. This was the fate of thousands of farm workers in Victorian Britain, as cheap imports from the Empire did for British farmers and labourers. Some would move to the cities to work in factories. Those who stayed on the land, however, could face a stark choice: starve – or emigrate. The cold statistics of the period tell us that between four and five million people left Britain in the twenty years between 1840 and 1860: three million

Richard Redgrave, *The Governess*, 1844. Victoria and Albert Museum.

John Everett Millais, *Bubbles*, 1885–1886. Lady Lever Art Gallery, Port Sunlight, Merseyside.

Frank Holl, *Hush!*, 1877. Tate Britain.

Frank Holl, *Hushed*, 1877. Tate Britain.

Luke Fildes, *The Doctor*, 1891. Tate Britain.

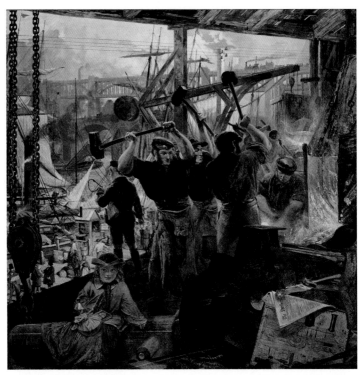

William Bell Scott, Detail from *Iron and Coal*, 1861. National Trust:
Wallington.

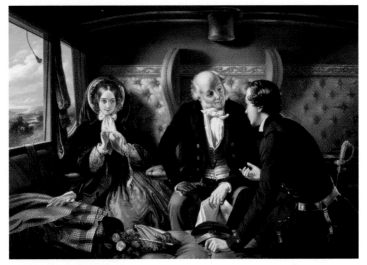

Abraham Solomon, *First Class – The Meeting, and At First Meeting
Loved*, 1854. National Gallery of Canada, Ottowa.

Elizabeth Thompson (Lady Butler), *The Roll Call*, 1874. Royal Collection.

Elizabeth Thompson (Lady Butler), *The Battle of Balaclava in 1854*, 1876. Manchester Art Gallery.

(*Above left*) Henry Nelson O'Neil, *Eastward Ho! August 1857*, 1857. Museum of London, Docklands.

(*Above right*) Henry Nelson O'Neil, *Home Again*, 1859. Private Collection.

Edward Armitage, *Retribution*, 1858. Leeds City Art Gallery.

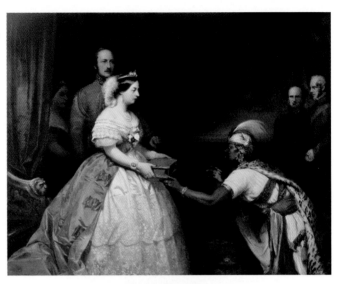

Thomas Jones Barker, *The Secret of England's Greatness*, 1861. National Portrait Gallery.

Ford Madox Brown, *The Last of England*, 1852–1855. Birmingham Museum and Art Gallery.

Ford Madox Brown, *Walton-on-the-Naze*, 1860. Birmingham Museum and Art Gallery.

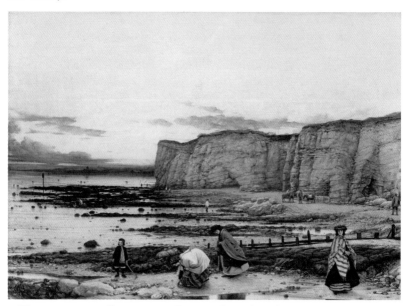

William Dyce, *Pegwell Bay: A Recollection of October 5ᵗʰ, 1858*, 1858–1860. Tate Britain.

William Dyce, *The Garden at Gethsemane*, c.1860. Sudley House, Merseyside.

(*Above*) **John Everett Millais, *Christ in the House of his Parents*,** 1849–1850. Tate Britain.

(*Above, right*) **William Holman Hunt, *The Light of the World*,** 1853–1856. Keble College Oxford/St Paul's Cathedral/Manchester Art Gallery.

(*Right*) **Edwin Landseer, *Man Proposes, God Disposes*,** 1863–1864. Royal Holloway and Bedford New College.

Henry Bowler, *The Doubt: Can These Dry Bones Live?*, 1855. Tate Britain.

George Frederic Watts, *Hope*, c.1885–1886. Watts Gallery, Compton, Surrey.

(*Right*) John Martin, *The Great Day of his Wrath/ The Plains of Heaven/ The Last Judgement*, 1851–1853. Tate Britain.

John William Waterhouse, *The Lady of Shalott*, 1888. Tate Britain.

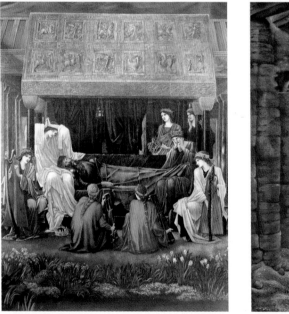

(*Above*) Detail from Edward Burne-Jones, *The Last Sleep of Arthur in Avalon*, 1881–1898. Museo de Arte de Ponce, Puerto Rico.

(*Right*) Edward Burne-Jones, *The Depths of the Sea*, 1887. Fogg Museum, Harvard University, USA.

John Everett Millais, *Speak! Speak!*, 1894–1895. Tate Britain.

J.M.W. Turner, *Queen Mab's Dream*, 1845. Tate Britain.

(*Above*) **Richard Dadd**, *Come Unto These Yellow Sands*, 1841. Private Collection.

(*Left*) Richard Dadd, *The Fairy Feller's Master Stroke*, c.1855–1864. Tate Britain.

bound for America, the rest principally to New Zealand, Australia and Canada. Such figures are startling; the daily emotion as witnessed in communities across the country impels many paintings of the time. In *The Emigrant's Farewell* (1838), Paul Falconer Poole (1807–1879) gives a busy picture of a family gathering in a cottage for a tearful leave-taking. In (the distinctly picturesque) *The Emigrant* (1858), by contrast, Poole's scene of the final, wrenching moments before departure appears deathly silent, as a ship stands off the coast waiting to sail. C.J. Staniland's *The Emigrant Ship* (c.1880) portrays a realistically un-picturesque scene of chaos, sorrow and a heady excitement for some – not to mention the sheer numbers of people forced to leave their native land – and Richard Redgrave's *The Emigrant's Last Sight of Home* (1858) emphasises the improbable beauty of the rural idyll being left behind for an unknown future. The couple in what is perhaps the most famous depiction of emigration, Ford Madox Brown's *The Last of England* (1852–1855), are squeezed into an emigrant ship with the white cliffs of Dover in the background: the expressions suggest not hope but anxiety; the grey breakers promise a stormy passage. The title – the backdrop of the painting notwithstanding – implies that the couple are looking not forwards to a new future, but backwards to a now-receding homeland. The painting is packed with pathetic detail: the lifeboat shows the name of the ship to be the *El Dorado*; supplies in the form of cabbages are slung from the side, suggesting a long voyage; the tiny hand being

held by the woman is that of the couple's baby, wrapped inside her shawl. But it is the expressions on their faces – resentment on his, resignation on hers – which give the picture its lingering power.

These were also the years in which the British trade union movement took shape and gathered power and authority. During the 1880s, socialism assumed a more belligerent form, as the gulf widened between organised labour and the more Leviathan-like aspect of capitalism. One significant moment came in 1892, with the appearance in the House of Commons of the ex-miner, James Keir Hardie, the newly elected Member for South-West Ham, who a year later would found the Independent Labour Party. Unlike the handful of his forerunners who had been elected to Westminster, Hardie refused to don the silk hat, entering the Commons in cloth cap. It was a portent of events to come; indeed, his very election was an indication of the degree to which the world was changing. Working-class literacy levels were rising and, with the poor increasingly concentrated in the cities, the mood for change was growing. There was a growing sense of solidarity amongst the underprivileged – and in response, oft-voiced fears of the power of the 'masses'. But, as the Chartist experience had shown earlier in the century, the working class was never the unified bloc that its critics frequently assumed; and on the whole too, successive governments were wily enough never to allow class conflict to harden to the point where widespread violence was inevitable. Concessions might

come late, but some measure of conciliation was usually offered before the dam burst.

Artists like Frederick Barnard (1846–1896) turned their gaze on the new urban underclass – and the results of their studies can be deeply evocative. In *The Unemployed of London: We've Got No Work To Do*, printed in the *Illustrated London News* in 1886, Barnard portrays the frustration of reluctantly idle men hanging around the docks of London in the hope of a day's work loading or unloading a ship, and also evokes a sense of waste, of potential frittered away. Dockers were paid when there was work on; when there was none, they got nothing. And trade fluctuated: one week could see as many as 200 ships arriving at West India Docks; another week, as few as 40. Every morning, men crammed around the dock gates desperate to be picked for a day's work. Most would be unlucky, and on average, a docker worked just three hours a day. In *Warehousing in the City* (1872), Gustave Doré sets the lives of such workers against a backdrop that is not only dark and harsh – his trademark images, as we know – but also vast; and so he portrays their diminishing humanity.

In the summer of 1889, it was just such men – living on the edge of survival – who would make a decisive stand for the rights of the common worker. On 12 August, the fuse was lit in West India Dock with a pay dispute over the unloading of a ship called the *Lady Armstrong*. It rapidly escalated into a full-blown dock strike. The dockers were followed out on strike by the

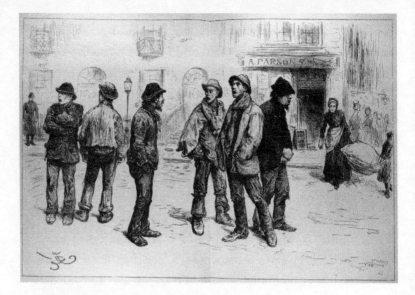

Frederick Barnard, *The Unemployed of London:
We've Got No Work To Do*, printed in the
Illustrated London News, 1886.

stevedores – the men who loaded the ships – and then by
all those who worked on the docks, including engineers,
carpenters and watchmen. Within a week, 30,000 men
were on strike and the docks had ground to a standstill.
The workers demanded 6d an hour instead of 5d, and a
minimum of four hours' work a day. What is more, the
strike held, which was no mean feat in Victorian Britain,
since union membership was low. In some quarters, it
came as a shock that ordinary people could unite so
forcefully. Dudley Hardy's painting *The Dock Strike*
(1889) shows one of the dockers' leaders urging his men

on, as the crowd enthusiastically cheer the scene. There is real dignity in this portrayal of working men – and indeed, there was real public sympathy for the strike. Thousands of dockers and their families marched, carrying huge banners, with their children holding signs saying 'Please feed us'. The strike was so successful that it soon spread beyond the docks, as numberless London trades – from tailors to rope-makers – decided to air their grievances. The *Evening News* realised where this was heading: 'The proverbial small spark has kindled a great fire which threatens to envelop the whole metropolis.' London teetered on the edge of a general strike. After three weeks, strike funds were running low and families starving, but, under huge pressure to settle, it was the bosses who gave in. This was a historic moment – the classes had squared up to each other, and the underdogs had won. Britain had altered for good.

Times were changing, at least for those Victorians who looked thoughtfully at the world around them. Of course, not all did so. Take the scene in London in 1897 when, after sixty years on the throne, Victoria celebrated her Diamond Jubilee. In the previous year, the Queen had surpassed George III as Britain's longest-reigning monarch, but, at her request, all celebrations of this milestone were held over until the following year, in order that the Jubilee might be marked in style. And marked it duly was, with festivities across the country and the Empire: G.S. Amato's *Queen Victoria's Diamond Jubilee* (c.1897) captures the gargantuan scale of the celebrations. A quarter of a

million pounds was spent decorating London in a fittingly triumphant way: the streets were festooned with garlands, banners and bunting; patriotic and imperial slogans were everywhere; and the Bank of England was emblazoned with the words 'She Wrought Her People Lasting Good'. On 22 June, Victoria embarked on a Progress through the streets of London, attended by 46,000 troops, eleven colonial premiers and a multitude of special envoys and members of foreign royalty. The *Daily Mail* pronounced that it was fitting that she should end her procession thanking God at St Paul's – after all, God was the only being more majestic than the Queen. 'No one ever, I believe,' she later wrote in her journal, 'has met with such an ovation as was given to me, passing through those 6 miles of streets ... The cheering was quite deafening & every face seemed to be filled with real joy. I was much moved and gratified.'

No doubt it *was* a splendid occasion. But for those with eyes to see, it must have seemed a temptation to fate. Britain's might was fading fast; Germany and the United States were threatening the country's international pre-eminence; and already, the clouds of war were gathering over Europe. The country's status as 'the workshop of the world' was no longer secure; and the Empire was chronically overstretched. How long could so few govern so many? The early Victorians had seen themselves as ancient Romans – but now others remembered how Rome, too, had fallen. And society had been revolutionised: power had shifted from the aristocracy to the middle class, and now also to the workers whose labour had

made industrial Britain great. The people's century was dawning. These profound changes brought fear and misgivings in their wake – but not to all. Victoria died at Osborne on 22 January 1901 and, when the immediate shock had passed (after all, practically no one, except the very old, could recall what life was like without her), there came amid all other feelings a sense of relief, the prospect of a new sovereign and of a new century. As Virginia Woolf, emancipated from the Stephen family when she moved to Bloomsbury in 1904, put it: 'Everything was going to be new, everything was going to be different; everything was on trial. We are going to do without napkins ... to have coffee after dinner, instead of tea at nine o'clock.'

FIVE
A LAND
OF DREAMS

Ah, love, let us be true
To one another! For the world, which seems
To lie before us like a land of dreams,
So various, so beautiful, so new,
Hath really neither joy, nor love, nor light,
Nor certitude, nor peace, nor help nor pain;
And we are here as on a darkling plain
Swept with confused alarms of struggle and flight,
Where ignorant armies clash by night.

Matthew Arnold, from 'Dover Beach' (*c.*1851)

I N THE AUTUMN OF 1857, the artist William Dyce
and his family were at Pegwell Bay, on the Kent coast
between Ramsgate and Sandwich. It was an area
popular with Victorian daytrippers and tourists, who
relished its tea gardens and picturesque ensemble of sand,
rock and gleaming chalk cliffs.

Charles Dickens had described a serene Pegwell Bay
in his comic short story 'The Tuggses at Ramsgate' twenty
years before Dyce's visit:

> Mr and Mrs Tuggs, and the captain, had ordered
> lunch in the little garden behind: – small saucers
> of large shrimps, dabs of butter, crusty loaves
> and bottled ale. The sky was without a cloud;
> there were flower pots and turf before them; the

sea, from the foot of the cliff, stretching away as far as the eye could discern anything at all; vessels in the distance with sails as white, and as small, as nicely-got-up cambric handkerchiefs. The shrimps were delightful, the ale better ... And then they went down the steep wooden steps a little further on, which led to the bottom of the cliff; and looked at the crabs, and the seaweed, and the eels, till it was more than fully time to go back to Ramsgate again.[1]

Dickens, like William Frith in *Ramsgate Sands*, was describing a scene of pleasure recognisable to any Victorian: all informality, crowds, donkeys, mouth organs, bathing machines and shoulder-rubbing social classes.

The coasts of Britain – and the Channel coast in particular – also played a big part in the nation's sense of itself: 'This precious stone,' as Shakespeare had written, 'set in the silver sea, Which serves us in the office of a wall, Or as a moat defensive to a house, Against the envy of less happier lands.'[2] Two hundred and fifty years later, the British could look at the precious coast and wide sea with a measure of satisfaction: on the continent, revolutions and invasions came and went but, behind its moat, Britain was impregnable. In Ford Madox Brown's *Walton-on-the-Naze* (1860), this satisfaction is radiant: a lady and a little girl dry their hair after bathing here on the Essex coast; the Union flag flutters over a nearby Martello tower (a building symbolic of the threat of Napoleon and

a reminder of his defeat), while the sight of a smoking chimney, a windmill, a ship at anchor in the estuary and the stacked wheat in the foreground are reminders of the country's secure prosperity.

Dyce painted a watercolour of Pegwell Bay after his visit – it now hangs in the municipal art gallery at Aberdeen, the artist's home city – and, following his return a year later, he executed in oils his *Pegwell Bay: A Recollection of October 5th, 1858*, which was exhibited at the Academy in the summer of 1860. For all the comfort the nation found in its insularity, it is an oddly disconcerting painting. Ostensibly a family portrait – the subjects are Dyce's wife Jane, their son and two of her sisters – the scene presents a group of individuals spread thinly across the landscape. There is no communication or togetherness, only solemnity; Jane Dyce and her son are gazing off intently to the left at we know not what; and Dyce himself figures on the canvas as a small figure in the middle distance, his back firmly to the viewer. The figures are diminished by the vastness of beach and sky that they inhabit. Overhead, wholly unobserved by the family, a comet streaks silently across the sky.

Dyce was a true polymath and maintained a keen interest in science and particularly in geology: the strata of the fossil-rich cliffs at Pegwell Bay are represented lovingly in the painting – so much so, indeed, that he was accused of having painted the scene from a photograph and not from real life at all – and the rock-strewn expanse of the beach illustrates the march of erosion on this stretch of the English coastline. Dyce was also

an enthusiastic amateur astronomer, and the precise date of the painting illustrates this fact: the blaze of light overhead was Donati's Comet, which appeared at its brightest in the skies over Britain on 5 October of that year, and it joins the painting's rocks, sands and cliffs in representing a conglomeration of anxieties and concerns that loomed large in Victorian society. Science in general – and astronomy and geology in particular – had assumed a role in the Victorian world view that would have been unthinkable only a few decades earlier, and the advances in these disciplines had opened up a physical and philosophical universe that profoundly challenged traditional ways of understanding the world.

In November 1859 – around the same time as Dyce was setting onto canvas his recollections of Pegwell Bay – Charles Darwin published *The Origin of Species*. Its full title, *On the Origin of Species by Means of Natural Selection, or the Preservation of Favoured Races in the Struggle for Life*, resonates with irony. The Victorians were, on the one hand, accustomed to the idea that they were one of these Favoured Races, and Darwin's theory, therefore, might well have given them comfort. But its central proposition – that species were in a state of continual evolution and that only those best fitted to their surroundings would survive – struck at many of the philosophical and religious orthodoxies of the day. It was, accordingly, pilloried in the press and by many politicians. ('You know all is development,' mocked Disraeli. 'The principle is perpetually going on. First there was nothing, then there was something; then, I forget the

next – I think there were shells, then fishes; then we came, let me see, did we come next? Never mind that, we came at last.') But Darwin's subversive ideas resonated with a society already subject to gnawing philosophical doubts. Swift advances in astronomy and the earth sciences were revealing troubling new worlds to the Victorians, and it was little wonder that, in the midst of this new universe, the industrial, imperial and cultural advances of their own society might suddenly seem to count for very little.

Dyce himself was firmly religious. His early paintings, like *Virgin and Child* (*c.*1838) and *Madonna and Child* (*c.*1827–1830), are deeply traditional, harking back to the Renaissance and greatly influenced by the Nazarene school in Germany. Twenty years later, this devotion was no less present in his life, yet *Pegwell Bay* reflects an acceptance of the reality of an altering world, as well as natural unease at such radical change and a striving to find a place in this new order for both God and humanity. Donati's Comet carries a weight of anxious expectancy of yet more unimaginable changes to come, and the figures on the beach represent an increasingly atomised industrial society. Can Pegwell Bay have been a mere chance seaside location? The artist would have been well aware that the bay sits in the area in which St Augustine was said to have landed on British soil to deliver the Good News of the Creation. Yet fossils embedded in the painstakingly drawn cliffs proved that the creation myth was nonsense. Sir Charles Lyell's *Principles of Geology* had already seriously undermined Biblical fables about how the world began; all over the

nation, ordinary Victorian men and women armed with hammers and magnifying glasses had taken to spending their weekends fossil-hunting at the seaside. For Dyce, there was discomfort but no essential contradiction in such a scene: the mere fact of the fossils' existence, in their miraculous intricacy, ubiquity and beauty, pulled religion and science together and provided proof enough of the existence of a benign and omnipresent God. And yet there could be no better setting than Pegwell Bay to illustrate the anxiety which was to convulse Victorian society on the publication of *The Origin of Species*. Mainstream Victorian thought – forward-looking, optimistic, rational, assertive, materialistic, imperialistic, moralistic, confident – was now being subverted as never before.

Doubt and Devotion

Religion – its role and meaning, and its function as part of the intricate machinery of society – was a topic of burning importance to the Victorians, and challenges to religious orthodoxies, to Anglicanism and the embedded position of the Church of England at the heart of national life, occurred throughout the period. Industrialism and the swelling population of the cities brought unprecedented challenges for the Church and, although it responded with a vigorous programme of church-building in these new urban communities, Sunday attendance fell steadily throughout

the nineteenth century. The growth of Methodism and other faiths added challenges of their own, as did a spreading culture of secularism. And the growing confidence of the Roman Catholic Church, after centuries of keeping its head down, was seen as a potent threat: Catholic Emancipation, which culminated in the Catholic Relief Act of 1829, was an historic legislative and cultural shift and one that many in Victorian society struggled to accommodate.

The paintings of the period reflect these anxieties. Some are steadily orthodox, as in the rural piety of Thomas Webster's *A Village Choir* (1847), which possesses all the hallmarks of a Cranbrook painting; it was much admired at the time for the individuality of the massed choristers.* Piety in a rather more simple guise was provided by Kate Greenaway, whose youthful choristers in *Singing in Church* have markedly little in the way of individuality; and *Speak, Lord, for Thy Servant Heareth* (1853) by James Sant (1820–1916) offers a version of the youthful cherub that was very much to the Victorian taste.

But iconoclastic tendencies – some more visible than others – flow through the art of the period. Take Dyce's *The Garden at Gethsemane* (c.1860), which reflects the artist's consistently firm religious devotion, but this time expressed in a new and distinctive style. The subject of the painting is Jesus praying alone before the crucifixion, and the setting of the Garden has been transplanted to a wild

*In fact, the scene is the Church of All Saints, Bow Brickhill, near Bletchley in Oxfordshire.

Scottish glen at twilight, with Christ's spiritual journey symbolised by the path that leads into a dense forest under the waxing light of a crescent moon. Dyce is at some pains to portray his Christ as a flesh-and-blood man, one with whom any viewer might identify.

Dyce was not a member of the Pre-Raphaelite Brotherhood but he shared their aim of painting all subjects as much as possible from real, observable life. In their different ways, *Pegwell Bay* and *The Garden at Gethsemane* reflect a shared preoccupation with such naturalistic detail: the landscapes are genuine and mirror the world as it truly existed.

Such innovation was by no means welcomed by all. Dyce, in fact, was one of the very few Academicians to offer the Pre-Raphaelites a measure of support. At the Exhibition of 1850, it was he who took John Ruskin's arm, wheeled him around and forced him to look at John Everett Millais' *Christ in the House of his Parents* (also known as *Christ in the Carpenter's Shop*, 1849–1850) – not just once, but twice.

Millais' painting had already been the subject of particularly vitriolic abuse, and is probably the most notorious ever produced by a member of the Brotherhood. It presents a scene from the boyhood of Jesus at Nazareth with his entire extended human family in attendance: the Virgin and St Anne as well as Joseph, John the Baptist, an assistant carpenter, and a dove and other birds, with a flock of sheep bringing up the rear. Millais, in his obsessive devotion to detail, spent long hours in an actual carpenter's

shop on Oxford Street in London, where he installed a bed and studied the musculature of the resident carpenter in order to capture correctly the form of Joseph's arms. Joseph's features, meanwhile, came courtesy of Millais' father, and Mary's were based on his sister-in-law.

Millais' version of realism is particularly striking, for the Holy Family are captured in the midst of their labours, all wrinkled visages and dirty fingernails: 'The impersonation of Joseph,' complained the *Art Journal*, 'seems to have been realised from a subject having been served a course of study in a dissecting room.'³ The portrayal of Mary in particular is very far removed from the passive Madonnas of paintings past: 'so horrible in her ugliness,' as Dickens described her in a lacerating review in *Household Words*, 'that (supposing it were possible for any human creature to exist for a moment with that dislocated throat) she would stand out from the rest of the company as a Monster, in the vilest cabaret in France, or in the lowest gin shop in England.'⁴

Other commentators criticised what were taken to be the painting's papist sympathies. By dwelling on the various pains and deformities that seem to afflict the Holy Family, a link was made with 'morbid' Roman Catholicism – although Millais was not a Catholic, either then or at any point in his life. The scene was imbued with Catholic liturgical symbolism: the dove was the Holy Spirit; the carpenter's tools the instruments of the Passion; the table the altar. Even the spatial arrangement of the shop invoked a Catholic and High Anglican separation of clergy and flock:

outside, beyond the fence, crowd the sheep – not only the congregation watching the mysteries of Holy Communion but, as it were, the Academy crowds seeing themselves in a mirror. It was all too much.

Having been brought to study Millais' painting, Ruskin begged to differ, praising the artist's use of 'stern realism', which was so different from the decadent art of the past. Ruskin was no uncritical admirer of the Pre-Raphaelites and their ways – and the fact that Millais would go on to marry the much put-upon Effie Ruskin after the annulment of the Ruskin marriage would not have endeared him further to the movement – but he had lit upon the version of realism that characterised their work. Ruskin's reaction to the work of another Pre-Raphaelite, *Convent Thoughts* (1850) by Charles Allston Collins (1828–1873) encapsulates this attitude of doubtful assent: Ruskin much approved of the natural rendering of the doleful nun who is the subject of the piece, the passion flower that the nun is contemplating and in particular the greenery that forms a backdrop to her thoughts. ('I happen to have a special acquaintance with the water plant *Alisma Platago* ... and never saw it so thoroughly or so well drawn.') But he thoroughly disapproved of the painting's 'Roman and Tractarian tendencies'. Ruskin might, perhaps, have more justly targeted James Collinson, whose *Renunciation of Queen Elizabeth of Hungary* (1848–1850), showing the medieval saint renouncing her royal title for a religious life, was also criticised for its taint of Catholicism: Collinson, an original member of the Pre-Raphaelite Brotherhood,

did convert to Catholicism, abandoning the Brotherhood in the process.*

This 'stern realism' and the mingling of the sacred and profane runs consistently through much of the art of the period. Ford Madox Brown's *Christ Washing Peter's Feet* (1851–1856) focuses on the humanity of Christ: the adult Jesus is pictured kneeling before the apostle; the watching followers cradle their chins in their hands, and fiddle and fidget with the straps of their sandals. They are unkempt, inattentive. The figures in William Holman Hunt's *The Finding of the Saviour in the Temple* (1854–1865) are more flatteringly depicted – the Virgin is clad in her standard blue and white, while the youthful Jesus is neat and graceful – but the scene of a young boy setting out to preach to a dauntingly sceptical crowd of officials and greybeards is arrestingly realistic. The purpose of the painting was explicitly to deepen the spectators' empathy with Christ – and it worked too: the picture was tremendously popular, with many thousands of advance orders for the engravings which followed its original exhibition. Hunt was similarly at pains to bring his own kind of dense texture to the picture, to the extent that a plate was issued with each print elucidating the painting's symbols, and elaborating on the care that he had taken in obtaining accuracy in architecture and costume.

*Collinson had been engaged to Dante Gabriel Rossetti's sister, Christina Rossetti and converted from Catholocism to Anglicanism; following his reconversion to Catholicism, the engagement was dissolved.

Hunt's knowledge of such matters stemmed in part from four journeys he had made to the Holy Land, the first of which took place from 1854 to 1856. Such visits were of course taking the Pre-Raphaelite dedication to authenticity to its logical conclusions. It led to the artist sometimes really having to suffer for his art. Hunt's curious *The Scapegoat* (1854), for example, was partly painted amid the moonscape and salt pans on the shores of the Dead Sea, on a spot identified by contemporary scholars and historians as the location of the Biblical Sodom; it involved the purchase of an actual goat, which was tethered in this barren landscape while the process of painting took place. (Unsurprisingly, the poor beast died and Hunt was obliged to buy another one to round off the painting.) Once again, the piece is loaded with symbolism: this time, Hunt relied on the Talmud to supply the background information necessary to understand fully the painting's scriptural context: on the Day of Atonement, a goat was driven from the temple into the wilderness taking with it the sins of the congregation. When *The Scapegoat* was exhibited at the Academy in 1856, reviewers found it both puzzling and disturbing: 'We shudder,' sighed the *Athenaeum*, '... in anticipation of the dreamy fantasies and the deep allegories that will be deduced from this figure of a goat in difficulty.'

But Hunt was now accustomed to such reception of his work. His famous *The Light of the World* (1853–1856) was accomplished only after a good deal of labour. The expeditions he undertook to maintain its realism are in accord with the Pre-Raphaelite's extreme way of doing

William Holman Hunt photographed by
Elliott & Fry in 1865.

things: he worked in the glow of a lantern suspended from an apple tree, the better to capture appropriate light and shadow for the painting; and brought the canvas to Bethlehem in order to reproduce the glow of a perfect sunrise. *The Light of the World* may now be among the most celebrated of religious paintings, but it, too, was poorly received when it appeared, so much so that Ruskin felt impelled to pick up his pen once more and write to *The Times* to defend the artist's work. Ruskin's comments served to cement the painting's reputation and spread its fame – it was subsequently taken on tour all over the country and a large replica was shipped to the colonies before being presented to St Paul's – but they also illustrate exactly why elements of the painting were so disliked in the first place. The door to the human soul portrayed is choked with weeds and is 'fast-barred, its bars and nails are rusty; it is knitted and bound to its stanchions by creeping tendrils of ivy, showing that it has never been opened. A bat hovers above it; its threshold is overgrown with brambles, nettles and fruitless corn.' Such heavy, foreboding symbolism was difficult, and all the illumination in the world could not disguise the fact.

Hunt's dedication to his art might be seen as a dedication to his faith – but other religious paintings from the period also introduce persistently discordant notes. In Dante Gabriel Rossetti's *The Girlhood of Mary Virgin* (1848–1849), the youthful Mary sports not only an incongruous flow of siren-like red hair falling unchecked down her back, but also a chafing, sullen expression as she

looks at her mother, the stern St Anne; and the young Jesus in *Our Saviour Subject to his Parents at Nazareth* (1847–1856) by John Rogers Herbert (1810–1890) is pouting and resentful as he labours for his unsmiling parents.

None of these paintings, mildly disturbing though they may be, actually raises the issue of the existence of God – other artists, however, *did* probe this fraught question. In Edwin Landseer's cold, strange *Man Proposes, God Disposes* (1863–1864), two polar bears tear at the debris of a failed arctic expedition. The canvas commemorates Sir John Franklin's doomed journey of 1845 to find the Northwest Passage between the Atlantic and Pacific: it was over a decade later before an expedition, partly financed by Franklin's wife, discovered the remains of the men, along with evidence they had resorted to cannibalism to try to survive. This was a *modern* expedition, as signalled by the remains of a telescope and leather case visible at lower left; and the painting can be interpreted as a chilly commentary on the vanity and limitations of modern science.

Despite its title, the painting seems to depict a world over which no God at all presides and in which humanity is endlessly prey to amoral natural forces. The jagged ice is like teeth; the image of the broken ship's mast recalls the Cross; and it is as if the landscape itself has torn the members of the expedition apart, with the polar bears moving in simply to wrap matters up. Despite his widespread popularity, much of Landseer's life was marred by heavy drinking and nervous complaints – he was eventually declared insane at his own request – and *Man Proposes, God Disposes* was painted in the aftermath

of a particularly difficult spell.* It is not difficult to see the despair of the artist's mind reflected in this painting. Nor is it hard to understand why many Victorians, Ruskin himself among them, preferred to skirt such uncomfortable subjects, simply noting in minute and scientific detail what they found there. Paintings like Ruskin's *Mer de Glace* (1849) and John Brett's *The Glacier of Rosenlaui* (1856) classified rather than speculated; the artists observed the phenomena, dry but miraculous, of the natural world instead of wondering what it represented. It was better to define and to gaze, perhaps, than to interrogate and alarm.

The Doubt: Can These Dry Bones Live? (1855) by Henry Bowler (1824–1903) is one of the most evocative responses to the fissuring doubts of the time. A young woman stares at a skull and bones that have resurfaced in the soil of a churchyard. Confronted with such irrefutable evidence of human mortality, who can believe in an afterlife? The painting, predating by only a few years the publication of *The Origin of Species*, recalls the emergence of agnosticism, a term coined by Thomas Huxley in the 1840s to describe the religious doubt that arose from a lack of empirical evidence. The painting both raises anxiety and attempts to quiet it. The gravestone, after all, belongs to one 'John Faithful' and is inscribed 'I am the

*The painting was, in fact, executed shortly after Landseer had completed a commission to design the four bronze lions that surround Nelson's Column in London's Trafalgar Square – in the face of much carping from Parliament and the press at the protracted delays.

Resurrection and the Life', while to the woman's left – in an echo of the Parable of the Sower – a horse chestnut sprouts a shoot on a stone engraved ironically with the word *Resurgam*, or Resurrection. A butterfly, the symbol of the soul, rests on the skull, while others flit among the tombs. A bright day and glorious colours point to life rather than to death; ultimately, the woman's doubt is seen as only momentary.*

In the face of these profound and persistent questions, some painters came out fighting, addressing the issues by trumpeting confidently the power of the Lord to work wonders; and reminded the doubtful spectator that proof of God's existence was well and truly on the way. There was a succession of pictures representing the Flood: *The Deluge* (c.1840) by Francis Danby (1793–1861) is almost five metres long; and his science fiction-like *Apocalypse* (1829) shows us how the end of the world will be signalled by a vast celestial figure presiding over a red sunset. George Frederic Watts's *After the Deluge: the 4th Day* (1885–1886) is rather more abstract, and Watts himself noted this difficulty with God:

*This picture is also a reminder of the cult of death that, heightened by the Queen's years of mourning for her lost Albert, was such a visible aspect of Victorian society: in the face of a slowly ebbing tide of religious faith, society responded by developing ever more elaborate cemeteries, each of them – like London's Kensal Green, opened in 1833, and Highgate, founded in 1839 – prominent cities of the dead. Paintings like George Frederic Watts' strange and visionary *Love and Death* (1875) reflected this obsessive morbidity.

I paint ideas, not things ... I cannot claim for my pictures more than they are thoughts, attempts to embody visionary ideas ... There is only one great mystery – the Creator. We can never return to the early ideas of him as a kind white-bearded old man. If I were ever to make a symbol of the Deity, it would be as a great vesture into which everything that exists is woven.

In 1851, John Martin (1789–1854) began work on a series of paintings that addressed directly the doubts abroad in the land, and that seem now to foreshadow the destruction of pre-Victorian certainties. Martin specialised in the production of large and spectacular scenes of apocalypse and calamity. Some of this interest can be attributed to his Northumberland childhood: he was raised in a strictly pious Christian household in the small village of Haydon Bridge, and his mother's fire-and-brimstone sermons continued to ring in his ears during his adult life. In fact, the subject of his great trio of 'judgement paintings' – *The Great Day of his Wrath, The Plains of Heaven* and *The Last Judgement* (1851–1853) – on which he worked almost until his death depict scenes from the end of the world as described in the Book of Revelation. These brooding premonitions show the uncontrollable power of nature, and warn of the fate awaiting those who attempt to harness it. The triptych was enduringly popular and was toured throughout Britain for two decades. A later owner, George Wilson, remarked:

The rising generation will hardly understand the furore these extraordinary Pictures created when they were first exhibited in 1854. I remember the crowd of visitors waiting to be admitted to the Exhibition, and when I at length entered the darkened chamber, and noted the effect produced by the multitude, and how it all seemed to be carried away from worldly thoughts, and, as it were, intoxicated by the solemn, the lofty, and the majestic aspirations of the master mind of the great Artist, youth that I was, I would rather have been John Martin than king of England.[5]

But the trio is not for the faint-hearted. *The Last Judgement* is unsparing: a heavenly congregation of Christ and the angels preside in brilliant whiteness over the end of human history; eternity yawns below; above rises Zion, with the saved (who include many great figures from the national past, with artists and writers prominent among them) already safely inhabiting the Plains of Heaven. To the right are congregated the multitudes of the damned, whose numbers include the Whore of Babylon, a liberal sprinkling of Catholic priests and the unfortunate passengers aboard the new London to Paris express, which is shown plunging into a fiery abyss at the heart of the painting. Classical architecture crumbles – a warning that the fate that awaits the Victorians could be that of Imperial Rome. It is not altogether surprising to discover that Martin ended his days mentally disturbed;

his paintings, meanwhile, at last fell from grace and were eventually sold in 1935 for less than £7.

The contradictions inherent in the Victorian world view are perhaps best exemplified by G.F. Watts's famous *Hope* (*c*.1885–1886), which employs allegory in a way that would have been familiar to *both* sacred and secular artists. The female figure of Hope has figured in Christian art since the medieval period and in secular art since the Renaissance; but Watts breathed new life into the symbol in this painting, dispensing with some traditional images, freely adapting others, and mingling divine and profane ideas in a way that symbolised the social debates of the time.* Watts's Hope is a strained figure: blindfolded, her face is cast downwards rather than – as was traditional – up and into the heavens; and, while she clutches her lyre, the instrument has only one string and is barely functional, implying that the full spiritual music of the past can today barely be heard. The traditional hope of spiritual salvation appears now weak and fitful – although, crucially, it does persist.

'All the trouble and disquiet of modern times is in that picture,' noted one critic in 1896, 'all the doubt and questioning of these latter days, when "men lie down in darkness and sorrow, and know not whether their night has a morrow" or, at best, cling despairingly to the old truths and "faintly trust the larger hope".'[6]

* *Hope*'s most recent appearance was in the USA, as part of Barack Obama's Presidential election campaign.

Holy Warfare Against the Age

As they watched the world around them being stripped of its old certainties, many Victorians sought meaning and spiritual refuge elsewhere. Some found the spiritual security they craved in an idealised vision of a chivalrous, pre-industrial and sometimes mythological past, when the world was, if not precisely easier, then perhaps more pure and uncomplicated. This tendency to hark back to simpler times was not specifically Victorian in tendency – medieval subjects had been attracting artists since the turn of the century, partly as a result of the novels of Walter Scott – but it was elaborated upon during this period. As we have seen, receptiveness to the distant past could be seen in the new architecture shooting up in Britain's industrial cities: Glasgow University – the design of which was exported for replication as far away as New Zealand – Bradford and Manchester Town Halls, and London's St Pancras Station and the new Houses of Parliament are all enduring testament to these archaic leanings. In the Crystal Palace – that symbol of a modern present and thrusting future – prominence was given to a mocked-up medieval court complete with silverwork, stained glass, embroidery and painted tiles, all of which had been designed by that great celebrant of Gothic Britain, Augustus Pugin. (Ruskin was not impressed: Pugin, he snorted, had been 'lured into the Romanish Church by the glitter of it ... blown into a change of religion by the whine of an organ pipe; switched into a

new creed by the gold threads of priests' petticoats...'
Ruskin would later repent of his words.) Mock-medieval
pageants and tournaments became all the rage: 'I always
fancy a siege must be so very interesting,' sighed one
aristocrat. 'It must be so exciting.' And in literature
too, medievalism was dished up to an increasingly
receptive audience, as the popularity of Tennyson's
reinterpretations of the tales of King Arthur and the
Knights of the Round Table testify.

This fascination was taken to extremes by some, most
notably, perhaps, by John Crichton-Stuart, prominent
industrialist and third Marquis of Bute, who employed
William Burges (1827–1881) to rebuild Cardiff Castle
and erect a modern folly on the site of medieval ruins at
Castell Coch, north of the city. In spite of the Marquis's
financial stake in the modern world – he had made his
fortune in the rebuilding of Cardiff's docks in order to
accommodate larger and more profitable coal shipments
from the Valleys – he had both castles built in a fantastical
medieval style that owed little or nothing to their original
forms. With their Gothic ranges of turrets and towers,
they were a delight to behold, although Burges admitted
that a good deal of conjecture had gone into his designs;
they were 'more picturesque' than they probably should
have been, he admitted tersely, but offered 'much more
accommodation'. The interiors of the buildings are yet
more fantastic: in Cardiff Castle, Chaucer Room follows
Arab Room and Banqueting Hall, ceiling follows lavishly
painted ceiling, and all furnished accordingly.

Such dreamy turrets and towers were matched on the canvases of the second half of the century. There are any number of representations of the Lady of Shalott, for example, spawned by the tremendous success of Tennyson's poem. She is invariably presented either on the verge of fulfilling the curse that will cause her death or already dead in her boat, winding down to Camelot. In one of the most famous of these portraits (1888), by John William Waterhouse (1849–1917), the pensive, gowned and sorrowful Lady is shown staring into space as she contemplates her fast-approaching mortality; William Maw Egley's version of 1858 captures her at the instant before she turns and seals her fate as she beholds Lancelot through her casement. Holman Hunt's rendition of the same legend – his project originated in a drawing of 1850 that he returned to work on between 1886 and 1905 – is a good deal more elaborate and dense with symbolism. Tennyson was moved to grumble that Hunt had used his poem very ill, for while the poet imagined a castle and a room as still as death, with no sound but that of the Lady of Shalott at her loom, Hunt's painting showed a scene of devastation, with the Lady standing with her shattered loom and her hair blowing in a tempestuous cloud above her head; a silver lamp, symbolising wisdom and faith, sits extinguished at her feet.

For Edward Burne-Jones (1833–1898), the goal of life and art was simple and easily stated: his avowed wish was 'to wage a crusade and Holy Warfare against the age'. Burne-Jones had discovered an affinity with medieval

images and ideas while at Oxford and relinquished an earlier idea of a Church career in favour of art (about which, as a young man, he knew next to nothing). At first, this meant more than canvases: he had long practice in the design of unique furniture, glass, tiles and textiles, and it was only later in his career that he began to apply this experience to the visual arts. His later paintings – *Le Chant d'Amour* (1868–1873), say, and *The Beguiling of Merlin* (1873–1874) – are exercises in large-scale dreamy beauty rather than in any kind of action. In the former, a young woman, beautiful in the expected Pre-Raphaelite fashion, impassively plays the organ at twilight; nearby, Cupid closes his eyes as he works the bellows – love, after all, being blind – while a young, androgynous and spellbound Knight of the Round Table reclines and listens as though in a daze; in the distance are glimpsed the towers and walls of medieval England. The scene is overwhelmingly still and strange. *The Beguiling of Merlin* is yet more odd: here the powerful magician lies trapped amid a hawthorn tree, mastered by the beautiful enchantress Nimue. Merlin manages to seem, at one and the same time, half-dead and yet ravaged by pent-up desire; and this time, it is the woman who is androgynous. In both paintings, the women wholly ignore the men nearby, this being a prominent feature of Burne-Jones's work. And, while the detailed, rich and glowing beauty of such paintings cannot be denied, such a static and heavy atmosphere is also disturbing. The sleepers were generally – although not always – female; and their slumbers frequently

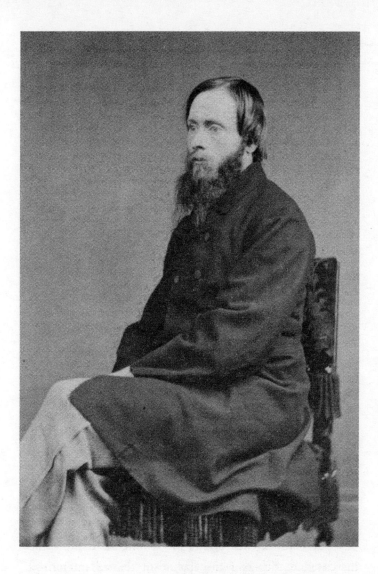

Sir Edward Coley Burne-Jones,
photographed by John Watkins,
or by Cundall, Downes & Co., *c.*1864.

resemble death itself. Leighton's *Flaming June* is one of the more famous examples, but a wide variety of other artists also adopted the device – from Frith's realist *The Sleeping Model* (1853) to *Midsummer* (1887) by Albert Moore (1841–1893) and *Sleep* (1898) by Philip Wilson Steer (1860–1942).

Burne-Jones's fascination with the medieval reached its culmination with a painting which came to obsess its creator: *The Last Sleep of Arthur in Avalon* (1881–1898), which remained unfinished at the time of his death. It is an enormous work – over six metres in width – and its sale and removal to Puerto Rico in 1963 was seen, even at a time when Victorian art was deeply unfashionable, as a substantial loss to national life. Burne-Jones worked on the piece for seventeen years, even moving into a studio that was large enough for his purposes; and it became increasingly autobiographical as the artist retreated ever further into his inner life: he identified himself with the sleeping king he was creating, awaiting his end in an atmosphere of silence and stillness. Towards the end of his life, Burne-Jones made explicit the impulses that created this piece: 'I need nothing but my hands and my brain to fashion myself a world to live in that nothing can disturb. In my own land I am king of it.'

Burne-Jones and others were able to exploit the increased enthusiasm for classicism that characterised these years, an interest that had its origin in the widening Victorian knowledge of the world. The Elgin Marbles had been taken from the Acropolis at Athens

and brought to London in 1803, later joining the spoils of the world then being gathered under the roof of the British Museum; and this, together with the subsequent reopening of Europe to the Grand Tour and to the mass travel that came later, all contributed to a renewed interest in Hellenism and ancient Rome. The obsession with the ancient classical past allowed the naked body to return stealthily to art; for all their historical trappings, what leaps out from many such paintings and sculptures is their sheer eroticism. The Great Exhibition of 1851, for example, had included a presentation of the American sculptor Hiram Powers' *Greek Slave* (1844), which caused a sensation. The sculpture had been inspired by the Greek War of Independence, and it depicts a Greek maiden who has been captured by the Turks and forced to stand naked in a slave market. The statue was secreted in a curtained alcove but placed on a stand that could be rotated discreetly by gentlemen in order to reveal her delightful posterior. Powers explained that the slave's faith in God shielded her from shame, thus effectively dispelling moral objections to her nudity. Other paintings, such as Frederic Leighton's *The Fisherman and the Syren* (1856–1858) and *Bath of Psyche* (1890) were brazenly erotic; and the mermaid in Burne-Jones's disconcerting *The Depths of the Sea* (1887) wraps her arms around the loins of her underwater captive and stares straight and challengingly into our eyes – once again, not into *his* – with a sly smile quivering on her lips. But Burne-Jones's *Phyllis and Demophoon* (1870), with its undisguised

genitalia, overstepped the mark, causing such a scandal that the painting had to be withdrawn from exhibition.

For some, however, imaginary utopias were not enough. William Morris (1834–1896), who like his friend Burne-Jones had found his vocation as a young man at Oxford, had abandoned his early painting in favour of a more utilitarian involvement with the practical arts, as well as an increasing dedication to the evolving concept of socialism. In 1861, he and Rossetti founded the design firm of Morris, Marshall, Faulkner & Co., the prime motivation being his dissatisfaction with the quality of the furniture he saw on display in London. Morris's work, however, was about more than the making of tables and chairs and the patterning of the firm's famous wallpaper. He wanted to create a new model for living. His idea was to break down the barriers between designer and maker that had been created by a mechanised factory system. Inspired by Ruskin's vision of the medieval guild workshops, Morris's firm designed textiles, tiles, stained glass and furniture for ecclesiastical and domestic use. The intention was for the designer to oversee the creation of his product in cooperation with the workers, or, even better, for him to make the product himself. Morris felt strongly that a designer should understand the manufacturing process, adapting his ideas to the need of the materials – in short, that a 'hands-on' approach was the only approach. But not everyone was pleased: when the firm's designs were displayed in the Medieval Court section of the

Exhibition of 1862, the *Building News* noted acidly that they were:

> almost perfect; their hangings, their music stand, their sofa, their chests, would all suit a family which might suddenly be awakened after a sleep of four centuries, and which was content to pay enormous prices suitably to furnish a barn. ... Messrs Morris, Faulkner & Marshall's works are the most complete, and the most thoroughly medieval of any in the Court. They are consequently the most useless.[7]

Morris applied his evolving aesthetic and political principles to his own domestic life: he wished to build a home for his new wife Jane and himself; and more than that, he wanted to create his own Camelot, inhabited by his own circle of friends. One result – in a collaboration with the architect Philip Webb – was the remarkable and beautiful Red House, completed in 1859 at Bexleyheath in what were then the fringes of south-east London. Morris and Webb's design was deliberately hand-crafted and the Red House, with its warm, detailed brickwork and pointed Gothic arches, was a romantic and social experiment. It was by no means a complete success in design terms – the main rooms faced north and the kitchen west, catching the sun's heat just as dinner was being prepared. Nor was it authentic – the medieval commonplace of having to walk through one room in

order to reach the next was judged embarrassing in the nineteenth century and was smartly circumvented by means of long corridors instead. But its furniture and murals, stained glass and roof lights, were marvellous, and the five years that Morris and his family spent at the Red House were, he said later, among the happiest of his life.

Morris would later go on to run the Kelmscott Press – named for his later house in rural Oxfordshire and founded to create books according to principles of traditional craftsmanship, complete with presses, inks, handmade paper and unique types derived from fifteenth-century Venice and Germany. Although the Kelmscott was a natural culmination of the broad canvas of Morris's life work as poet, designer, painter, weaver and political activist, he (like a good many other observers) was painfully aware of the contradictions inherent in his position as a socialist, an employer and a publisher of exquisite books that only the wealthy could afford.

Of Fairies and Fantasy

Many Victorians clung to the hope, in a life full of uncertainties, that there was more to life than the mere material world. In the 1850s, spiritualism arrived in Britain and quickly took hold: from Rossetti to Ruskin to Conan Doyle, spiritualism's adherents were various and

influential; and table-turning, a form of séance, became a craze across the country.* The new inventions of the age brought novel speculations in their wake: if people could communicate over the telegraph, some reasoned, then why couldn't they communicate with the dead? And indeed, many of the pioneers of electronic communication were deeply interested in the paranormal: Marconi attended séances; Alexander Graham Bell became fascinated by the possibilities of spiritual communication; Michael Faraday built a machine to attempt to prove the credibility of table-turning; and, in 1882, Frederick Myers founded the Society for Psychical Research, whose aim was to subject séances, table-turning and all things paranormal to rigorous scientific enquiry.

How could artists resist the lure of reflecting the poignancy, the theatricality and the heightened atmosphere of otherworldly encounters? In *The Spell* (1864) by William Fettes Douglas (1822–1891), a magician is portrayed attempting to raise the spirit of a dead man, and a sorceress in Waterhouse's *The Magic Circle* (1886) creates a space around her in preparation for casting a spell. Millais' *Speak! Speak!* (1894–1895) is perhaps the most melodramatic of the lot: a man starts up from his bed; on the candle-lit bedside table are letters written by

*In table-turning, participants would gather around a table upon which lettered cards had (Ouija-style) been laid, place their hands upon it and wait for it to move or rotate; with luck, a message would be delivered from the spirit world. Sceptics, needless to say, put such phenomena down to involuntary muscle-movements or trickery.

his lost love, whom he suddenly beholds as an apparition standing by the foot of her bed in her bridal attire.

From this point, it is only a small step to the fairy paintings – the very oddest, and yet curiously popular, aspects of nineteenth-century art. To our eyes, these seem the weirdest of all the art of the time. Yet one can see how they play to the concerns of the age: the desire to escape for a little while the dreary hardship of everyday life; the stirrings of a new attitude to sexual freedom; an interest in the supernatural and invisible; the beginnings of psychoanalysis; and a fear – seldom articulated yet deeply felt – of the new medium of photography and its tyrannical exactitude. Fairies added glamour to life – the very word 'glamour', indeed, originated in the widespread folktale of the fairy midwife.* Fairy painting became a surrogate for certain subject matter, motifs, and themes unavailable or unacceptable in more elite categories of the academic hierarchy of painting.

Events in the wider world contributed to its popularity. The developing German national consciousness through the course of the century had led to a greater awareness of German culture, in particular the rich tradition of the folktale

*A human midwife – so the story went – was summoned in the middle of the night by mysterious figures to deliver a baby. Before she entered the home, she was told to smear an ointment on her eyes – when she crossed the threshold, the house appeared to her as a palace. Having safely delivered the baby, she accidentally rubbed one eye with a sleeve – and the house was revealed to her as a hovel, its inmates fairies. The ointment was fairy 'glamour', a magic potion.

with its hinterland of dark forests, uplands and otherworldly creatures (the tales of the Brothers Grimm appeared in English translation in 1823). In the Victorian imagination, fairies were given minute stature – the invention of the microscope had led to a sparking of interest in the new worlds revealed by its lens, and a delight in tiny detail – and both the Grimm anthology and Thomas Keightley's *Fairy Mythology* of 1828 were illustrated by George Cruikshank with remarkable etchings offering an ant's-eye view of frenzied fairy revels. Closer to home, the plays of Shakespeare provided ample material for artists to exploit, most notably *The Tempest* and *A Midsummer Night's Dream* – from which is derived, for example, Turner's *Queen Mab's Dream* (1845) – as did the poetry of Milton and Spenser, to say nothing of homegrown Celtic mythology.

Given the popularity of the genre, it is not surprising that some Victorian artists pragmatically selected fairy painting as a means of establishing their professional careers and of soliciting critical and public recognition. Others, including Turner and Landseer, also took advantage of its creative scope and possibilities: fairy painting offered unique opportunities for artists to experiment with a new kind of literary narrative painting and to reach a larger proportion of the art-going audience with compelling subject matter. In December 1847, for example, Landseer accepted an invitation to dinner from Isambard Kingdom Brunel – that supreme exponent of the power of steam and forge and therefore rather a surprising proponent of fairy painting. Brunel wanted to have his dining room decorated with a set

of Shakespearean subjects – and he wished, furthermore, to have these subjects painted by some of the most famous artists of the day. Other diners that evening included Augustus Egg and the landscapist Augustus Calcott, and the Shakespearean images were duly commissioned. Landseer opted to paint his accessible and easily recognisable *Titania and Bottom* (1848–1851), for Brunel's dining-room wall.

Other artists were able to use fairy illustrations to carve out a successful commercial niche for themselves. Cruikshank and Richard 'Dicky' Doyle (1824–1883), for example, were the successful founders of a century-long dynasty of Victorian fairy illustration: the art of the former acted as a link between the satirical broadsides of the Regency period and the moral bromides of the early Victorian era, while the latter helped initiate the Victorian revolution in popular media with his contributions to *Punch* and illustrations for Dickens' Christmas novels. By the 1870s, Doyle had become one of the most prominent fairy illustrators in a crowded market, and the fairy vocabulary developed into a variety of sophisticated illustrative styles, both in colour and in black and white. His watercolour *The Fairy Tree* (c.1865) is illustrative of an odd streak of competition among fairy painters, as to who could cram the most creatures into a single canvas. Certainly, Doyle excelled at it: in this, one of his most famous watercolours, over 200 fairies perch on the branches of the tree, while a boy looks on in wonder. Doyle was able to achieve the effect of minuteness by juxtaposing the activities of the fairies with natural forms to create magical effects of diminution in scale. It is an extraordinary painting.

John Anster Fitzgerald (1819–1906), a loner and eccentric known as 'Fairy Fitzgerald', brought off some paintings which were not merely bizarre, but troubling. There is an almost alarming element to some of his work, as shown in the miniscule subjects of *Fairies in a Bird's Nest* (*c.*1860); and particularly *The Artist's Dream* (1857), which shows the artist having fallen asleep at his easel now slumbering in a respectable Victorian armchair in a room thick with flying fairies. The titles of other, equally weird, works – *The Pipe Dream, The Stuff Dreams Are Made of* – are suggestive of someone more than usually familiar with the opium, chloral and laudanum of the Victorian drug scene.

Some of the fairy paintings of the age are thickly peopled confections that act as eerie counterparts to the realist canvases of William Powell Frith and others. Joseph Noel Paton's packed tableaux – Shakespeare's sprites depicted in *The Quarrel Between Oberon and Titania* (1849) and *The Reconciliation of Oberon and Titania* (1847); a throng of the fairy folk in *The Fairy Raid: Carrying off a Changeling – Midsummer Eve* (1867) – are strikingly elaborate examples of this kind of art. In spite of the fantastic subject matter, the backdrops to these vast gatherings of minute fairies have elements of naturalism, albeit of an exaggerated kind: the trees are heavy with foliage, but their trunks are twisted into tormented shapes that suggest the creatures and monsters inhabiting such deep, dark forests. Lewis Carroll – who would go on to create his own fantasies in *Alice's Adventures in*

Wonderland (1865) and *Through the Looking Glass and What Alice Found There* (1872) – claimed to have counted a total of 165 individual fairies depicted in *The Quarrel Between Oberon and Titania*. One attraction of the business of such detailed scrutiny was that these scantily clad creatures are not 'real' ladies, but innocuous fairies from another world, tastefully veiled in the trappings of allegory or myth.

Other paintings made use of the Royal imprimatur of approval. As a child, Victoria had been devoted to the romantic European ballet of the 1820s and 1830s and to the cult of its best-known proponent, the ballerina Maria Taglioni. She would dress her wooden dolls in costumes that recalled her heroine's most famous roles. Taglioni had brought the technique of dancing *en pointe* to effortless perfection, and in so doing she created an image of aerial weightlessness reflected in the fairy painting of the time. The Irish-born Daniel Maclise (1806–1870) used such symbols and ideas in his *Undine and the Wood Demon* (1843), which was inspired by the fairy ballet *Ondine* – and which was duly purchased by the adult Victoria as a birthday present for her husband.

It is hard not to reach for adjectives like 'mad' when dealing with some of these paintings. What extraordinary mental processes had produced them? In the case of the best-known fairy painter, Richard Dadd (1819–1887), the question of sanity is especially relevant. As a young man, Dadd had been a member of the Clique, an informal sketching society which came together in 1837. He was

joined in the group by Maclise, Egg, Frith, Henry Nelson O'Neil and others, but Dadd was generally acknowledged to be the best draughtsman among them. At one such meeting, the group's members mapped out their futures with a good deal of prescience: Frith set himself to paint pictures of ordinary life, such as would please the public; O'Neil would depict incidents of colour and character, designed to appeal to the emotions; and Dadd would devote himself to works of the imagination. His earliest fairy works are characterised by lightness and an ethereal freedom: *Come Unto These Yellow Sands* (1841) takes as its beginnings the lines of Ariel in *The Tempest*; and, unsettling and odd though the painting is, it possesses a spaciousness and fluid mobility that is quite at odds with his later work.

In 1842, Dadd accompanied Sir Thomas Phillips as draftsman on an expedition to the Levant. The trip seemed at first to be a success – Dadd busied himself with picturesque watercolours – but in December of that year, during a boat trip on the Nile, he succumbed to what seemed at first to be sunstroke, becoming delusional and increasingly aggressive. During the return journey to Britain, Dadd's mood worsened – in Rome, he declared that he felt inclined to attack the Pope 'in a public place' – and on his arrival home, he was taken by his family to recuperate in Kent. But by August 1843, Dadd's delusions were worse than ever: he imagined his father to be possessed by the Devil and, having acquired a blade, murdered him by slitting his throat. He fled to Paris,

where he tried to murder a tourist; after being detained in France for ten months, he was returned to Britain where he admitted his guilt, claiming in mitigation that he was a representation of the Egyptian god Osiris. Dadd was detained first at the Bethlem Hospital (Bedlam) in Southwark before being moved, in 1864, to the newly opened Broadmoor asylum for the criminally insane, where he spent the rest of his life.

Dadd was most likely suffering from an extreme case of paranoid schizophrenia, but he had the good fortune to be treated by progressive doctors who allowed him access to both oils and watercolours. He produced much significant work during his detention at Bethlem and Broadmoor, and the latter holds a collection of his art to this day. He was naturally isolated from new trends in art and so returned to earlier influences: *Contradiction: Oberon and Titania* (1854–1858), which was painted at Bethlem and showed the quarrel over the changeling Indian boy, is dense with symbols and detail, much of it wholly inexplicable. *The Fairy Feller's Master Stroke* (c.1855–1864) was also painted at Bethlem, as a gift for the hospital's new superintendent, George Heyden. In a poem accompanying the painting, Dadd suggested that the characters thronging the canvas symbolise various recognisable types from contemporary society.

This painting began as random smears of paint, until gradually a microscopic world assumed an intricate form. The completed canvas was packed with figures: a fairy crowd has gathered to watch the fairy feller split

an acorn with a single blow of his tiny axe. The detail is extraordinary and it supports Dadd's claim that here indeed is a window on a world – even if that world is set out on the forest floor, invisible to the naked eye. The ruler of the forest faces the fairy feller, and along the brim of his hat are ranged a group of minuscule Spanish dancers, as well as Queen Mab, Cupid and Psyche. Oberon and Titania stand poised above, watching the scene; and grouped around them are representatives of common society – sailor, tinker, apothecary, ploughman, tailor and thief (who can be identified only by the flash of a red cloak), as well as minstrel, dairy maid, tanner – and so it goes on. Sex is signalled in the peep of an ankle and a tight bodice; and a fragile screen of grass shields this scene from our own world. There is a strong, bold narrative: the acorn, it seems, *must* be split in two, but we have no idea why, or why so many fairies have gathered to watch. Gaze as we may, this world is closed to us, as Dadd himself acknowledged gleefully in the accompanying poem:

> But whether it be or be not so
> You can afford to let this go
> For nought as nothing it explains
> And nothing from nothing nothing gains.

Fairy painting can be viewed as at best dismissibly odd, at worst horribly unsettling. But, set against the corrosive doubt and uncertainty, the ebbing of the 'sea of faith'

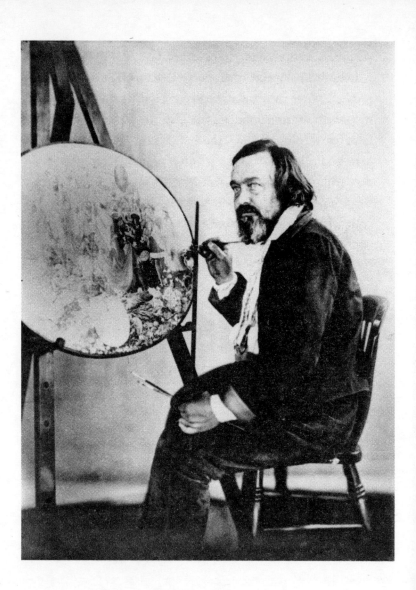

Richard Dadd photographed by Henry Hering, *c.* 1856.

that marked the Victorian era, the appearance of a flood of paintings suggesting there really might be fairies at the bottom of the garden begins to make sense. Perhaps they were no more than a reassurance that, for all the apparent solutions and explanations offered by science and engineering, there existed something unknowable, a reassurance against a dreadful kind of functionality. They made it possible to keep alive a sense of faith, a belief that not everything was discoverable by telescope or microscope.

AFTERWORD

Much has changed since the day in 1963 when Frederic Leighton's *Flaming June*, having been touted hopelessly around various British museums, was despatched to a newly founded art gallery in Puerto Rico. In early 2009 you could have seen the painting again in Britain – it had been loaned to the Tate, along with Edward Burne-Jones's masterpiece *The Last Sleep of Arthur at Avalon*, while the Puerto Rican gallery was being refurbished. In Manchester you might have visited the first Holman Hunt retrospective for forty years and, in Birmingham, a Ford Madox Brown exhibition had just closed its doors. It would be a ridiculous exaggeration to say that these shows demonstrated that twenty-first-century Britain had come to love Victorian art. But they did demonstrate a renewed interest.

Victorian artists reflected the character of their age, where energy, confidence and wealth co-existed with anxiety, doubt and querulous debate. The distant views of the reeking chimneys and grime of Leeds and Manchester or of throngs of ships moored on the Clyde and Mersey portray a time long gone. But human emotion is unchanging: the suffering and fear of ordinary soldiers in wartime are no less raw now than when Lady Butler set out to reconstruct the battlefields of the Crimea. Love

is as exuberant and as painful as ever. Families still seethe with loyalty and resentment. Even the flights of fantasy of a Burne-Jones or Richard Dadd speak to the corrosive uncertainty which emerged in the Victorian period and which remains the great characteristic of our time.

Many of these paintings have a cinematic quality to them, as if they are still frames from a movie. But the coming of the cinema spelled the end for the kind of story-telling pictures that these artists had painted for so long. The physical legacy of the Victorians is all around us. We walk their city streets, rush through the railway stations they engineered, and live in the houses they built. They shaped our world, and it shapes us. We take it for granted. But the paintings of the time provide a striking insight into Victorian social history. They show us what it must have been like to live in a rigidly structured society, to acknowledge an imperial destiny and to wrestle with doubt, to huddle in the snow waiting for admission to a night shelter.

These under-appreciated paintings hang on the walls of galleries across the land. And they belong to all of us.

ACKNOWLEDGEMENTS

All television is a collaborative exercise, so it is rather silly for this book – which accompanies a television series – to appear with only one name on the cover. The truth is that while Victorian paintings have been a personal enthusiasm for many years, turning an interest into something that might draw in a wider audience involved a big team of people.

I have no idea how the BBC chain of command works in a case like this (or, indeed, in many other cases). After numerous meetings with heads of departments, commissioning editors, channel controllers and ladies serving the custard in the staff canteen, the series was finally commissioned by Roly Keating, who at that time was in charge of both BBC One and BBC Two. As I write, the programmes have yet to be broadcast. If they are deemed successful (as opposed to 'an interesting challenge' or some similarly damning BBC-ish judgement) they will, doubtless, turn out to have a bafflingly large number of parents. If the series fails, it will be an orphan.

However, some things cannot be disputed. The films were made by four of the most talented documentary-makers it has been my pleasure to meet. I was determined that the series should not be about art appreciation

– there were to be no historians standing in front of paintings pointing out the finer details of brushwork. I am not competent to talk about such things, and, anyway, for me the fascination lay in what the paintings told us about social history: what were the stories the pictures were telling, why were they telling them, and – critically – were they true? Any individuals we interviewed had to be rooted in what we were discussing, and there was to be no fancy dress.

The great challenge was to translate one medium – painting – into another – television. Quite how John Hay, Kate Misrahi, Robin Dashwood and Phil Cairney managed to produce the programmes they did, I'm really not sure, and my frustration at the tedium of being filmed walking down corridors, opening doors, and so on, while waiting for perfect synchronisation with the movement of a camera on the end of a jib turned out to be more than offset by my delight at seeing what they had brought off. That the films had such a rich feel is entirely their business. They were skilfully edited by Damian Leask, Andrea Carnevali and Susan Brand.

The single name on the cover of this book short-changes a large team of individuals. The serious spadework was done by researchers Jane Mayes and Lulu Valentine, whose efforts disclosed how very superficial had been my own amateur enthusiasm. The energy and resourcefulness of cameraman Mike Garner and sound-recordist Dave Williams was a masterclass in how to make things happen. The series was shaped by producer/

calligraphist Julian Birkett, whose thoughtfulness was rivalled only by his childlike delight in the chance of going up in a helicopter. Of Basil Comely, I can only quote the comment 'is that man really the head of the Arts Department? Because, if so, the BBC's in much better shape than it usually appears.'

I had written the introduction for a book well before the series went into production. For a long time, I resisted repeated requests from Albert DePetrillo at BBC Books that I finish the thing. I simply did not have the time. In the end, the solution arrived in the form of the young Irish writer, Neil Hegarty. Quite apart from pulling together the various elements – scripts, research notes, ideas and other material – his creative talents ensured, I hope, that the book is a worthwhile thing in its own right. He is a gifted writer and we shall, I think, hear a lot more from him.

The project editor at BBC Books, Christopher Tinker, saw the thing through from typescript to final product. The manuscript was read for accuracy by Rosemary Barrow, of Roehampton University: I am grateful to her, and take responsibility for any howlers that remain. Steve Tribe managed the complicated and onerous business of editing the copy as it came in. In a book that deals with works of art, of course, the critical question is how it looks and feels, and for that all credit must go to picture researcher Sarah Hopper and, most importantly, to the designer, Tara O'Leary. I think she's done a terrific job. I hope you do, too.

Further Reading

Introduction
Lionel Lambourne, *Victorian Painting* (London: Phaidon Press, 2003)
Julian Treuherz, *Victorian Painting* (London: Thames & Hudson, 1993)
Christopher Wood, *Victorian Painting* (London: Weidenfeld & Nicolson, 1999)

one: The Mob in the Picture Gallery
Mary Cowling, *Victorian Figurative Painting: Domestic Life and the Contemporary Social Scene* (Winterbourne: Papadakis Publisher, 2000)
Lionel Lambourne, *An Introduction to Victorian Genre Painting: From Wilkie to Frith* (London: H.M.S.O., 1982)
Julia Thomas, *Victorian Narrative Painting* (London: Tate Publishing, 2000)

two: Thy Long Day's Work
Tim Barringer, *Men at Work: Art and Labour in Victorian Britain* (New Haven and London: Yale University Press, 2005)
Julian Treuherz, *Hard Times: Social Realism in Victorian Art* (London: Lund Humphries, 1992)

John A. Walker, *Work: Ford Madox Brown's Painting and Victorian Life* (London: Francis Boutle Publishers, 2006)

THREE: THE ANGEL IN THE HOUSE
Susan P. Casteras, *Images of Victorian Womanhood in English Art* (New Jersey: Fairleigh Dickinson University Press, 1988)
Erika Langmuir, *Imagining Childhood: Themes in the Imagery of Childhood* (New Haven: Yale University Press, 2006)
Alison Smith, *The Victorian Nude: Sexuality, Morality and Art* (Manchester: Manchester University Press, 1996)

FOUR: A WORLD OF WEALTH AND POWER
Peter Harrington, *British Artists and War: The Face of Battle in Paintings and Prints, 1700–1914* (London: Greenhill Books, 1993)
John M. MacKenzie (ed.), *The Victorian Vision: Inventing New Britain* (London: V&A Publications, 2003)
Nicholas Tromans (ed.), *The Lure of the East: British Orientalist Painting* (London: Tate Publishing, 2008)

FIVE: A LAND OF DREAMS
Michaela Giebelhausen, *Painting the Bible: Representation and Belief in Mid-Victorian Britain* (Aldershot: Ashgate, 2006)
Elizabeth Prettejohn, *The Art of the Pre-Raphaelites* (London: Tate Publishing, 2007)

Christopher Wood, *Fairies in Victorian Art* (London: Antique Collectors Club, 2007)

WORKS ON INDIVIDUAL ARTISTS

Robyn Asleson, *Albert Moore* (London: Phaidon Press, 2004)

Rosemary Barrow, *Lawrence Alma-Tadema* (London: Phaidon Press, 2003)

Kenneth Bendiner, *The Art of Ford Madox Brown* (Philadelphia: Pennsylvania State University Press, 1997)

Mark Bills, *Edwin Longsden Long RA* (London: Cygnus Arts, 1998)

Mark Bills, *G.F. Watts: Victorian Visionary* (New Haven: Yale University Press, 2008)

David Peters Corbett, *Edward Burne-Jones* (British Artists; London: Tate Publishing, 2004)

Gustave Doré, *Doré's London: All 180 Illustrations from London, A Pilgrimage* (New York: Dover Publications, 2004)

Lee MacCormick Edwards, *Hubert Von Herkomer: A Victorian Artist* (Aldershot: Ashgate, 1999)

Katharine Lochnan, *William Holman Hunt and the Pre-Raphaelite Vision* (New Haven: Yale University Press, 2008)

Christopher Newall, *The Art of Lord Leighton* (London: Phaidon Press, 1993)

Richard Ormond, *Sir Edwin Landseer* (New York: Rizzoli, 1981)

Richard Ormond and Carol Blackett-Ord, *Franz Xaver*

Winterhalter and the Courts of Europe, 1830–1870
(London: National Portrait Gallery, 1992)

Christine Riding, *John Everett Millais* (British Artists;
London: Tate Publishing, 2006)

Alexander Robertson, *Atkinson Grimshaw* (London:
Phaidon Press, 1996)

William Simpson, *The Autobiography of William Simpson
(Crimean Simpson)* (Prenton: InfoDial, 2007)

Lisa Tickner, *Dante Gabriel Rossetti* (British Artists;
London: Tate Publishing, 2003)

Peter Trippi, *J.W. Waterhouse* (London: Phaidon Press,
2005)

Paul Usherwood and Jenny Spencer-Smith,
Lady Butler: Battle Artist, 1846–1933 (Stroud: Sutton
Publishing, 1987)

Diane Waggoner (ed.), *The Beauty of Life: William
Morris and the Art of Design* (London: Thames &
Hudson, 2003)

Christopher Wood, *William Powell Frith: A Painter & His
World* (Stroud: Sutton Publishing, 2006)

NOTES

INTRODUCTION
1 'Silver Memory of Euston Arch'. *The Times*, 7 March, 1962.

ONE: THE MOB IN THE PICTURE GALLERY
1 William Blake, 'And Did Those Feet', in 'Milton'; *Norton Anthology of English Literature* (London and New York: [*c*.1804–1810] 1986), 77.

2 Jane Austen, *Emma* (Harmondsworth: Penguin [1816], 1995), 309–10.

3 John Ruskin, Two Paths (1859), quoted in John D. Rosenberg (ed.), *The Genius of John Ruskin* (Charlottesville: University of Virginia Press, 1998), 223.

4 Quoted in Julian Treuherz, *Victorian Painting* (London: Thames and Hudson, 1993), 89.

5 Quoted in Asa Briggs, *Victorian Cities*, 88.

TWO: THY LONG DAY'S WORK
1 *Art Journal*, July 1874, 201.

2 Charles Dickens, 'A Nightly Scene in London', in *Household Words*, 26 January 1856.

3 *Saturday Review*, 2 May 1874, 562.

4 William Blake, 'The Chimney Sweeper', from *Songs of*

Innocence, in *Norton Anthology of English Literature* (London and New York: Norton [1789], 1986), 33.

5 Henry James, 'London', in *Essays in London and Elsewhere* (Freeport: Books for Libraries [1893], 1922), 27, 32.

6 W.T. Stead, *Pall Mall Gazette*, 1 October 1888; quoted in Judith R. Walkowitz, *City of Dreadful Delight: Narratives of Sexual Danger in Late-Victorian London* (London: Virago, 1992), 191.

7 'Polly Nicholls's Last Words', in *Police Illustrated News*, 12 October 1888, cited in Walkowitz, 134.

THREE: THE ANGEL IN THE HOUSE

1 Charlotte Brontë to Emily Jane Brontë, 2 April 1841; quoted in Juliet Barker, *The Brontës* (London: Phoenix, 1995), 353.

2 F.M. Redgrave, *Richard Redgrave: A Memoir*, 1891; quoted in Christopher Wood, *Victorian Panorama: Paintings of Victorian Life* (London: Faber [1976], 1990), 129. Not everyone, however, was pleased: Harriet Martineau claimed that people were fed up 'with the incessant repetition of the dreary story of spirit-broken governesses'.

3 *Blackwood's Magazine*, July, 1860.

FOUR: A WORLD OF WEALTH AND POWER

1 Alfred, Lord Tennyson, 'The Charge of the Light Brigade', in *Norton Anthology of English Literature* (London and New York: Norton, [1854], 1986), 1176.

2 William Butler, *Autobiography* (1911), 349.

3 The writers were two disciples of William Morris called W.B. Richmond and Heywood Sumner.

FIVE: A LAND OF DREAMS

1 Charles Dickens, 'The Tuggses at Ramsgate', in *Sketches by Boz Illustrative of Every-Day Life and Every-Day People. Oxford Illustrated Dickens* (Oxford: Oxford University Press, [1837] 1987), 353–4.

2 Shakespeare, *Richard II*, Act 2, Scene i.

3 *Art Journal*, June 1850, 175.

4 *Household Words*, 15 June 1850, 265–6

5 Brochure: George Wilson, 'The Martin *Judgement* Pictures' (undated, London), in author's possession; cited in William Feaver, *The Art of John Martin* (Oxford: Oxford University Press, 1975).

6 *Art Journal*, Easter 1896, 11.

7 *Building News*, Vol IX, 1862, 99.

Index

Picture Credits

BBC Books would like to thank the following individuals and organisations for providing photographs and for permission to reproduce copyright material. While every effort has been made to trace and acknowledge copyright holders, we would like to apologise should there be any errors or omissions.

Abbreviations: *t* top, *b* bottom, *l* left, *r* right, *c* centre, *tl* top left, *tc* top centre, *tr* top right.

p.25 Museum of London; p.26 © National Portrait Gallery, London; p.51 Stapleton Collection/The Bridgeman Art Library; p.63 TopFoto/Fotomas; p.67 Punch Limited; p.72 Mary Evans Picture Library/ Mary Evans ILN Pictures; p.78 © National Portrait Gallery, London; pp.92, 94 and 96 Mary Evans Picture Library; p.97 Bibliothèque des Arts Decoratifs, Paris, France/Archives Charmet/The Bridgeman Art Library; p.99 Mary Evans Picture Library; p.101 The British Library Newspaper Library; p.108 Private Collection/ The Stapleton Collection/The Bridgeman Art Library; p.113 The Royal Collection © 2008 Her Majesty Queen Elizabeth II; pp.120 and 122 © Linley Sambourne House, London/The Bridgeman Art Library; p.127

Mary Evans Picture Library; p.132 Private Collection/
The Bridgeman Art Library; p.140 Mary Evans Picture
Library; p.150 © National Portrait Gallery, London;
p.157 Courtesy of Ken Wells, Thames Valley Police
Museum; p.174 © V&A Images, Victoria and Albert
Museum; p.191 © National Portrait Gallery, London;
p.212 Private Collection/The Bridgeman Art Library;
p.231 Private Collection/The Stapleton Collection/
The Bridgeman Art Library; p.243 © National Portrait
Gallery, London; p.258 TopFoto.

Plate Section 1: 1t National Gallery, London/ The
Bridgeman Art Library;1b © Ashmolean Museum,
University of Oxford/The Bridgeman Art Library; 2-3t ©
Russell-Cotes Art Gallery and Museum, Bournemouth/
The Bridgeman Art Library; 2-3b © Manchester Art
Gallery/The Bridgeman Art Library; 4-5t © New
Walk Museum, Leicester City Museum Service/The
Bridgeman Art Library; 4b Harrogate Museums and Art
Gallery, North Yorkshire/The Bridgeman Art Library;
5b Museum of London/The Bridgeman Art Library;
6-7t Private Collection/Copyright Pope Family Trust/
The Bridgeman Art Library; 6b Private Collection/
The Bridgeman Art Library; 7b Art Gallery of New
South Wales, Sydney, Australia/The Bridgeman Art
Library; 8t Royal Holloway, University of London/
The Bridgeman Art Library; 8b © Walker Art Gallery,
National Museums Liverpool/ The Bridgeman Art
Library; 9tr © Walker Art Gallery, National Museums

Liverpool/The Bridgeman Art Library; *9b* © Manchester
Art Gallery/ The Bridgeman Art Library; *10t* Royal
Holloway, University of London/The Bridgeman Art
Library; *10b* Manchester Art Gallery/The Bridgeman Art
Library; *11t* Birmingham Museums and Art Gallery; *11b*
© Blackburn Museum and Art Gallery, Lancashire/The
Bridgeman Art Library; *12t* © Museum of London/The
Bridgeman Art Library; *12b* Art Gallery and Museum,
Kelvingrove, Glasgow, Scotland © Glasgow City Council
(Museums)/The Bridgeman Art Library; *13t* Private
Collection/Photo © Christie's Images/The Bridgeman Art
Library; *13c* The Royal Collection © 2008 Her Majesty
Queen Elizabeth II; *13b* © Trustees of the Watts Gallery,
Compton, Surrey/The Bridgeman Art Library; *14t-b* ©
Tate, London 2008; *15t* © Tate, London 2008; *15b* ©
Royal Holloway and Bedford New College, Surrey/The
Bridgeman Art Library; *16t&b* © Tate, London 2008.

Plate Section 2: *1t* Private Collection © The Maas
Gallery, London/The Bridgeman Art Library; *1b*
Elida Gibbs Collection, London/The Bridgeman Art
Library; *2t-b* © Tate, London 2008; *3t* Wallington
Hall, Northumberland/National Trust Photographic
Library/Derrick E. Witty/The Bridgeman Art Library;
3b © Southampton City Art Gallery, Hampshire/The
Bridgeman Art Library; *4-5t* The Royal Collection
© 2008 Her Majesty Queen Elizabeth II; *4-5b* ©
Manchester Art Gallery/The Bridgeman Art Library;
6tl Private Collection/The Bridgeman Art Library; *6tr*